UNDERSTANDING FAR EASTERN ART

A Complete Guide to the Arts of China, Japan and Korea –
Ceramics, Sculpture, Painting, Prints, Lacquer, Textiles and Metalwork

UNDERSTANDING FAR EASTERN ART

A Complete Guide to the Arts of China, Japan and Korea –
Ceramics, Sculpture, Painting, Prints, Lacquer, Textiles and Metalwork

JULIA HUTT

with a foreword by Margaret Medley

E. P. DUTTON NEW YORK

Published in the United States by E.P. Dutton,
a division of NAL Penguin Inc.,
2 Park Avenue, New York, N.Y. 10016.

First American Edition

This book was created and produced by Roxby Art Publishing Limited
a division of Roxby Press Limited
98 Clapham Common North Side
London SW4 9SG

Editor : Elizabeth Drury
Typesetting : Vantage Photosetting Co. Limited
Reproduction : Minervascan Limited

Library of Congress Catalog Card Number : 87–70749.
ISBN : 0–525–48295–4

Printed and bound in Italy by
Interlitho, Milan

CONTENTS

CHRONOLOGY

CHINA

Neolithic Period	c.7000 – c.1600 BC
Shang	c.1600 – 1027 BC
Zhou	1027 – 256 BC
Western Zhou	1027 – 771 BC
Eastern Zhou	771 – 256 BC
Warring States Period	481 – 221 BC
Qin	221 – 206 BC
Han	206 BC – AD 220
Western Han	206 BC – AD 8
Eastern Han	AD 25 – 220
Period of the Three Kingdoms and Six Dynasties	AD 220 – 589
Sui	AD 581 – 618
Tang	AD 618 – 907
Five Dynasties Period	AD 907 – 960
Liao	947 – 1125
Song	960 – 1279
Northern Song	960 – 1126
Southern Song	1127 – 1279
Yuan	1279 – 1368
Ming	1368 – 1644
Qing	1644 – 1911

JAPAN

Jōmon	→ c.200 BC
Yayoi	c.200 BC – c.AD 250
Kofun (Tumulus)	c.AD 250 – 552
Asuka	AD 552 – 710
Nara	AD 710 – 794
Heian	794 – 1185
Kamakura	1185 – 1392
Muromachi	1392 – 1568
Momoyama	1568 – 1615
Edo	1615 – 1868
Meiji	1868 – 1912

KOREA

Three Kingdoms Period	37 BC – AD 935
Kingdom of Koguryŏ	37 BC – AD 668
Kingdom of Paekche	18 BC – AD 660
Kingdom of Silla	57 BC – AD 935
Unified Silla	AD 668 – 918
Koryŏ	918 – 1392
Chosŏn	1392 – 1910

FOREWORD

The recent growth of popular interest in the arts of China is more than justified by the important and often spectacular nature of the archaeological finds that have come to light during the years since the founding of the People's Republic of China in 1945. Many of these finds have resulted in considerable revisions to our knowledge of the arts themselves, as well as to our vision of the history of this vast country.

How, then, should these arts be presented to satisfy and stimulate readers at all levels? Many chronological, stylistic and aesthetic surveys have been produced in the past, all of them failing to provide in a satisfactory manner the background information that is essential to an understanding of Far Eastern Art. Here an entirely original approach has been chosen. The Chinese are nothing if not practical, and it is this practical element that forms the basis of the present study, which covers Japan, and to a lesser extent Korea, as well as China. The rewards of using this as the starting point are very real, since when one begins to understand *how* artists and craftsmen have actually worked, and with what instruments, one's aesthetic appreciation is immensely enlarged.

Perhaps nowhere is this more true than with reference to painting and calligraphy, which for Westerners are the most difficult subjects. The purely visual impact of painting is, however, comparatively easy to come to grips with, and it has been decided to refer to calligraphy only in the context of painting.

The difficulties in the way of the appreciation of painting lie mainly in its non-specific nature, and the fact that it is much more concerned than is painting in the West with the interpretation of mood and spirit. It also attemps to reveal realities of a profoundly personal kind which are virtually impossible for the artist, or indeed the connoisseur, to express in words. The fact that the painter's preparations are lengthy and sacramental in character, makes both painting and calligraphy in some sense remote and spiritual, demanding of the viewer a similar slow, contemplative and reverent response. Without some understanding of brushwork and the enormous range of strokes available to the painter, the rewards to the viewer brought up in the Western tradition may be somewhat limited. A way of enhancing one's appreciation is to try handling the brush oneself after discovering something of its management in these pages.

There are fewer difficulties in achieving an understanding of most of the other arts, where the technical problems presented by

the materials are much the same the world over. Only one exception springs to mind and that is lacquerwork, a peculiarly Chinese, Japanese and Korean product which led craftsmen into some strange areas in design, and brought about the introduction of a range of materials and techniques, many of which are unique to this medium.

While all the techniques in lacquerworking employed in one region could be, and were, employed in the others, each of the three regions had its own preference. China, for instance, exploited carving to a greater extent than any other technique, although its development was comparatively late. Even inlaying in mother-of-pearl, at which the Chinese were exceptionally skilful, took second place, while the Koreans developed inlaying in a remarkable way in the Koryŏ period. The Chinese were well aware of what the Japanese terms *maki-e* and *takamaki-e* meant – and did occasionally use the techniques – but it was the Japanese who brought them to the high pitch of perfection that we recognize instantly as a unique expression of the character of Japan, breathtaking in its technical excellence and exciting in design.

We are apt to associate woodblock printing with Japan, in particular. This is not surprising since the output, which began only in the late seventeenth century, reached dimensions far in excess of what the Chinese, who brought the skill to its maturity, ever achieved. Indeed, by the time Japanese prints began to reach the peak of their perfection in the early nineteenth century, in the hands of Hokusai, Hiroshige, Utamaro and the Kuniyoshi, Chinese colour printing had declined to become, with the ephemeral and attractively gaudy New Year prints and prints of the household gods, little more than local folk art.

The same fluctuations are apparent in most of the other arts, but notably in metalwork. While the Chinese excelled in ancient times in bronze casting, their skill and the quality of their design failed them in later centuries, when they were surpassed by both the Japanese and the Koreans, the Japanese especially in the Edo period, when metalworkers found themselves turning their creative talents to decoration rather than to fitting out samurai warriors with functional equipment. Their technical skill and unusual sense of design, which was extremely refined, meant that their work far outstripped anything which the Chinese were capable of at the time.

For many centuries what seems to have interested the Chinese most was the ceramic medium. While earthenware was naturally the first type to be developed, the potential of stoneware began to be exploited quite early, and clearly by the end of the third century

AD it was already much admired. The ability to achieve high firing temperatures was to some extent a spin-off from the technique of bronze and iron casting, and the smelting of those metals. The design of the furnaces must have helped considerably in the evolution of kilns.

The kilns used even in Tang times, in the eighth and ninth centuries, were very advanced, so far advanced indeed as to make possible the achievement of temperatures in the region of 1300°C that were required to produce the high-quality white porcelains of the period. From that time on, high-fired wares, whatever the colour of the body and whatever the colour or type of glaze, became the centre of attention. The greenish glazed wares commonly named 'celadon' were much sought after, not only by the Chinese but also by foreigners, being better and stronger than anything produced elsewhere at the time, and they were widely exported; they certainly had a great impact on both Korea and Japan.

Long before the end of the ninth century the Koreans had been making handsome dark grey stonewares. Towards the end of the tenth century they encountered the best of the early Chinese celadons, the Yue wares, and were promptly inspired to produce their own variety. This was not difficult as the basic materials in Korea, for geological reasons, are almost identical to those of present-day Zhejiang province where Yue was made. Their control of the kilns was inclined to be haphazard, but the best of their products rivalled, (if they did not actually surpass,) the Chinese northern wares of the eleventh and twelfth centuries. The Korean potters, however, trod a different path from the Chinese. Although they accepted some of the shapes, decoration and decorative techniques, they seem to have had a greater interest in the last of these and the use of colour; they introduced black and white inlay, something never attempted by Chinese potters, and were fairly successful in using copper red, which they later exploited on their white-bodied ware in a spectacular manner.

Meanwhile, the Japanese remained content with the unglazed stonewares which had succeeded the remarkable earthenwares of the Jōmon culture and the Haniwa. The Chinese Yue wares (green wares) did, however, stimulate the use of high-fired glazes. The Japanese may not in fact have been so interested in that colour once they had learned the technique, seeming to have preferred to explore variety of form, only gradually turning their attention to glaze effects and decoration. The lateness of their development of white-bodied high-fired porcelain, in the seventeenth century, is a little surprising. Having mastered that technique, however, they evolved a remarkably attractive series of decorative styles under the

9

combined stimulus of Chinese wares and the requirements of the Dutch market, and in conjunction with their own unique approach to surface.

Glass, which to some extent is related to ceramics, presents peculiar problems. Because the available material is so intermittent in date and so limited in range, it has been thought best to omit glass and glass making from this survey. It was a skill learned by the Chinese and then forgotten, though revived from time to time down the ages, usually as the result of contacts with the peoples of western Asia. It was really only in the eighteenth century that the Chinese developed it into any kind of art form, the best examples often being of the overlay type with a strong colour for the main body of the vessel, usually a vase or jar of some kind, which was then overlaid with an opaque white and carved through to the main body in complex and rich designs. There was also some carving and engraving of plain glass, and also gilding.

It was the ceramic art that held a dominant place in, above all, Chinese affections, and it was they who discovered all the fundamental techniques of manufacture and decoration, other than that of lustre, in use in the West today. As we have seen, these techniques were adopted in Korea and Japan, and served as a springboard for developments in new and often original directions. Each culture evolved its own favoured shapes, and gradually also styles of decoration. The relationships are usually easy to see, but defining the differences can sometimes be more difficult.

This problem of defining with precision the differences between the three cultures is most obvious in Buddhist sculpture, which attained a degree of maturity first in China in the late sixth century, a time when the Koreans and the Japanese became converted to this Indian religion. By the Tang dynasty, Chinese Buddhist sculptures had for the most part little to do with Indian art, although of course the Indian iconography was largely accepted. The gilt-bronze figures, especially the small ones used in household shrines in both China and Korea, are not always easy to distinguish from each other at first. Stone figures present less of a problem, as do the larger wooden figures. The great persecution of Buddhism in China in AD 845 meant that the best Buddhist sculpture thereafter tended to be in Japan, where the Tang style, adopted there in the seventh and eighth centuries, lived on. It gradually became more elaborate and decorative, moving slowly away from the style of earlier centuries when distinctions were often unclear.

When it comes to textiles, whether woven or embroidered, such problems rarely arise, partly for technical reasons and partly

because of the wide differences in concepts of decoration. On the technical side, the Chinese (initially at least) were far in advance. By Han times not only were they producing very complex weaves, but they were also making polychrome silks of a very complicated kind, using five or seven colours and often incorporating inscriptions into the design.

Silk tapestry weaving, a technique which had its origins in Central Asia in about the sixth century, was developed to a high pitch by the Chinese and was passed on by them to the surrounding regions. Other textiles such as hemp and cotton were extensively used and the techniques for these were varied, tie-dyeing being common; the Japanese added to this the use of stencils.

Gold seems always to have been highly regarded, and it was used in robes and hangings intended for the aristocracy and the emperors; it was also sought after by wealthy monastic foundations. In China, and even more in Japan, the monks often acted as financiers for large commercial undertakings. It is, therefore, of some importance to bear in mind that in the East religious foundations played a vital part in the spread of both materials and ideas, not only within the region in which they were situated, but also in the total geographical area. The close links between the arts of China, Japan and Korea in terms of the techniques employed and the use of decorative forms and styles owe almost as much to the common religion as to the skill and energy of the merchants, whom it benefited greatly to make known abroad the arts of their own countries.

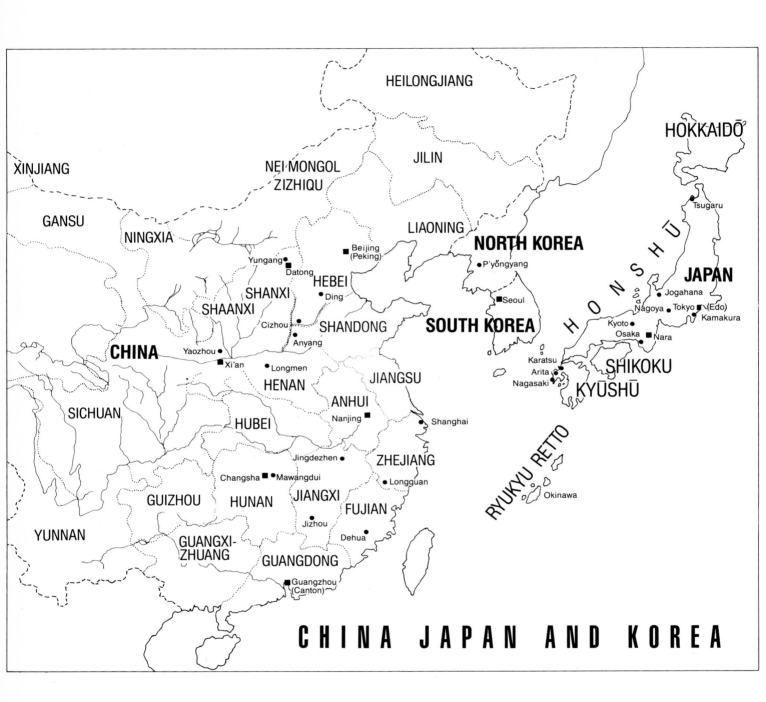

HEILONGJIANG

XINJIANG

GANSU

NEI MONGOL
ZIZHIQU

JILIN

NINGXIA

LIAONING

NORTH KOREA

HOKKAIDŌ

Beijing
(Peking)

P'yŏngyang

Tsugaru

Yungang
Datong

HEBEI

Ding

Seoul

JAPAN

Jogahana

SHANXI

SOUTH KOREA

Nagoya

Tokyo (Edo)

SHAANXI

SHANDONG

Kyoto

Kamakura

CHINA

Cizhou

Anyang

Osaka

Nara

Yaozhou

Longmen

Xi'an

JIANGSU

Karatsu

SHIKOKU

HENAN

ANHUI

Arita

Nanjing

Nagasaki

KYŪSHŪ

SICHUAN

HUBEI

Shanghai

Jingdezhen

ZHEJIANG

RYUKYU RETTO

Changsha

Mawangdui

Longquan

GUIZHOU

HUNAN

JIANGXI

Okinawa

YUNNAN

FUJIAN

Jizhou

GUANGXI-
ZHUANG

Dehua

GUANGDONG

Guangzhou
(Canton)

CHINA JAPAN AND KOREA

H O N S H Ū

INTRODUCTION

The aim of this book is to introduce the arts of the Far East, of China, Japan and Korea, to the non-specialist reader. Rather than providing a historical survey of the subject, it sets out to describe the main materials and techniques that were used and so to encourage a greater understanding of the objects themselves.

Each chapter deals with a particular type of material, concentrating on the way it was employed and worked. No attempt has been made to cover the entire history of a medium, but simply to give some account of the most important technical developments and the periods when a high level of technical excellence was achieved.

Inevitably this arrangement means that much has had to be omitted. In the Metalwork chapter, for example, the description of bronze and bronze casting refers mainly to the ancient bronze artifacts of the Shang and Zhou periods. Not only was this a time of innovation and experimentation in the bronze medium, but it also coincided with the appearance of some of the finest bronzes ever produced in the Far East. There is, however, little mention of the later bronzes or, indeed, of those of Korea and Japan.

There are various reasons for discussing China, Japan and Korea together. Geographically, the countries are close to each other. Whereas the mountain ranges and deserts to the south west, west and north west of China have made communications and cultural exchanges difficult, no such physical barriers exist to the east. Korea is situated in the same landmass as China, separated by Manchuria, while Japan is made up of four main islands in the Pacific Ocean off the coast of Korea. Korea provides a bridge between China and the Japanese islands, only a short stretch of water separating the Korean and Japanese coasts.

From as early as the third century BC China began to exert an influence over Korea. At various times Chinese armies invaded and subjugated Korea, imposing on it Chinese political and social institutions. In 108 BC, for instance, Emperor Wu of the Han dynasty succeeded in conquering the Korean state of Chosŏn. The Han Commandery of Lelang (Korean: Nangnang) was set up at its capital, along with three other commanderies in other parts of the country, establishing Korea as an outpost of the Han Empire.

Chinese civilization is considerably older than that of Korea or Japan. It is hardly surprising, therefore, that the Koreans and the Japanese sought to emulate the well-established and sophisticated culture of their neighbour. The basic system of writing adopted in Korea and Japan, for example, is based on that of China, and it is

closely connected with the introduction of Buddhism. This is a religion which originated in India and, after becoming established in China, reached Japan by way of Korea. The practice of Buddhism in the Far East was an additional unifying factor, and it gave rise to a new art form, complete with its own iconography.

The government and institutions, as well as the culture of Tang China, were held up as a model in Japan during the Nara period; also in Korea, which had recently been unified under the state of Silla. Nevertheless, there was <u>never</u> any danger of Korea or Japan being assimilated into the Chinese Empire, for they always retained distinctive traditions of their own and did, indeed, exert an influence on each other.

Until comparatively recently Korea has been somewhat overlooked in favour of China and Japan. In the West, research into Korean art is still in its infancy, a fact which is (inevitably) reflected in this book. Since there are <u>few</u> scholars competent to tackle the subject adequately and, since the best of Korean art is often overshadowed by that of its neighbours, Korean art is not discussed here as fully as it might be. Many of the general comments, however, refer to Korean art <u>as well as</u> to that of China and Japan.

● *Below :* Japanese woodblock print, coloured by hand, by Terushige (*c.* 1715–1725). A couple warming themselves under a *kotatsu.* The man holds a tobacco pipe in one hand and has a smoking-cabinet in front of him, while his sword lies discarded on the floor behind. To the rear of this scene is the *tokonoma,* or display alcove, in which a hanging scroll is exhibited; on the slightly raised floor there are a pile of treasured books, a lacquer box and an offering of incense. To the left is a two-fold screen.

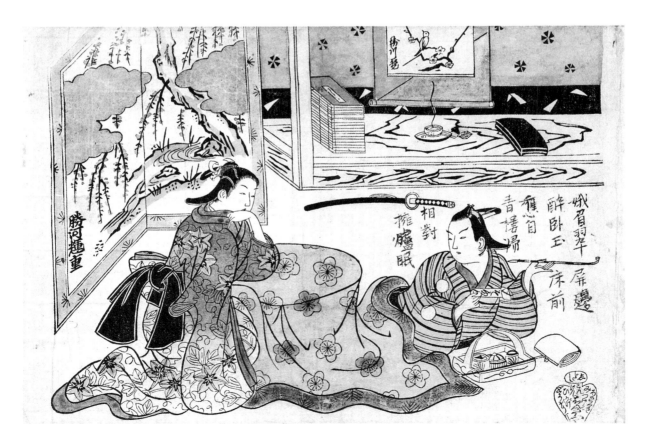

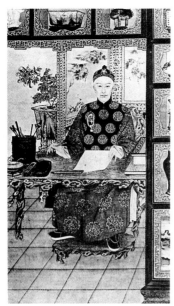

● *Above* : Chinese later copy of an original painting, reproduction from *Qing dai di hou xiang* ('Portraits of Qing Emperors'), published at Beijing, 1935. The emperor Guang xu (1874–1908) seated at a table with gnarled wooden legs. On one side of the table are a pile of books and albums with figured-silk covers, and on the other an inkstone, vase and brushpot. Behind him there are screens and a chrysanthemum in a ceramic pot on a bamboo stand, while in the foreground, framing the composition, are panels containing precious objects.

Before passing on to the descriptions of the different materials and techniques, it is worth considering the context in which the objects were to be used and shown. There was considerable variety in the types of houses characteristic of the separate regions and countries of the Far East. A fundamental variation relating to the interiors of the houses was the fact that from a period just before the Tang the Chinese sat on chairs, while the Koreans and the Japanese sat or kneeled on the floor.

During the Qing period in China the reception hall was one of the most important rooms for the display of *objets d'art*. A common arrangement was that of a large painted hanging scroll flanked on either side by a scroll of calligraphy. In front stood a table, on which were placed a bronze vessel or a flower in a vase, or some item that was in keeping with the theme of the painting. The rest of the hall was filled with furniture and other objects such as vases. Although subtlety and restraint epitomized good taste, in reality an ostentatious and crowded display of objects was often to be found.

The room reserved for the scholar of the house was generally sober in appearance. Books and scrolls were kept there, as well as the materials and implements used in calligraphy, the most treasured articles frequently being displayed on the so-called Scholar's Table.

The Japanese interior was extremely sparse and restrained. The traditional Japanese house was wood framed and had paper or wood panels. The interior walls consisted of decorative panels and sliding doors, while painted screens were used as an additional form of decoration, or to divide up a room. The floors were covered with straw mats, known as *tatami*.

The most important part of a Japanese house was the guest room, which contained two recesses: the *tokonoma* and the *chigaidana*. The *tokonoma* was used to display a painted hanging scroll. A vase with flowers stood directly on the slightly raised floor or on a low table. Figures of household deities, together with offerings, would be placed in the *tokonoma*. The *chigaidana* consisted of built-in cupboards and shelves which extended from either side at different heights and overlapped in the centre. It was used for the storage of household wares and also for displaying ornaments and other prized possessions.

The highest forms of Far Eastern art exhibit many common characteristics, though deeply rooted native styles and traditions generally make it possible to distinguish those made in each of the cultural spheres. The arts of Korea and Japan should not be considered simply as an extension of the arts of China since some of the finest examples of Far Eastern art were produced there.

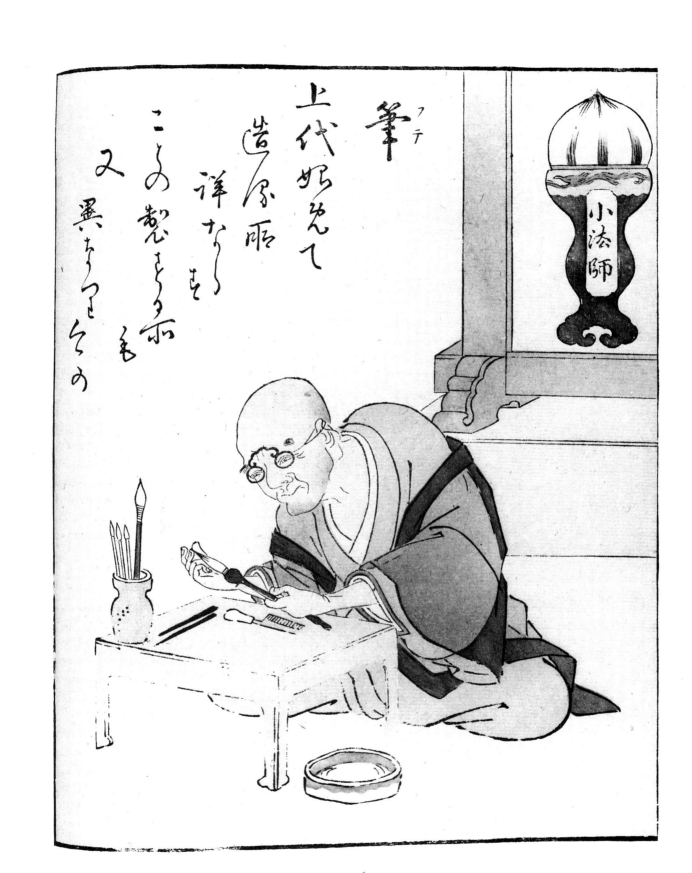

筆（フテ）

上代始めて
造られしも
詳かなり
この製ちを示
又異ちつきその

Chapter 1

PAINTING

PAINTING in the Far East developed during the course of some 3,000 years in such a way that it became one of the highest forms of artistic and intellectual expression. Its distinctive nature was directly influenced by the use of particular materials, not all of them exclusive to China and Japan, and by the manner in which they were employed. The main ones, used for both calligraphy and painting, were the brush, inkstick, inkstone and paper, traditionally referred to as the Four Treasures.

Some kind of brush had been used to decorate Neolithic pottery during the third millennium BC. A brush discovered in a tomb of the Warring States period (481–221 BC), the long slender handle and hair tip fitting neatly inside a bamboo tube, is probably the earliest to have survived, and it must be similar to the ones used to depict scenes on a T-shaped silk banner found draped over the inner coffin of a tomb at Mawangdui, Changsha, of the Western Han period (206 BC – AD 8). Contained within the same tomb were silk, lacquer and pottery objects with decoration displaying a similar accomplishment of brushwork. It was during the Han period that painting as a form of art in its own right appears to have become widespread.

● *Above:* Chinese 'spinach' jade brushpot, Qian long period (1736–95). The surface is deeply carved, illustrating the Three Immortals in a landscape, together with a pavilion and a river spanned by a bridge.
● *Left:* Japanese woodblock colour print, 1784. A brushmaker, from the book *Saiga shokunin burui* ('*Types of artisans portrayed in colour*') by Tachibana Minkō (1784), original edition 1770. Having inserted the hairs into a holder, the craftsman is now carefully shaping the tip to form a sharp point.

BRUSH AND INK

The brush traditionally used for writing and painting was made up of fibres tied together and set into the open end of a holder. Many types of animal fibre were used, such as goat, deer, horse, wolf, fox, rabbit and hare. The hairs were plucked and then cleansed of any traces of dirt or oil which might resist the ink. After careful grading of the hairs, so that they would form a sharp point when wetted, they were tied into a bundle and glued into a tubular case, usually made from bamboo or reed stalks. The holders available in China today are generally of light, mottled bamboo or stained a colour such as deep purple-red, and they are often engraved with the place of manufacture accompanied by a small decorative motif. Before use, the bristles were held together in a point by weak size, and they were protected by an outer tubular cap. The size was broken down by dipping the tip into water and by gently agitating the

point against the side of a dish, or by chewing it as far down the bristle length as required. Once this has been done, the cap could not be replaced as it would damage the shape of the point.

The main medium used when putting brush to paper was ink. Carbon, the basic ingredient, was derived from a variety of natural products such as vegetable oils, animal fats and timber. After having been burned inside a container, the residue of soot, or lampblack, which was deposited by the smoke, was brushed into pottery jars and mixed with animal glue. The compound was then heated for several hours and thoroughly pounded before the addition of musk and camphor to neutralize the smell of the glue. The resulting malleable substance was then pressed into moulds and left to harden.

The inksticks so produced were frequently decorated with moulded designs, together with calligraphy, sometimes enhanced with coloured lacquers (see Chapter 6) or gold leaf. Such was their durability that one stick could last many years, even when put to daily use; indeed, sticks were not regarded as mature until they were several years old. Already by the Tang period (AD 618–907),

● *Above, top:* Chinese woodblock print, 1606. A page from the twelve-volume book containing designs for inkcakes and inksticks, *Cheng shi mo yuan* ('*Mr Cheng's ink garden*'). *Above, bottom:* Chinese inkcake, 1621. Moulded with the 'hundred birds' design on one side and an inscription on the other which reads: 'Made in the first year of Tian qi [1621] by Cheng Junfang'. The design is taken from *Cheng shi mo yuan*. *Left:* Japanese woodblock colour print, 1784. An inkstone maker, from *Saiga shokunin burui* by Minkō. The craftsman is using one of several chisels to make a flat recess in the stone, with a sunken well at one end in which the ink would collect. Some finished carved stones are placed to the craftsman's left. The text quotes Chinese sources regarding prized materials used to make inkstones.

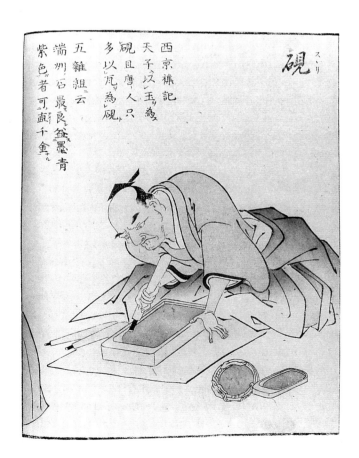

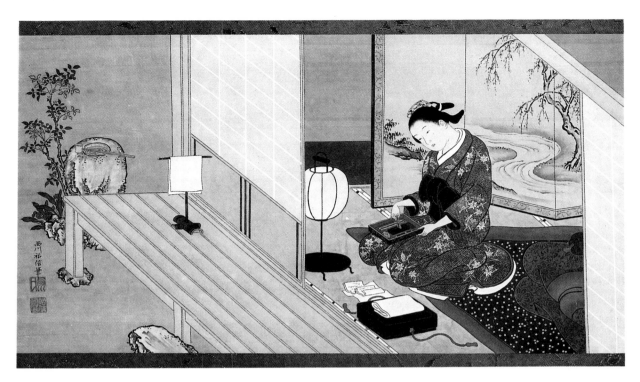

● *Above:* Japanese painting, ink and colour on paper, by Nishikawa Sukenobu (1671 – 1751). Detail from a painting showing a lady preparing ink. She is holding an open *suzuribako* ('inkstone box'), which also contains brushes and a water-dropper. She is in the process of grinding the inkstick on the inkstone, together with water from the water-dropper. Lying on the floor is a lacquered box in which paper would be kept.

workshops had been established where ink of exceptional quality was produced, the most famous maker being a certain Li Tinggui. Inksticks were much sought after by collectors, and it was not unknown for artists to use old ones in preference to contemporary sticks. The fame of Chinese inksticks spread to Japan, where lacquer artists of the eighteenth and nineteenth centuries made exact copies of old and treasured sticks, in lacquer, reproducing even cracks, chips and other signs of wear and tear.

The dry, hard inkstick was ground with water against an inkstone so that the particles of ink could combine with water. In order to produce a smooth ink, it was necessary to use a hard stone with a fine grain such as slate or, perhaps, jade. The inkstone generally took the form of a flat slab with a sunken well at one end. The first step in preparing the ink was to pour water into the well of the stone by means of a water-dropper. The inkstick, which was held at right angles to the stone slab, was dipped into the water to moisten it, the amount of water depending on the quantity of ink needed since it was preferable to prepare fresh ink for each session. The stick was firmly ground on the flat surface of the stone in a circular motion until the ink became thick and 'oily', at which point it was considered to be ready for use. This repetitive and time-consuming process was regarded as an essential one, serving to concentrate the artist's mind on the ultimate task of putting brush to paper.

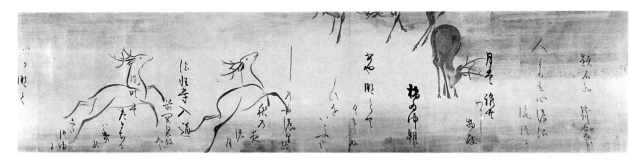

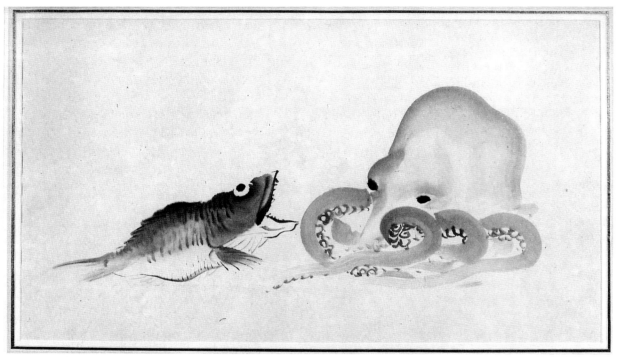

TECHNIQUES OF CALLIGRAPHY AND PAINTING

In both China and Japan the brush was traditionally held in the middle or towards the top of the handle in an upright position, between the thumb and the index finger, with the middle finger also touching the brush but below and behind the index finger. Because the artist's hand never rested on the work surface, he could rotate it through 360° at the wrist, giving him complete freedom of movement. Only the tip of the brush was in direct contact with the paper, and it was extremely sensitive to the slightest movement or to any alteration in pressure. Using a single brush, the artist could create a great range of strokes, ink tones and washes.

When writing Chinese characters, the strokes were subject to strict rules as to the order and method of their execution. The beginning and end of the individual strokes, for example, were

● *Above:* Japanese woodblock print by Nishikawa Sukenobu (1671–1751). The frontispiece to the first volume of the book *Calligraphic instruction for ladies*. A girl, guided by her instructress, labours at copying characters from a textual model on her left. A *suzuribako* ('inkstone box') lies open to her right, with a water-dropper beside it.

20

● *Left, top:* Japanese painting, ink, gold and silver on paper, by Tawaraya Sōtatsu (1576–1643) (painting) and Honami Kōetsu (1558–1637) (calligraphy), early seventeenth century. A section of a handscroll with deer and poems. The characters of the text are closely intermingled with the composition, a tradition which originated in the Heian period (794–1185). The deer leap round or above the characters and one even confronts them with its antlers. The close connection between the type of brushwork used for the calligraphy and the calligraphic use of the brush for the painting are particularly evident.

● *Left, bottom:* Japanese painting, ink and colour on paper, Shijō school, nineteenth century. Fish and octopus.

produced by pushing the point of the bristles downwards on to the paper so that more or less of the bulk of the hair bundle touched the surface as the brush travelled across it. A character was completed as though all the strokes were joined together in an even movement, even though the tip had to leave the paper in places. They were executed with extreme discipline and rigidity but, at the same time, with relaxed fluidity, which could only result from a firm grasp of the brush in the fingers and from the use of the artist's whole arm.

For painting, the same basic materials and implements were used as for calligraphy, and mastery of the individual strokes, which together formed the characters in writing, was also fundamental to the art of painting. The requirements of painting, however, were such that a rigid approach to the use of the brush was not always necessary. The brush was often held perpendicular to the writing surface, as in calligraphy, but it could also be held at almost any other angle. For example, broad strokes in various widths and textures, as well as areas of 'wash', could be produced using the side of the bristles, with the brush held almost parallel to the paper.

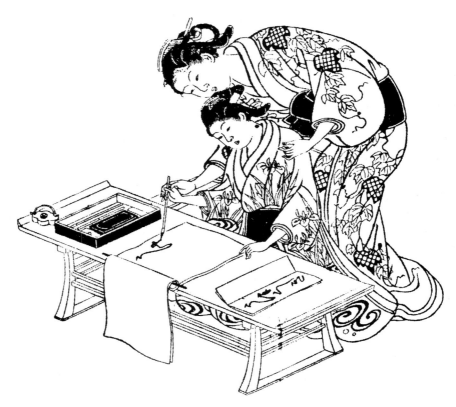

SILK AND PAPER

Two of the most widely used materials for painting were paper and silk. Sericulture, the production of raw silk, has been practised in China from at least the Shang period (c. 1600–1027 BC). Indeed, the Romans, who imported great quantities of silk brought by traders along the Silk Route (see p. 182), referred to China as Seres, the Land of Silk. It is, therefore, no surprise to find that, at least as early as the third century BC, painting of a comparatively sophisticated nature was executed on silk.

According to the late seventeenth-century manual of painting *Jie zi yuan hua juan* ('the *Mustard Seed Garden painting manual*') only unprimed silk was used by painters up until the sixth century. Then, during the Tang period, a priming process was introduced, reputedly by the artist Wu Daozi, which involved first immersing the silk in a hot glucose solution and then beating chalk or starch on to its surface to smooth the gaps between the warp and the weft. Another type of unprimed silk, which was beaten on a polished stone slab until the surface became smooth and flat, was also used at that time. The latter method of preparing the silk is recorded as having been first used by Zhou Fang during the late eighth and early ninth centuries for his delicate and detailed paintings of court life. A new method of priming was subsequently introduced which involved mixing together glue and alum, and this soon became widely used.

It is generally appreciated that paper was invented in China; the fact that it was in widespread use there six centuries before it was known in the Middle East, and a millennium before its appearance in Europe, is less often realized. True paper consisted of some form of vegetable fibre, broken down into a pulp. The pulp was poured

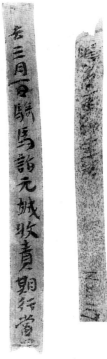

● *Above and right:* Chinese bamboo strips with calligraphy, *c.* third century. These administrative records, of Chinese origin, were found at Min feng (Niya), Xinjiang, a border outpost. The slips would once have been secured together for rolling up and storing.

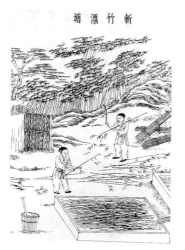
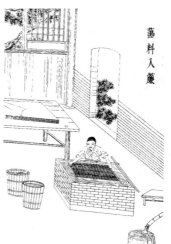
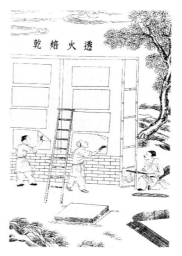

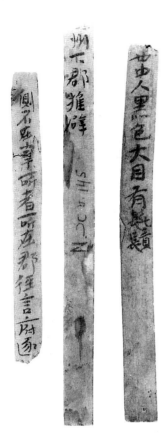

● *Left:* Chinese woodblock prints. A series of pages from the *Tian gong kai wu* (a book about the technology of a variety of crafts and industry) by Song Yingxing, first published in 1637, with numerous later editions. These three pages represent different stages in making paper. Left: bamboo stems were cut, trimmed and laid in a trough of water before being broken down into a pulp. Centre: a type of tray mould was lowered into a trough containing the bamboo pulp. The mould was then lifted out with a deposit of pulp on the surface, while excess water drained away. Right: the sheets of paper thus formed were then left to dry over an oven.

over a type of tray made from coarse cloth stretched over a frame which allowed the excess water to drain away. It was then left to dry in the sun. More frequently used was a method whereby the tray itself was dipped into a container of pulp. When this, too, had dried, the sheet of paper that had formed was removed from the tray.

As with most cultures, writing systems were developed long before it was known how to make paper. A variety of writing surfaces were found to be suitable, including tree bark, ivory, bone, clay tablets, animal hides and papyrus. In addition, the Chinese made use of slips of bamboo. These were placed vertically, side by side, and joined together by a cord to form a flat sheet, which could be rolled up for storage.

The invention of paper is traditionally ascribed to Cai Lun, an official of the Imperial Guard who was responsible for overseeing the palace library, in AD 105. This early paper was composed of old rags, linen waste, fishing nets and tree bark. Paper as a writing surface rapidly replaced silk, since it was cheap and offered a smooth writing surface, and it was less heavy and bulky than the slips of bamboo. Although some calligraphers and painters preferred to use unsized paper in order to achieve particular effects or to demonstrate their technical virtuosity, most of the papers produced in China were sized. This was done by adding glue or some other agent such as gypsum, wheat flour or rice meal to the initial pulp mixture. The paper was then left to be bleached by the sun or the action of other natural elements, and the final smoothing and polishing was carried out with a hard stone, such as agate.

Papermaking spread to Japan during the mid-sixth century, at the same time as the introduction of Buddhism and the adoption of the Chinese system of writing. It was the Japanese who ultimately perfected the craft. They produced paper of exceptional beauty and quality, whether it relied on its natural texture, which might be deliberately rough, or was dyed or otherwise decorated. That paper was more than a medium for painting and calligraphy is well reflected in Japanese society, where paper was used for anything from the interior walls of a traditional house to paper toys, as well as *origami*, the Japanese art of paperfolding.

Different regions of the Far East produced their own special kinds of paper made largely from local materials, the most common ones being rice, mulberry, bamboo, hemp, reed and wood pulp. The artist chose the type of paper, taking account of its inherent qualities, according to the type of painting he had in mind, as well as the brushstrokes necessary for its execution, since the appearance of the strokes was affected by whether the surface of the paper was rough, smooth or glossy, and by the absorbency of the

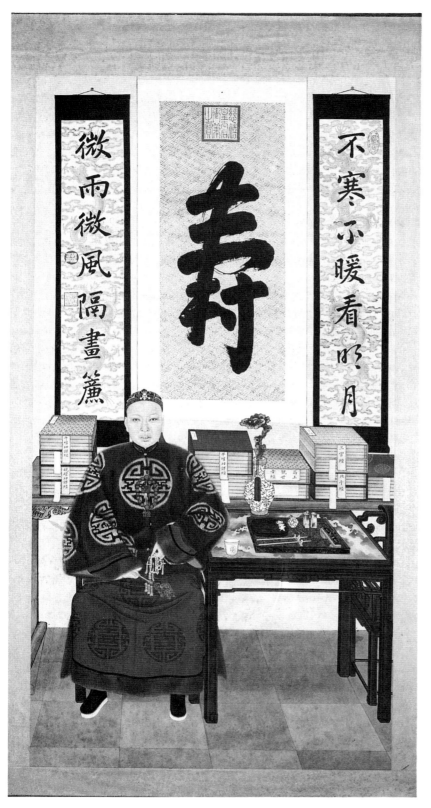

● *Left:* Chinese hanging scroll, ink and colour on paper, by the Empress Dowager Ci xi (1835–1908). A portrait of the Chief Eunuch of the Imperial Household, Li Liangying, who was renowned for his greed and, together with the Empress Dowager, effectively ruled China for nearly fifty years. He is shown leaning on a table which holds an inkstone, inkstick, water pot, two seals, and brushes on a brush rest. Behind him are arranged volumes of various Chinese classics, together with a pair of narrow calligraphic scrolls hung on either side of a wider one. The main, central character reads *shou* ('long life'), with a seal of the Empress Dowager above it.

paper. Generally speaking, untreated paper absorbed the ink, more rapidly, while sized paper enabled the artist to have more control over each individual brushstroke.

THE SCHOLAR'S TABLE

In China, the Four Treasures were traditionally kept on the so-called Scholar's Table, together with various other accessories. These may have included a paper-knife, to cut paper to the required size, a seal, a ruler, paperweights, a water-dropper and a wrist rest. This latter was used to cover a vertical line of characters for, when writing in columns from right to left, it was easy to smudge the line to the right which had just been written. A brush rest was used to accommodate the different ink-laden brushes during painting. After use, the brushes were thoroughly cleansed to remove all traces of ink and allowed to dry horizontally by resting them over the edge of the inkstone or some other suitable object. When dry, the brushes were stored in a brush pot. Since the Scholar's Table was used for serious and scholarly pursuits, it was characteristically subdued in appearance, yet elegant. Although the pieces found on it were functional, they were frequently objects of great beauty in their own right. In Japan, the implements used for calligraphy were kept in a writing-box, which contained the inkstone and water-dropper, while there was also a compartment or removable tray for the brushes.

INK AND COLOUR PAINTING

In the West, painting is usually considered to be synonymous with the use of colour. In certain categories of Chinese and Japanese painting, however, colour was of secondary importance or was not used at all.

Early representations in China and Japan were highly coloured, the colours most widely used being blue, green and brown. However, in China, from the tenth century onwards, when landscape had become fully established as an important category of painting, ink became the most popular medium; details were frequently added in colour.

True monochrome painting in the Far East was executed in black ink alone, yet, owing to the combined qualities of the ink and paper or silk, the overall effect could be far from monochrome. The painter worked in individual brushstrokes, ink tones and washes, and with skill he could exploit these to produce a painting which evoked the full range of colours.

The pigments used in Far Eastern painting were vegetable or mineral in origin. Apart from carbon black and lead white, there

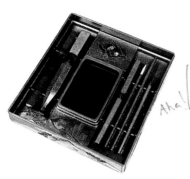

● *Above:* Japanese lacquer *suzuribako*, nineteenth-century. A lacquered box in gold *hiramaki-e* and *takamaki-e* (see Chapter 6), containing an inkstone, inkstick, brushes, cutting instruments and a water-dropper in the form of a double raft.

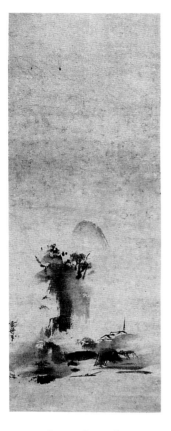

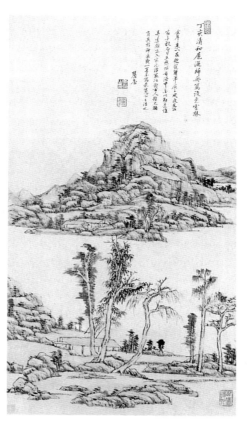

● *Far left:* Japanese hanging scroll, ink on paper, by Sesshu (1420–1506). Haboku ('splashed ink') landscape executed in broad, rapid brushstrokes, with a variety of ink tones, in an impressionistic manner. Sesshu was a Zen monk-painter who studied painting under Shūbun, the well-known fifteenth-century painter, while pursuing his religious training. This is a typical example of Zen ink painting, which makes use of large areas of empty space.

● *Left:* Chinese hanging scroll, ink and colour on paper, by Wang Yuanqi (1642–1715), 1707. A landscape after Ni Zan. Ni Zan's paintings are characterized by the sparing use of ink and the division of the composition into a foreground, with an expanse of water forming the middle ground, and a background.

were six main colours available to the painter – brown deriving from earth, a yellow from orpiment, a red from cinnabar, a green from malachite, a blue from azurite and a metallic gold. Once again, the *Mustard Seed Garden painting manual* provides much useful information regarding the range of colours within each main colour group. Among the reds, for example, were vermilion, coral dust red, carmine and red ochre. With the introduction of aniline dyes during the latter part of the nineteenth century, the range was extended to include, among others, particularly strong purples and oranges.

The pigments were ground down before being mixed with water, and glue was then added. The blocks of colour pigments thus resembled inksticks in their basic composition. Although whether colour was to be used was ultimately the choice of the artist, there were certain defined categories of painting which readily lent themselves either to the prominent use of colour – animals, insects, birds and flowers – or to ink alone – landscapes. For example, the type of painting favoured by the Chan sect of Buddhism, known as Zen in Japan, which was generally executed swiftly and in a spontaneous manner rather than with tight and detailed strokes, was usually in ink alone. Japanese painted screens and sliding doors of the Momoyama (1568–1615) and Edo

● *Below:* Chinese fan painting, ink and slight colour on silk, by Ma Lin (born *c.* 1185, died after 1256), dated 1256. Scholar reclining and watching rising clouds. Artists of the Southern Song period (1127–1279) favoured an intimate style of painting, with the focal point of the composition in one of the lower corners – a style well suited to the fan format. The line down the middle of the painting suggests that it was originally mounted as a fan but was subsequently removed from the frame to preserve it.

(1615–1868) periods, on the other hand, were composed of contrasting areas of bright colour. Frequently depicting trees, flowers, birds and animals on a gold-leaf ground, they appealed to the lavish and sumptuous taste of the new patrons, the military rulers; they also served to reflect light in the dimly lit interiors of contemporary buildings.

PAINTING FORMATS – THE SCROLL

One of the main features characteristic of Far Eastern painting is the format in which it was most commonly presented, namely, the scroll. The evolution of the scroll in China was no accident since, before the invention of paper, silk bearing calligraphy was rolled up for storage, as were slips of bamboo which were joined together. Of the two main scroll formats, the hanging scroll is also thought to have been influenced by Buddhist temple paintings on silk

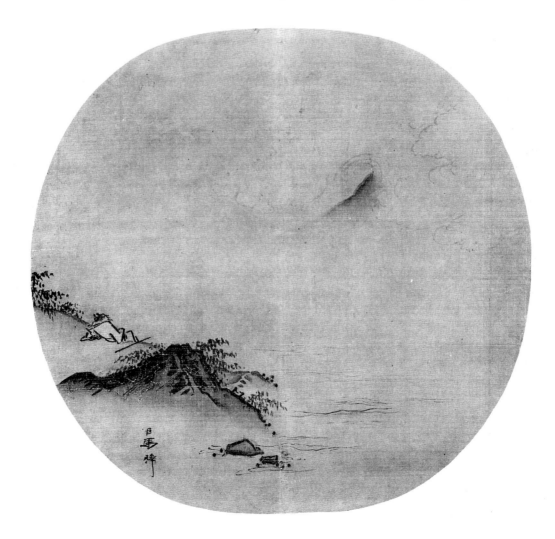

27

banners. The hanging scroll format was well established by the tenth century and coincided with the 'classic' period of Chinese landscape painting, which is characterized by an emphasis on towering and imposing mountain peaks.

In Japan, the rise in popularity of the hanging scroll also coincided with the development of the alcove ('*tokonoma*'), which was set aside in houses for the display of hanging scrolls and other art objects. The hanging scroll could be of any size, but it generally averaged between 0.5 and 3 metres in height. At the top was a rod, semi-circular in section with a round dowel at the bottom. Although these were made of wood, the protruding ends of the rollers were usually of ivory, bone or hardwood. The weight of the dowel helped the painting to hang flat, and it also acted as a roller around which the painting could be rolled from the bottom upwards. It was secured by means of ties at the top end and was identified by means of a title label on the outside. The fact that such scrolls could be rolled up to a size representing a small fraction of their surface area meant that large collections could be stored with comparative ease. In both China and Japan, the scrolls were usually hung individually, but they also occurred in groups of two or four when they were related in theme or when they were designed to form a continuous composition with their vertical edges touching. Variants included the slimmer calligraphic scrolls of couplets, which hung on either side of a central, wider scroll.

A hanging scroll was not displayed for any length of time. Instead, the painting was brought out for a specific purpose, such as the visit of a friend or a guest, at the beginning of a new season or simply for the pleasure of the owner.

Another type was the handscroll, which was in the form of a continuous horizontal scroll averaging between 1 and 9 metres in length and 25 and 40 centimetres in height. It had a dowel attached to the left-hand end of the scroll and a semi-circular rod at the other end. The scroll was rolled up around the roller from left to right, up to the semi-circular rod, and secured by means of ties. In order to view a handscroll, it was placed on a table or similar flat surface. The free end was unrolled to the right, while the left hand held the roller with the remainder of the scroll around it. Although it was unrolled from left to right, it was viewed from right to left.

Handscrolls were never intended to be seen in their entirety, fully unrolled; the length of some of them would have made this impracticable. Museums may choose to display the full length of a handscroll, but it is important to try to resist the temptation to view it as a whole: it was conceived, and should be seen, bit by bit. The viewer unrolls it in convenient, arm-span sections, going quickly

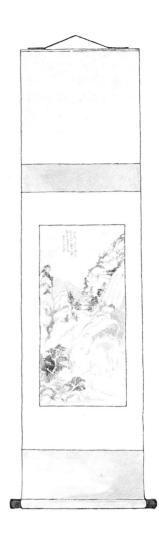

● THE HANGING SCROLL
The hanging scroll format was composed of a vertical painting which was backed with paper. All remaining areas of the mount were covered with sections of contrasting silks, which were often patterned. At the top of the scroll was a semi-circular rod, while at the bottom was a round dowel, around which the painting was rolled for storage.

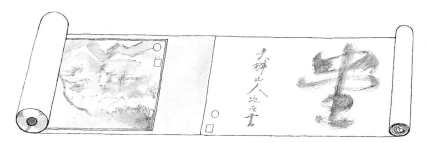

● THE HANDSCROLL

The handscroll format was made up of a horizontal painting, or a series of paintings and pieces of calligraphy, backed on to a silk mount. The scroll would be rolled up on a round dowel on the left-hand side, and secured at the right-hand end to a semi-circular rod. Thus the scroll would be unrolled to the right, and the contents viewed from right to left.

● *Below:* Japanese handscroll, ink and colour on paper, *c.* 1200. A section of the narrative handscroll *Jigoku zōshi* ('Hell scroll'), depicting the 'Hell of shrieking sounds'. It portrays Buddhist monks being subjected to punishment and torment for torturing animals on earth. A recurring feature of Japanese scrolls is the use of movement from left to right, while the scroll is unrolled from right to left.

through some sections and lingering over others. The format readily lent itself to a narrative subject, with the story unfolding over the length of the scroll, and there was also scope for depicting the passage of time and for transferring to a different location. This is well illustrated in the Japanese narrative handscrolls of the twelfth and thirteenth centuries which mostly relate and illustrate popular and classical literature, biographies, historical events and stories connected with the founding of shrines and temples.

For small studies and collectors' items, separate compositions were pasted into albums and, for this reason, are usually called album leaf paintings. They were mounted on stiff reinforced leaves which were joined at either side, along their vertical edges, producing a continuous concertina. Broadly speaking, artists of the Northern Song period (960–1126) favoured a monumental style of painting in which were depicted immense panoramic views well suited to the hanging scroll and, to a lesser extent, the handscroll. During the Southern Song period (1127–1279) a more intimate style developed which lent itself to a smaller format, such as the album leaf. It was probably not until the Yuan period (1279–1368), however, that paintings were produced specifically for mounting in an album. There were usually between six and ten

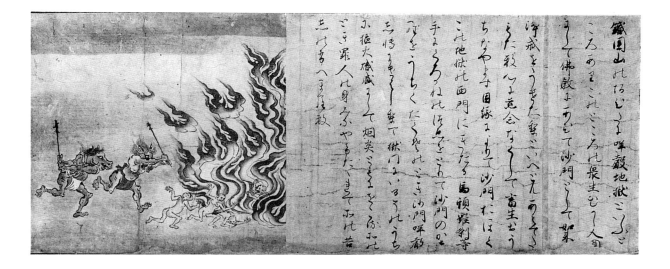

29

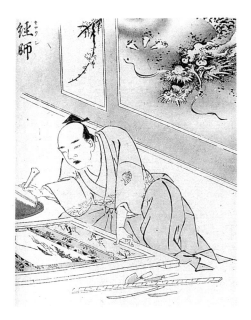

● *Left:* Japanese woodblock colour print, 1784. A mounter of paintings, from *Saiga shokunin burui* by Minkō. Having backed the painting with paper, the areas surrounding the painting were covered with strips of contrasting, figured silk.

of them on a particular or related theme, not necessarily executed by the same artist. Albums were also used for preserving the damaged fragments of larger paintings. These could be removed from their original mounts and, if necessary, reduced in size.

MOUNTING

The mounting of a scroll was a highly skilled process. It involved reinforcing a painting or piece of calligraphy by pasting it on to a backing paper.

As the paper was handmade, and therefore of a fixed size, it was usually necessary to paste several pieces together. Once the painting or calligraphy had been attached to this backing, the borders at each side were covered with silks, which were themselves backed with paper. The colour and design of these textiles depended on the painting itself, and also on the region: Japanese mounts are distinguishable from Chinese ones of the same date in colour, layout and the type of decorative silks that were used. Whether the mounts contrasted with the painting or blended harmoniously with it, they were considered an integral part of the whole. With the handscroll, an equal amount of silk was placed at the top and bottom of a painting, with a longer piece at the beginning. Similarly, the side mounts of a hanging scroll were of equal, narrow width, while there was either an equal amount above and below the painting or a greater amount at the top.

The mounter needed to take great care that the paste took account of extreme climatic conditions, that allowance was made for the different tensions between the various parts and materials,

and that curling, peeling and the growth of fungi were prevented. In addition, the quality of the materials and the way the painting was mounted had to be such that they could withstand repeated rolling and unrolling, and being stored rolled up for long periods. With the passage of time, however, a painting is likely to have been repaired and remounted, so that the mounts are not necessarily of the same date as the painting.

FANS

In the hot and humid parts of China and Japan fans were adopted as a necessary adjunct to male and female attire, and it became popular to paint fan leaves and present them to friends or patrons. The leaves were mounted on sticks as folding fans or, in the case of silk, were stretched over frames of a different shape, usually rectangular, or circular, as a rigid or screen fan. The folding fan was generally composed of two semi-circular leaves of silk or paper pressed into folds. Sticks of bamboo – usually between ten and thirty – were inserted between the leaves to form a support. Although the folding fan was introduced to China from Japan during the tenth century, it was not until the Ming period (1368–1644) that fan painting became a recognized branch of Chinese painting. Most of the leading artists of the time produced some paintings for fans, the format of the fan leaf being considered one of the most interesting (and challenging) with which to work.

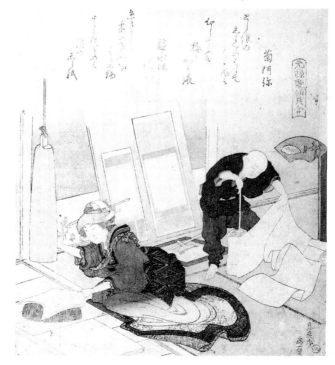

● *Right:* Japanese woodblock colour print by Hokusai (1760–1849), 1828. *Surimono* from a series of thirty-seven entitled *Genroku kasen kai awase* ('The Genroku (period) [1688–1704] poetry shell game'). This example shows a man and a woman involved in the various stages of mounting paintings. The woman is depicted with an elaborate dress so as to provide an additional feature of interest.

Because the folding fan was subject to much wear and tear, some of the most treasured leaves were removed from their sticks and mounted in albums. Others were so highly regarded from the first that they were mounted directly on to a scroll or album.

DOORS, SCREENS AND WALL PAINTINGS

Two types of painting which reached particular prominence in Japan were in the form of sliding doors and folding screens. Sliding doors were made in pairs, fours and so on, and were used to divide Japanese houses into different areas. Folding screens, on the other hand, served several purposes: they provided a decorative background to an important person, and so drew attention to him, or they were simply a decorative feature, the concertina shape breaking up the harsh angles of a room.

With both screens and sliding doors the artist was presented with a large surface broken up into equal sections. He took great delight in spreading the composition unevenly over the available space so that a complete folding door, or section of screen, might be purposely left almost empty, while the main elements of the design might be concentrated in another. In the case of sliding doors, however, the artist had to take into account the fact that one or more doors would be hidden behind another when they were opened, so that each one also had to stand as a satisfactory composition in its own right.

Wall paintings, which for the most part lie outside the scope of this book, occupied an important place in the early history of Chinese painting, particularly during the Han to the Tang periods. The paintings generally decorated interior walls of palaces and temples, or tomb walls, in accordance with the custom of providing the deceased with objects of great artistic beauty for the afterlife as well as with utilitarian objects. The most celebrated extant wall paintings are undoubtedly those which adorn the walls in great numbers at the Buddhist cave complex at Dunhuang, Gansu province, which date from the mid-fourth century.

● *Left:* Chinese fan painting, ink and colour on gold-flecked paper, late seventeenth or early eighteenth century. A painting for a folding fan which has been removed from its frame, though the fold lines are clearly visible. It depicts a landscape scene with two figures making their way across a bridge towards a building high in the mountains. To accommodate the fan format the composition has been made to follow an artificial curve, but without detracting from the effect. The folding fan was opened from left to right; it is interesting to note that the focal point of this composition is on the left-hand side, which would have been the last part of the design to be revealed.

● *Right:* Japanese screens painted in colours on a gold-leaf ground, by Kanō Chikanobu (1660–1728). A pair of six-fold screens depicting pheasants with flowers, trees, plants and water. Screens of the Momoyama (1568–1615) and early Edo (1615–1868) periods are characterized by the use of bright, contrasting colours.

artist had put brush to paper, it was almost impossible to make any changes. He had to have an impression of what he wanted to create before he started, and he had to let the composition unfold in a relatively spontaneous manner. It was, therefore, quite natural for a painter to depict a piece of scenery which did not actually exist, but which looked as though it should. The artist might be portraying a specific place, according to the title of his painting, but in fact it might bear little actual resemblance to that place.

Once it is recognized that the main aim of the painter was not to create a faithful reproduction of what he saw, the fact that scientific perspective was not used is easier to understand. Instead, the Chinese initiated other methods, which were to become standard in the Far East.

One of the basic principles that they employed was to depict nearer objects low down in the painting and further ones higher up, as well as paler and less distinct, with intermediate areas overlapping. The composition would be divided into three, representing the foreground, middle ground and background, to emphasize the sense of height and depth. These artificial divisions could be achieved by the appropriate disposition of rivers, mists and clouds, for example. Certain elements of the composition would also serve to draw the viewer's eye up or along the painting, such as winding paths, a bridge, a mountain hut or a figure strategically placed.

The painter Guo Xi defined three methods by which an artist

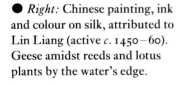

● *Right:* Chinese painting, ink and colour on silk, attributed to Lin Liang (active *c.* 1450–60). Geese amidst reeds and lotus plants by the water's edge.

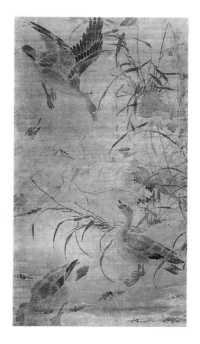

35

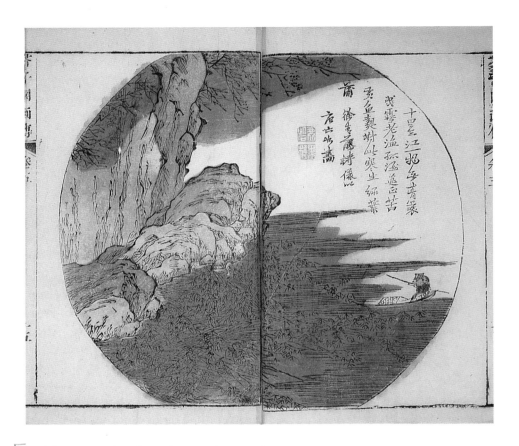

十里江邊多青襄
武霖老溢孤漁逐垂苦
黄色魚熱謝此褢生綠葉
蕭
徐象沒詩儀此
启六如畫

could convey depth and recession, and they apply almost universally to Chinese landscape painting. In the first of these, *jin yuan* ('near distance'), the viewer seems to look from a place in the foreground into the far distance, generally across a flat landscape. In *shen yuan* ('deep distance'), the viewer appears to be standing on a raised piece of ground in the foreground. From this vantage point he looks down and then up to the highest point of the picture. In *gao yuan* ('high distance'), the viewer seems to be looking from the bottom of the composition to the top, a device that readily lent itself to towering, imposing mountain scenes. The painter did not necessarily make use of either a fixed viewpoint or source of light; there could be several in one composition.

THE STATUS OF THE PAINTER

In China and other countries of the Far East the role of the painter, and also the patron and the collector, had a direct bearing on the development of painting. From an early date, in both China and Japan, there existed groups of painters who were paid in return for services. On the one hand were skilled craftsmen, who could turn their hand to most types of painting and who operated shops or studios. They produced paintings for the mass of the population

● *Above:* Chinese woodblock colour print, 1679–1701. Double-page spread from the *Jie zi yuan hua juan* ('he *Mustard Seed Garden painting manual*') by the artist Wang Gai, published in Nanjing in three volumes, the first in 1679, subsequently reissued with the second and third volumes in 1701, with numerous later editions. This book was intended primarily as a manual for painting, with sections on brushwork for the various elements of a painting (such as rocks, trees, bamboo and chrysanthemums), as well as entire compositions, complete with calligraphy and seals. This particular example shows a landscape with an overhanging cliff and a fisherman in a boat.

● *Right:* Japanese painting, gold and colour on gold-flecked paper, Tosa school, *c.* 1800. One of a series of five album leaves illustrating the life and pastimes of the court. Artists of the Tosa school relied heavily on native Japanese traditions of painting, known as *Yamato-e*, and, particularly, on painting conventions of the twelfth century. They combined bright colours offset by gold, which was used particularly for clouds that linked the various compositions. Tosa artists frequently portrayed scenes of court life, with the hair and facial features of the women depicted in a stylized manner. Interior scenes were generally seen from above, as though the roof of the building had been removed.

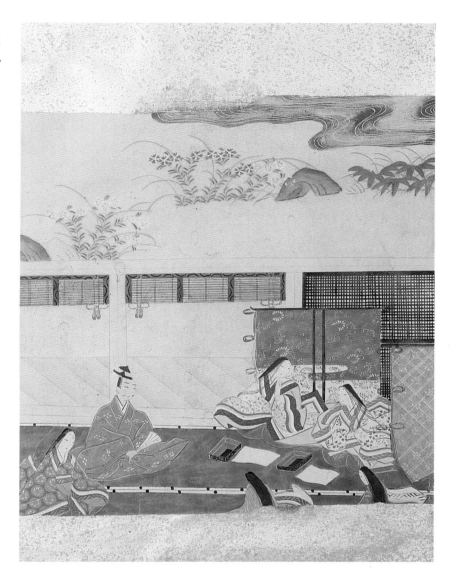

who could not afford to buy works by the leading artists of the day. This category included painters who were centred in workshops in and around Canton and who catered for the Western market during the eighteenth and nineteenth centuries. Painters such as Lamqua frequently produced portraits of foreigners from photographs.

On the other hand, there were groups of educated men of some social standing who devoted themselves to painting. On account of their talent, titles and posts were conferred on them at court and in official circles. The Tang painter Yan Liben held a succession of offices, including Senior Secretary of the Peerage Bureau, Grand Architect and President of the Board of Works; ultimately, in 668, he was appointed one of two State Ministers. In many instances, such posts were little more than sinecures, the real work being

carried out by the vast Chinese bureaucracy of officials and secretaries.

The importance of painting in imperial and official circles is epitomized by the Imperial Painting Academy in China, established by the Song emperor Hui zong. The exact function of the Academy remains somewhat obscure, but it sought to enlist as members the leading artists of the day, who worked in a style of painting that met with official approval. In this way it was able to establish and enforce certain standards and principles of painting. In Japan, too, the recognition of the Kanō and Tosa schools of painting by successive rulers established their artists as guardians of the 'official' style.

Apart from painters who received payment for their work, there were those who painted for pleasure. From the Ming period onwards, in particular, educated men considered that the ability to produce good calligraphy and painting was, together with an interest in literature, poetry and music, an essential accomplishment of the cultured man. It was partly for this group of painters

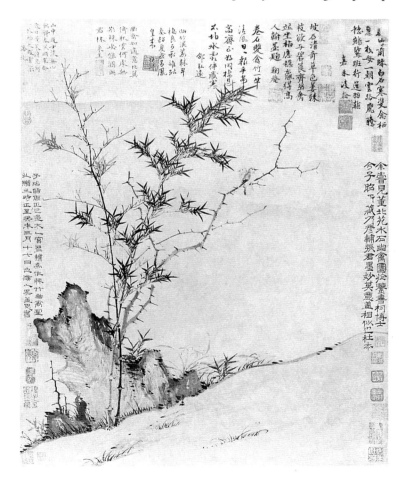

● *Left:* Chinese hanging scroll, ink on paper, by Zhang Yanfu (active during the first half of the fourteenth century), *c.* 1343. Birds, thorns and bamboo. From the Yuan period (1279–1368) onwards, it became increasingly popular to add inscriptions and poems to a painting. This painting was executed when friends visited the artist, who was a monk in a Daoist temple. It was painted for the artist Sheng Mou; another of the friends wrote an inscription describing the occasion, and others added poems.

(Peking) in the Forbidden City, probably the most important single group of Chinese paintings in the world.

The collector frequently added his own seal, together with some dedicatory colophon. Some paintings changed hands numerous times over the years, and might have 30 or more seals of collectors on them; a collector could even have a painting remounted to allow additional space for his comments. In so doing he may have actually changed the appearance of a painting and upset the delicate balance between blank space and elements of the composition, thereby interfering with the original intentions of the artist.

The custom of adding the collector's seal had the effect of authenticating a painting and increasing its status and material value. In Japan, Kanō Yasunobu, who was head of the main branch of the Kanō school of painting during the early Edo period, was considered a great connoisseur, and he added written authentications to numerous works by earlier Kanō artists.

FAMILIES OF PAINTERS AND SCHOOLS OF PAINTING

It was quite common in the Far East for a successful artist to be followed by a son or other close relative. The Song artist Ma Yuan was probably the best known in a line of painters which included his great-grandfather, Ma Fen, his grandfather, his father and his uncle, Ma Gongxian, the last two each being appointed Painter-in-Attendance to the Academy. Artistic talent may have run in a family for a few generations, but there was little attempt in China to establish formal schools of painters.

Amongst the various branches of arts and crafts in Japan, however, there emerged families of artists who carried on a tradition for years, the most notable in the sphere of painting being the Kanō and Tosa schools. A school generally comprised a head painter with students working under him. They adhered to a style of painting which became associated with the family name.

There were also schools of painting which took the name of the founder member, such as the Maruyama school of Maruyama Ōkyo. These consisted of a master and pupils who shared similar ideals, concepts and principles. Since it was shared ideals which held the school together, rather than close family ties and a rigid style of painting, the schools rarely lasted for more than a few generations. The continued existence of such schools depended on the most talented pupils, though some of them might establish separate branches of the school.

Despite changes of fashion and style, the work of past masters was highly regarded in China. Their paintings were considered to

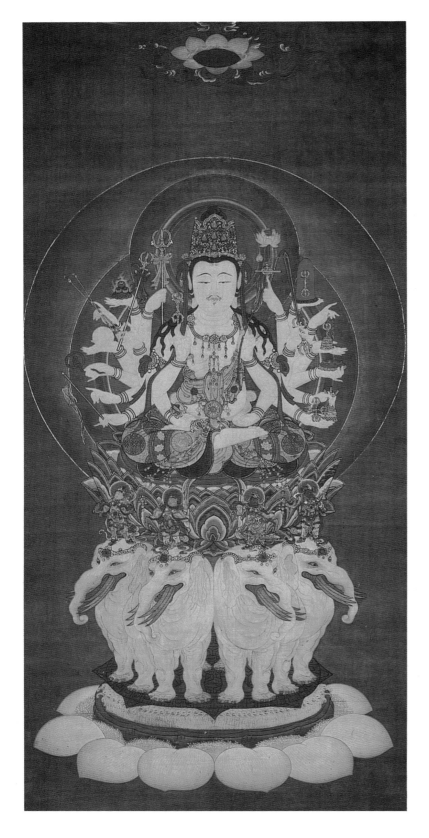

● *Left:* Japanese hanging scroll, colour and cut gold leaf on silk, second half of the fourteenth century. This depiction of Fugen Emmei, probably featured as the main object of worship at an Esoteric Buddhist service to help obtain prosperity, wisdom and longevity. Fugen is portrayed with twenty arms holding ritual implements, with five Buddhas in his headdress. His lotus throne is supported by four elephants, while the Wheel of the Law beneath is supported by hundreds of tiny elephants.

● *Right:* Detail of a Chinese wall painting from cave 285 at the Dunhuang cave temples, Gansu province, AD 538–539. Situated along the Silk Route in the extreme west of China, Dunhuang was the site of the first of many cave temple complexes in China, a tradition which was brought from India together with Buddhism. Since the stone was <u>not</u> suitable for carving, the inner surfaces of the cave walls were mostly painted. The soft stone was dressed with clay and finished with a layer of kaolin (china clay) mixed with chalk before the pigments were applied in a medium of gum, as in the tempera technique. This example shows Kumāra and Vināyaka with two *lokapālas* (guardian kings). Much of the painting at Dunhuang reveals a strong Central Asian and Indian influence.

embody the essence of tradition and, in order to become fully proficient in all aspects of painting, it was considered <u>necessary</u> to study and <u>copy</u> them. This is not to say that the aim was to produce an exact copy of what the artist saw, but to capture its spirit while, at the same time, attempting to master the complexities of brush technique. It is for this reason that a painting may bear the name of the artist and the words 'after ...' or 'in the style of ...', thereby acknowledging the painter who had inspired the work. <u>Only when</u> a painter had studied and fully mastered painting styles and techniques of the past was he competent to embark on <u>his own</u> creative path. It is also due to this practice that early paintings which have long since disappeared, are preserved in the form of later copies.

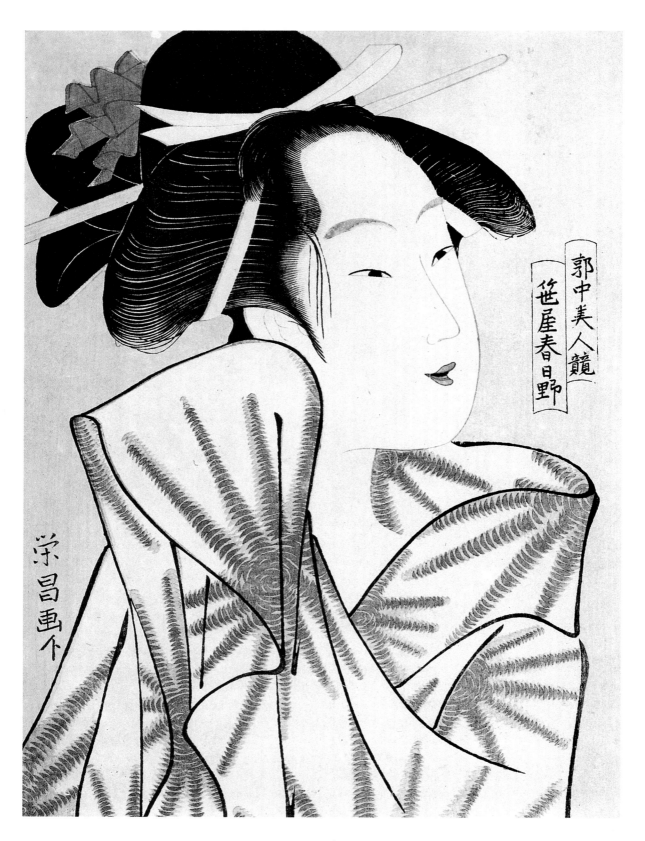

郭中美人競
笹屋春日野

栄昌画

46

Chapter 2
PRINTS AND PRINTED BOOKS

PRINTING, like papermaking, had its origins in China, and the two are closely connected. The earliest surviving printed 'book', the *Diamond sūtra*, dated 868, reveals a considerable degree of sophistication which reflects a long period of experimentation.

SEALS AND STONE RUBBINGS

Printing developed from the use of seals and the practice of taking stone rubbings. By the Han period (206 BC – AD 220) the imprint of a seal had become firmly established in educated circles as a guarantee of an individual's identity. Initially, the characters were cut into the body of the seal so that when they were inked and applied to a surface the characters appeared in white as the un-inked areas. Around the year 500, however, seals began to appear with the characters cut in relief. These were generally inked with vermilion, and they came out in red on a white ground. The gradual change from incising the characters in the body of the seal to cutting the characters in relief, which necessitated cutting them in reverse, was a vital step towards true block printing.

The text of the Confucian classics and, to a lesser extent, Daoist texts, were carved into stone to preserve them in their approved form and, by taking inked rubbings, they could be reproduced. This practice is known to have been carried out in China from at least the second century AD.

The process involved moistening a sheet of thin, strong paper, laying it on the stone and applying pressure by means of a stiff brush to force the paper into every depression of the surface. Once the paper had dried, a pad of silk or cotton dipped in sized ink was passed over it. The ink 'took' on those areas which were not carved; when the paper was peeled away, an exact copy of the inscription was revealed with the text in white on a black ground.

The process differed from block printing in that the characters of the inscription were carved into the stone surface, instead of in relief, and that ink was applied to the outer surface of the paper rather than between the stone and the paper.

Some stone blocks were carved specifically for the taking of rubbings, and whole texts were reproduced in this manner. The

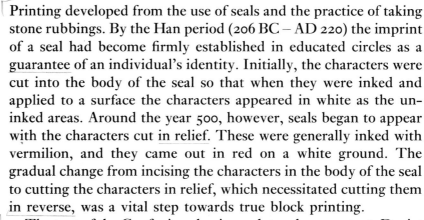

● *Above:* Japanese woodblock, *c.*1770. Detail of a woodblock from a book by Harunobu (died 1770), illustrating women beneath the text of a poem. The block has been carved leaving the lines of the design in relief.
● *Left:* Japanese woodblock colour print by Eishō (active 1785–1800), *c.*1795. The courtesan Kasugano of the Sasa-ya, having just emerged from a bath. One of the series *A comparison of beauties within the quarter* (i.e. the Yoshiwara, pleasure quarter of Edo). The robe illustrated here is an example of *shibori* tie-dyeing (see Chapter 7).

47

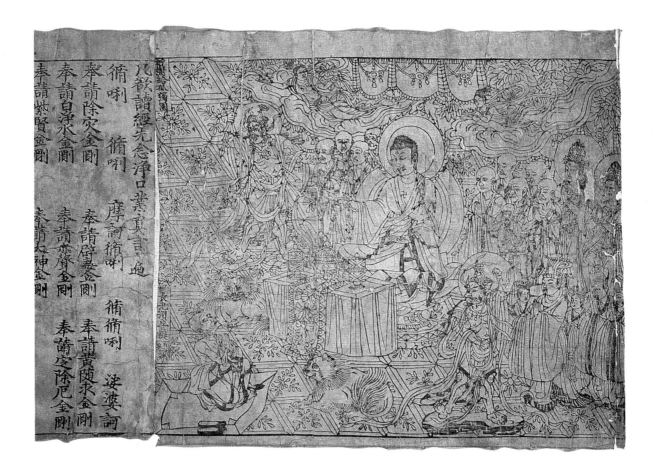

fact that ink rubbings continued to be made after the widespread introduction of printing indicates that they were regarded not simply as a means of duplicating a text, but also of capturing the beauty of the original calligraphy, in a manner pleasing to the eye. At a later date, in both China and Japan, there were books and prints in which the effect of the ink rubbings was produced by woodblock printing. A distinctive feature is that the areas of text or design show up as white against a black ground, with black ink predominating. The prints were made in much the same way as ink rubbings except that the design was cut into a wood rather than a stone block. In certain cases the surface of the wood was treated so that when it was rubbed it gave the appearance of stone.

The spread of Buddhism, and with it the need to duplicate Buddhist texts and pictures, was crucial to the development of printing. Paper, a prerequisite of printing, was also already available in China in sufficient quantities and at a price reasonable enough to make the whole process viable.

● *Above:* Chinese woodblock print, dated 868. Buddha, surrounded by his monks, preaching to a disciple: the frontispiece of the *Diamond sūtra*, the oldest surviving printed book – a scroll formed of sheets of text stuck on to a paper backing. The quality and sophistication of the image indicate that printing was already well established in China by this date. The *Diamond sūtra* was among the 1,500 texts and books discovered in 1900 by Sir Aurel Stein at Dunhuang in a manuscript chamber sealed during the tenth century.

48

WOODBLOCK PRINTING

True block printing is thought to have originated in China some time during the first half of the eighth century, and the method invented there has altered little over the years. The text or design to be printed was first drawn on thin, transparent paper by a skilled draughtsman or calligrapher. The wood used for the block needed to be of a smooth and even texture, yet sufficiently hard to take fine and intricate carving: jujube, pearwood and catalpa were most commonly used for this purpose. The block was first cut to the desired size and planed to make it flat and even. The surface of the block was then treated with size or paste, which not only left it smooth and soft, but also helped the paper with the design adhere to it. The paper was then placed face down on the surface of the block; the back of the paper was gently rubbed so that the characters could be seen through the thin paper, but in reverse. The engraver then cut away all areas of the wood not covered by the ink, which left the characters, still reversed, in relief. Small mistakes could be rectified by cutting away one or more of the characters and by replacing them with the correct ones. The actual process of printing was carried out by laying the paper on to the inked block and applying pressure by means of a dry brush.

● *Below:* Chinese woodblock, 1888. One of several blocks for provincial examination papers found in 1911 at Nanjing examination hall, Jiangsu province.

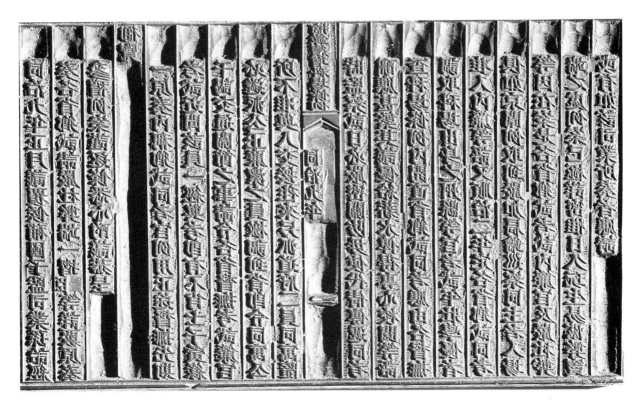

In the West, Chinese woodblock printing has frequently been overlooked in favour of that of Japan. This is partly because large numbers of so-called 'Japanese prints' reached the West after Japan was opened up to foreign intercourse from around 1860. Despite cultural differences, the prints were immediately appealing, and they had a fundamental and far-reaching effect on contemporary artists in the West, particularly the Impressionists. At that time there was great interest in the technical aspects of their manufacture. The Museum of Fine Arts, Boston, and the Victoria and Albert Museum, London, possess sets of tools and materials for woodblock printing which were assembled towards the end of the nineteenth century.

MOVABLE TYPE

The invention of movable type, traditionally ascribed to Bi Sheng between the years 1041 and 1049, was the direct result of experiments to improve printing methods. It involved the use of many thousands of individual characters which could be used in any order or combination. Since the characters consisted of individual blocks of identical size and depth, these could be fitted together in columns to produce a flat, even surface ready for inking. The impression was taken in the usual manner by laying the paper on the block and applying pressure with a brush.

The impact of this method of printing was not quite as revolutionary as it was in the West. The reason for this lies largely in the fact that the Chinese system of writing is made up of many thousands of individual characters rather than a finite alphabet. The invention of movable type in China, therefore, did not do away with the need to prepare large numbers of separate characters.

● **THE JAPANESE WOODBLOCK PRINT**
Stages in the preparation of a woodblock for printing.
1. Paper, with the design drawn on it in ink, was pasted face down on a prepared block. In order to make the drawing show through the paper clearly, the uppermost fibres of the paper were scraped or rubbed away; oil could be used to make the paper more transparent.
2. A knife was used to cut along the edges of the lines on either side so as to leave them standing in relief.
3. The areas of wood in between the lines were then removed with a chisel.
4. Ink was then applied to the raised areas of the block.
5. Paper was placed on the inked block and the *baren* was rubbed over it in a circular or zigzag motion.
6. This caused an impression to take on the paper.

Additional colour blocks could then be carved using the initial black-and-white print as the key block.

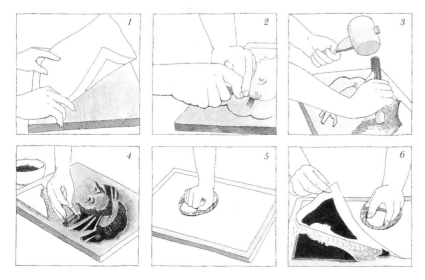

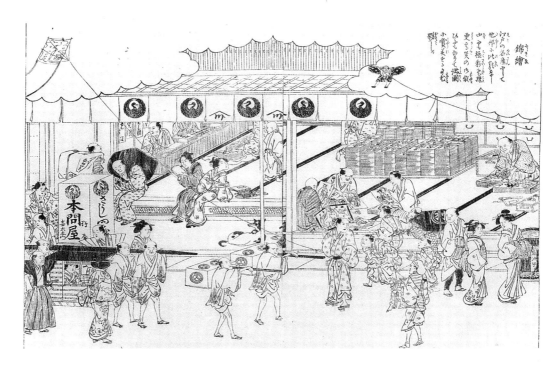

錦繪

● *Above:* Japanese woodblock
print, double-page book
illustration, by Settan (1778–
1843), *c.*1833. The publisher's
shop, Tsuruya, from the book
Famous views of Edo. In the
background are piles of prints for
sale, while in front are men
examining some of the latest
examples. To the left, two
women are perusing books.
Behind them is the accountant,
using his abacus. The lively scene
in the street outside includes a
boy who has entangled a passer-
by with the string of his kite.

Although they could be put away and used for subsequent printing,
there were problems of storage and of finding the right character
when it was needed.

JAPANESE PRINTS

The production of a woodblock print in Japan was the result of
teamwork and involved a publisher, designer, blockcutter and
printer. The role of the publisher was paramount, for it was
generally he who commissioned the various artists and craftsmen.
He owned the workshops where the blockcutters and printers
worked, and usually the sales outlets, too, the centres for the main
publishing houses being Edo, Kyoto and Osaka. Unless he were
approached to carry out a private commission, the success of a print
or book relied on the publisher's ability to make an appropriate
choice of subject, and to know and understand his market.

The first step was to commission an artist to produce a detailed
drawing in ink on paper. The artist usually supplied the necessary
calligraphy, though in exceptional cases this was carried out by a
calligrapher. The publisher then employed a draughtsman to
transfer the design on to thin and semi-transparent paper, *mino* and
gampi being the types of paper most widely used.

In Japan, wood deriving from the cherry tree was most favoured
for the block, though the choice of wood ultimately depended on
the intricacy of the design: the finer the detail, the harder the wood
needed to be. In all cases the wood needed to be soft enough to be

51

carved with ease and speed, yet hard enough to stand up to many printings. The seasoned wood was first cut into planks along the grain and planed until completely flat and smooth. The individual blocks were cut to correspond to the standard paper sizes and, for the sake of economy, were sufficiently thick for both sides to be cut and used as printing surfaces.

Paper with the design was pasted on to the block, face down, with a starch paste. In order to make the drawing show up clearly through the paper, the uppermost fibres of the paper were scraped away or rubbed gently with the fingers, while the application of oil helped to make the remaining paper more transparent. Next, the most skilled craftsman cut around all the lines of the design with a knife, which he held in his right hand and pushed along with his left. The areas of wood between the lines were then removed by means of chisels of different sizes. The great talent of the blockcutter lay in translating the flowing brush lines of the artist's original design into the hard and rigid wood. With the most successful, the end result was a print with a specific artistic character of its own while at the same time retaining the essence of a painting. Once the cutter had finished his work, a brush was used to remove any loose pieces of wood from the block, and it was washed and dried ready for the printer.

● *Below:* Japanese ink drawing by Hokusai (1760–1849), *c.*1839. The original drawing for No. 51 of the series *One hundred poems explained by the wet nurse*. It is executed on thin, semi-transparent paper so that, when pasted face down on the block, the uppermost fibres could be scraped or rubbed away, leaving the outlines of the design clearly visible. The block could then be cut from the lines of the drawing.

baren was applied with a zigzag or circular motion to those areas of the block which were left in relief. After each impression had been taken, the sheets were piled on top of each other ready for printing the next colour. Provided the paper had been moistened to an optimum level and the colour properly applied, there was no danger of the colour offsetting on to the back of the sheet above.

When a run of prints had been successfully completed, the blocks were either destroyed or stored for possible future use. In order to prevent warping, the blocks were framed on two sides. The first edition of a print usually ran to around 200 copies; Hiroshige's *Fifty three stations of the Tōkaidō* is reputed to have sold out in half a day. Subsequent editions generally made use of the same blocks, though in time these became worn, and also were likely to warp. Afterwards, the blocks could be sold to a different publisher, who might make slight changes to the colour scheme.

COLOUR PRINTING

The desire to achieve colour printing or, at least, to colour a printed design by hand, had followed shortly on the invention of printing itself. Colour printing first appeared in China at least as early as the twelfth century, though it was not widespread until the seventeenth century. It made possible the production of good-quality illustrations based on paintings at a reasonable price, as well as painting manuals such as the *Ten Bamboo Studio*, and the *Mustard Seed Garden painting manual*.

From around the mid-seventeenth century onwards printed albums by Moronobu began to appear which included instructions for colouring parts of the design. This practice spread soon to include individual sheet prints. By the late 1690s the publishers themselves were producing prints which had been hand coloured to their order, with orange-red predominating; green and yellow were later used for lesser areas of the design. Around 1715 the range of colours was extended to include a pink-red, while the colours were applied to the outlines with greater accuracy. Another innovation was the use of a black pigment mixed with glue, which resembled the lustre of lacquer, and fine brass powder or copper dust mixed with glue. In 1744 prints appeared with woodblock printing in two colours, green and pink, by such artists as Masanobu, Toyonobu and Shigemasa. Gradually more colours were added, culminating in the multi-coloured New Year prints of 1765. It was at this date that full colour printing from individual wooden blocks is thought to have become fully established.

Prior to the widespread use of aniline dyes, from the 1870s onwards, colour pigments were derived from vegetable and

● *Left:* Japanese woodblock print, *aizuri-e* (blue print, executed entirely in tones of blue) by Hokusai, *c.*1820. A wave and *chidori*, or sparrow-like plovers, from a series of birds, fish and flowers. The *chidori* inhabit beach areas and in poetry were referred to as the drops given off by waves. They were frequently seen flying in groups following a circular, wave-like movement. It is quite appropriate that this scene should have been portrayed in blue.

mineral sources. Black, white, red, yellow and blue were the five main colours; additional shades and colours were obtained by mixing different pigments together often, by an experienced printer, on the block itself. The colour was applied to the relevant colour block, where it was mixed with a rice paste. This served not only to fix the colour but also to increase its brilliancy. By wiping away some of the colour from the block before printing, it was possible to achieve gradations of a single colour from light to dark. Another special printing technique was 'blind printing.' This involved laying the paper on a dry block which produced an embossed effect when pressure was applied. Yet another technique produced an image printed entirely in tones of blue.

Since a different block was generally needed for each colour, some method to ensure accurate registration of colour was essential. In Japan this was achieved by a device known as the *kentō*, which was first used in 1644. A pair of marks was cut in relief on the key block: a right-angled mark in one of the lower corners and a straight line along the bottom towards the opposite corner. The marks were incorporated into each colour block so that, by lining up the paper with them, it was possible to ensure that the different areas of colour corresponded to the relevant parts of the design.

BOOKS AND ALBUMS

In the Far East printed material appeared in two basic forms: the individual sheet print and the book. Books were produced at all levels, from academic and scholarly biographies and histories to romantic fiction for mass consumption, as well as the illustrated book which was of universal appeal.

Since the type of paper most widely used for printing in China and Japan was thin and semi-transparent, printing showed through to the other side of the page of a book. The printer overcame this by printing two pages from a single block on one large sheet of paper, which was then folded down the middle so that the two outer faces had printing on them while the inner faces were left blank. The pages were collated with the folded, uncut edges of the sheets on the outside and the unfolded edges at the centre, taking into account that a book was traditionally opened from right to left. This meant that each page was of double thickness. These were stacked between two soft covers and sewn together with long vertical stitches at regular intervals down the side with the cut edges. There were usually four needle-holes, at each of which was a

● *Below:* Chinese woodblock-printed book, nineteenth century. A multi-volumed book, the volumes stacked one upon the other and contained within a hard casing which was folded round and secured with bone or ivory toggles. The individual volume shows the stitching on the spine with the characteristic four needle-holes.

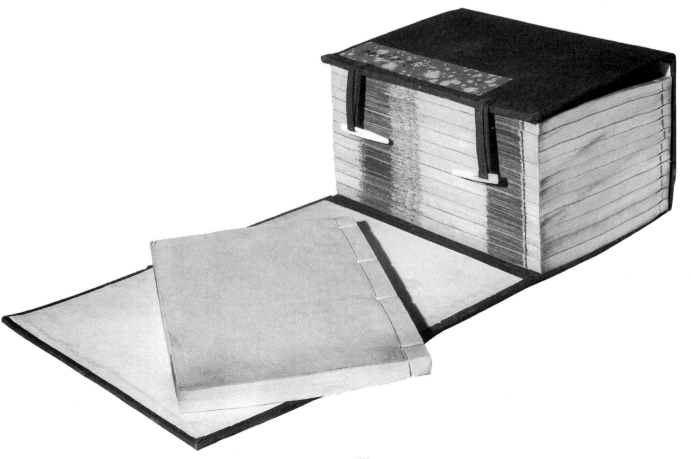

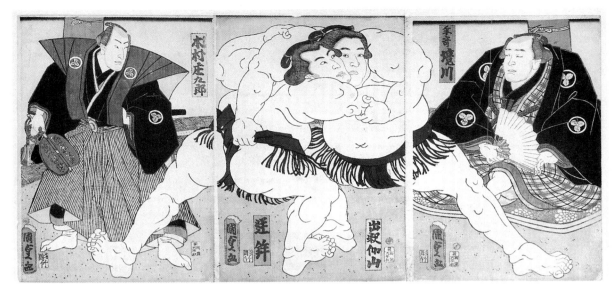

horizontal stitch round the spine of the book. When dealing with a text of considerable length, the pages could be bound in convenient sections. These were then piled on top of each other within a hard outer casing, which was folded round and secured with bone or ivory toggles. The materials acted together to make the book strong and at the same time flexible: when the book was opened on a flat surface, the pages gently curved back and stayed open.

In Japan, the seventeenth century saw the rise in popularity of the illustrated book, which often had very limited text. In the course of time it became customary for the picture on each page to be framed by a continuous border, which made it easier to align the sheets for printing and for sewing the pages together. This last was done in such a way that, when the pages were lying open, the two innermost frame-edges were deliberately left slightly apart, thus creating a physical 'break' between the two facing pages. Before long the artist with an eye for compositional effects began to spread his design over two facing pages, making the central break an interesting and integral part of the design. The devices used by artists to draw the viewer's eye from one page to the next were numerous. They include examples of a flowering branch spreading over the two pages, birds in flight, two figures addressing each other over the central break and a figure split in two vertically down his body.

Albums were made up of individual horizontal sheets, printed from a single block, which were folded down the middle with the design facing inwards. The sheets were joined together so that the back of each left-hand edge was attached to the back of the right-hand edge of the following sheet to form a concertina; the sheets at either end were attached to a cover. The album was intended to be

● *Above:* Japanese woodblock colour print in triptych form by Kunisada, *c.*1862. A *sumō* wrestling match, with the two contestants locked in combat. Notice the successful portrayal of the bulk of the bodies, complete with rippling muscles. Although each sheet stands in its own right, the overall composition is cleverly designed so that certain elements lead the viewer's eye on to the next sheet.

viewed <u>one sheet at a time</u> rather than fully opened out.

The album required good-quality paper, which could withstand the strain put on it where the sheets were pasted together. This, in turn, necessitated greater pressure from the block during printing. Since this tended to wear out the block, the print run of an album was generally <u>smaller</u> than that of a book.

SHEET PRINTS

'Ukiyo-e' was a Buddhist term, the meaning of which <u>changed</u> during the seventeenth century, when it came to indicate 'the floating world': that is, a buoyant world of pleasure and of changing fashions. It was applied to woodblock prints of the Edo period (1615–1868), many of which reflect a life of pleasure and enjoyment, and has become synonymous with what in the West is referred to as the 'Japanese print'.

In Japan, the individual sheet prints appeared in a number of different sizes, the most common measuring approximately 38 by 25 centimetres. The artist, in conjunction with the publisher, chose the size that was most suited to his design. Apart from the single sheet, artists produced designs which spread over two or more sheets as diptychs, triptychs and so on. Although <u>each</u> sheet was a

● *Below:* Japanese woodblock colour print by Hokusai, 1823–29. One from the series *Thirty-six views of Mount Fuji*, showing Mount Fuji and lightning. This is probably one of the best known of all Japanese Ukiyo-e prints.

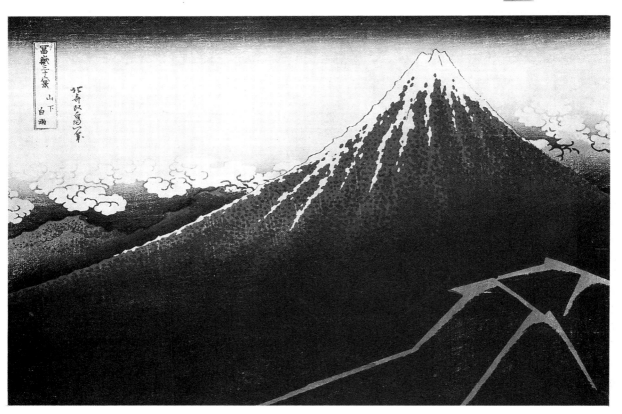

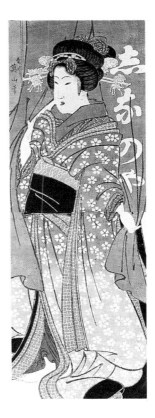

balanced composition in its own right, together they formed part of a continuous scene and were intended to be viewed as a whole. Series of prints, which were based on a common theme or subject, were also produced, most notably Hokusai's *Thirty-six views of Mount Fuji* and Hiroshige's *Fifty-three stations of the Tōkaidō*. The latter was a personal pictorial record of the 53 post-towns and resting places along the highway between Edo and Kyoto; the series actually comprised 55 prints, for it included views of the beginning and end of the route at these two centres.

The size of the individual print was also frequently dictated by its function. The tall, narrow format of the pillar print, for example, was designed to be displayed on the pillars of a house. Others were designed to imitate the painted hanging scroll, complete with its silk mounts. Fan prints, which were designed either for the folding fan or the rounded fan, were a cheap and fashionable substitute for the painted fan leaf. The fan shape was printed from a block of standard size and was subsequently cut out

● *Above:* Japanese woodblock colour print by Eizan (1787–1867), *c.*1825. A print imitating the form of a hanging scroll painting, or *kakemono-e*.
● *Above, left:* Japanese woodblock colour print, *surimono*, by Shunman (1757–1820), *c.*1790. The embossed effect used for the flowers was produced by blind printing.
● *Opposite, left:* Japanese woodblock colour print by Eisui (active 1789–1801), *c.*1790. Pillar print, *hashira-e*, designed to be displayed on the pillars of a house.
● *Opposite, right:* Japanese woodblock colour print by Hiroshige (1797–1858), *c.*1840. Fan print, intended to be cut out and pasted to the ribs of a rigid fan.

● *Opposite:* Japanese woodblock colour print by Sharaku (active late eighteenth century), 1794. Actor print showing Ichikawa Komazō II as Kameya Chūbei and Nakayama Tomisaburō as the courtesan Umegawa, based on a well-known story. The facial expressions and grimaces are <u>characteristic</u> portrayals of actors. The umbrella is cleverly positioned to unify the composition.

● *Right:* Japanese woodblock colour print by Toyokuni (1769–1825), *c.* 1807. The actor Ichikawa Danjurō VII in the type of role known as *shibaraku* ('wait a minute'), after the cry of the actor, with its characteristic face make-up and costume. The print represents the debut of this actor as a serious performer; he was one of many in a long line of actors from one of the great acting families, the Ichikawa.

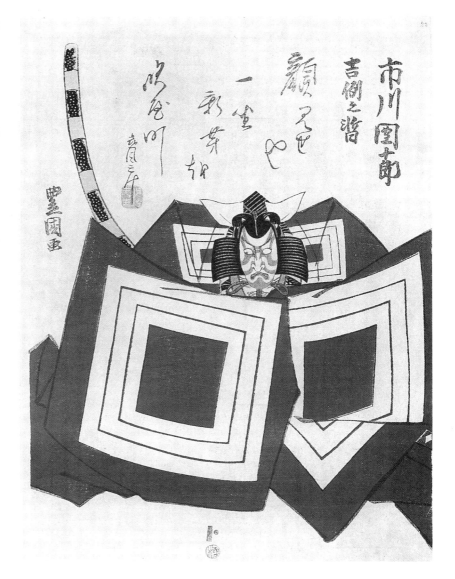

indulge their pleasures. Numerous establishments emerged which were concerned with enjoyment and entertainment, such as the Kabuki theatre, *sumō* wrestling halls, eating houses, licensed brothels and so on; Edo, the capital, had a special quarter, the Yoshiwara, devoted to such pursuits. It is <u>this</u> lifestyle, above all, which is reflected in contemporary Japanese prints.

By the seventeenth century Kabuki had become firmly established in Japan as the popular theatre. Great acting families, such as the Ichikawa, came to be associated with it, and leading actors of the day were the subject of much adulation. During the early history of Ukiyo-e prints the woodblock medium was used to provide people with prints of theatrical subjects, including

portraits of favourite actors in their latest roles. The actors were frequently portrayed in an exaggerated pose with their eyes crossed in a particular grimace. Because men also played the female roles, the portrayal of women was somewhat masculine. Of the many artists who specialized in the subject of the theatre, Toyokuni, Kunisada and (above all) Sharaku deserve mention.

Beautiful women constitute one of the most enduring subjects. All classes of female appear in Japanese prints, from the prostitute to the respectable woman. Subject matter for such prints runs the full gamut of women's lives, from compositions showing explicit sexual activity to scenes of self-improvement, such as practising calligraphy. In addition, they are concerned with the illustration of high fashion, with considerable attention paid to hairstyles, and the style and design of the kimono. Nowhere are these better seen than in the prints of Utamaro and Eishi.

Although landscape scenes, birds and flowers, animals and insects, were all important categories of painting in the Far East, they did not appear in Ukiyo-e prints in significant numbers until after the 1820s. Artists who specialized in this field included Hokusai and Hiroshige. Then, with the Tempō reforms of 1842, when prints depicting actors and prostitutes were banned (for a while) artists sought alternative subjects. This encouraged the production of landscape and associated scenes, and also the depiction of myths and legends, heroes, famous battles and warriors.

In China, the popular print tradition is best represented by its own types of New Year print. These usually portrayed subjects of an auspicious nature, often, but not always directly, connected with the New Year, and various deities and divinities such as the gods of wealth and longevity. The prints were made from a black key block,

● *Below:* Japanese woodblock colour print in triptych form by Kuniyoshi (1797–1861), *c.*1844. Takiyasha the witch, on the left, summoning the skeleton spectre to frighten Mitsukuni. The contrast between the left-hand sheet and the other two is particularly striking.

● *Opposite, above:* Japanese woodblock colour print by Utamaro (1753–1806), *c.*1788. From the album *The poem of the pillow.* Erotic prints, known as *shunga* ('spring pictures'), formed a considerable part of the output of many Ukiyo-e print artists.

● *Opposite, below:* Japanese woodblock colour print by Hokusai, 1827–30. The Yatsuhashi ('eight fold bridge') in Mikawa province, one of the series *Unusual views of famous bridges in the provinces.* This bridge inspired many artists over the centuries.

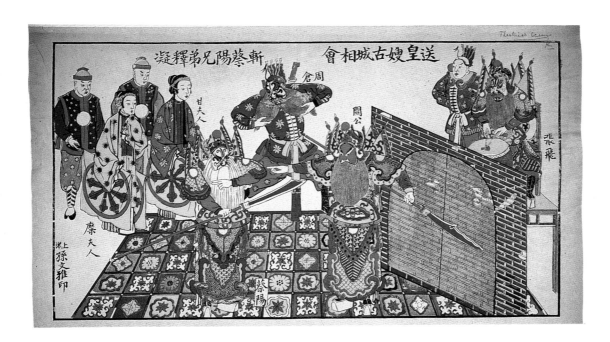

Theatrical Scene

● *Above:* Chinese woodblock colour print, late nineteenth or early twentieth century. A scene from Chinese opera based on the history of the Three Kingdoms period (AD 220–280). Guan yu (in the centre with a red face) and Zhang Fei (behind the gate), two of Liu Bei's generals, were accompanying two of his wives when they were captured by Cao Cao. Here they are seen arriving at the city gates of the capital. The mask-like faces of the actors are characteristic of Chinese opera.

was credited with its success or otherwise. The majority had studied painting under one or more of the different schools of painting; in time they established their own studios, often with schools of their own, though they generally remained outside the mainstream of Japanese painting. The artist may have worked for different publishers or he may have been under contract to one. Sharaku, for example, is thought to have worked exclusively for Tsutaya Jūsaburō, one of the most successful publishers of his time.

The typical Japanese print provides information which is of enormous value to the scholar and collector. The artist's signature, the date, title, series title and number in the series, the publisher's seal, and possibly even that of the printer, might be included; it was also common to find the censor's seal, for printed matter was subject to official scrutiny. Prose or poetry relating to the subject matter would also appear on the print which, as in the case of painting, formed an integral part of the design.

Despite the immense popularity of the woodblock print in Japan during the Edo period, it has until comparatively recently received scant attention by Japanese art historians. From around the 1860s large numbers of prints made their way to Europe via Dutch traders at Nagasaki. The subsequent impact on Western art was profound, and important collections were built up. In the West the popularity of Japanese prints has remained high, and some still command high prices today in the commercial world. What is, perhaps, most encouraging is that in the twentieth century the art of woodblock printing is still very much alive in China and Japan.

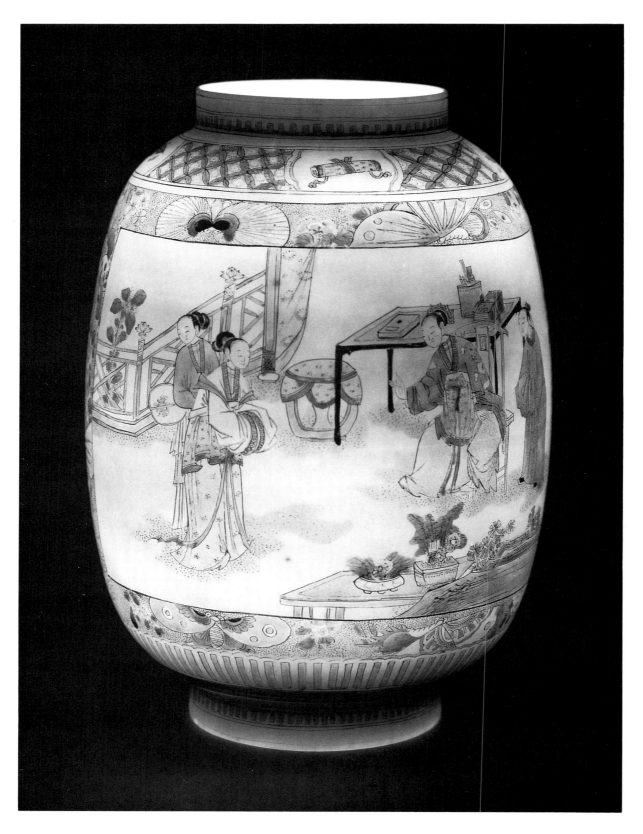

Chapter 3

CERAMICS

THE forming of vessels out of clay is a skill that appears early in the cultural development of most regions of the world. In the Far East pottery has been found from around 10000 BC and the finely potted vessels with sophisticated decoration dating to the fifth millennium BC are part of a continuous artistic tradition that stretches from the Neolithic period (*c*. 7000–*c*. 1600 BC) to the present day. The number of technological innovations that are seen for the first time in the Far East, particularly in China, is remarkable, as is the variety of ceramic wares, shapes and decoration from this part of the world.

Chinese ceramics, especially porcelain objects, have been admired and collected in Europe for centuries, and it is not insignificant that the word 'china' has been taken into the English language as a generic term. The earliest recorded item of Chinese porcelain in Europe dates to the fourteenth century. The European precious-metal mounts applied to Chinese porcelains in the succeeding centuries are indicative of the esteem in which such objects were held in the West.

Ceramics have also been highly valued in the Far East. Collected, handed down from generation to generation, depicted in paintings and their qualities extolled in poetry, they have ranged from the simple, purely utilitarian earthenware bowl to the outrageous and impractically elaborate porcelain ornament. This wide range of products has been achieved by continuous experimentation with materials, technology and design.

CLAY BODIES

Although refining and mixing may produce different characteristics in clay bodies (used to form ceramic objects), it is the basic geology of an area that determines what kinds of clay and minerals are available to the potter. In the Far East many varieties of clay have been found and used to produce a considerable number of different body materials.

As early as the fifth to fourth millennium BC the Neolithic potters of the Yangshao culture in north-west China were producing a fine-grained, buff earthenware from the fine clay of

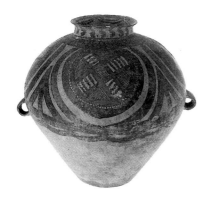

● *Above*: Chinese buff earthenware urn, Yangshao Neolithic period, third millennium BC. This urn from the Yangshao culture has been made by the coiling method and painted with unfired earth pigments.

● *Left*: Chinese lantern decorated in *famille verte* enamels (shown lit from the inside), Qing period, Kang xi, (1662–1722), early eighteenth century. An ornamental balustrade has been used in the background to indicate recession, A Scholar's Table with writing implements is shown on the left.

the area, while a little later the craftsmen of the Longshan Neolithic culture to the east were producing an equally fine-grained earthenware that was almost black in colour. In the early Bronze Age the Shang period (*c.* 1600–1027 BC) produced a pure white earthenware from clay found in conjunction with the coal deposits of the region.

Earthenware is pottery made of clay that remains unfused after firing and is therefore porous. It is usually fired at temperatures between 800°C and 1000°C. It can be made impermeable by glazing (see p. 76), but if the pot is to be fired only once the glaze must be of a similar low-firing type.

Stonewares, which appeared in the Bronze Age, are harder, stronger and generally heavier than earthenwares. The clays used for these wares can be fired at between about 1200°C and 1300°C, and they fuse to produce an impermeable body with a low porosity. In the Far East, stonewares were usually at least partially glazed, using a glaze type that matured at the same temperature as the clay body to form a combined body-glaze layer.

Unlike earthenware and stoneware, which are both found with a wide range of body colours, porcelain is generally white. The name 'porcelain' is traditionally supposed to have been the invention of Marco Polo in the thirteenth century, deriving from *porcelino* – a white, translucent cowrie shell shaped somewhat like a little pig. Porcelain is non-porous, vitrified (glass-like) and usually translucent, and it is normally fired at around 1300°C. It is generally glazed, and the body and glaze mature together to form a thick body-glaze layer which gives considerable strength to the material. Pieces that have been thrown on a wheel give a clear bell-like ring when they are struck.

The porcelain bodies in north China were somewhat different from the porcelain bodies from the southern kilns. The northern wares were rich in china clay – known in Europe as kaolin and named after Gaoling hill north-east of the town of Jingdezhen in Jiangxi province. The southern bodies frequently had very little clay in them and were made mainly from a refined, felspathic material which in the West is called china stone, and which in China is often called *baidunzi*, 'little white bricks', from the form in which the pulverized stone was delivered to the potters.

The above describes so-called 'hard-paste' porcelain, but 'soft-paste' porcelain was also made in China. This was rather different from the soft-paste porcelain produced in Europe. The Chinese material is rarely translucent, rather creamy in colour, very hard and brittle, light in weight and more porous than ordinary porcelain. Its glaze is often crackled with a slightly uneven surface.

● *Right:* Japanese Arita porcelain hexagonal bottle, with underglaze blue decoration, *c.* 1700. The neck of this Arita bottle has been cut down and fitted with a Dutch silver mount which probably dates to the nineteenth century. The bottle stands on three small feet.

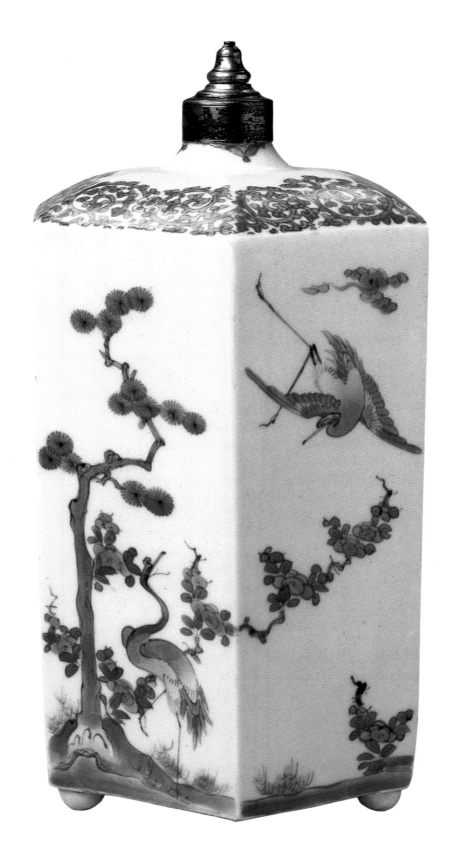

71

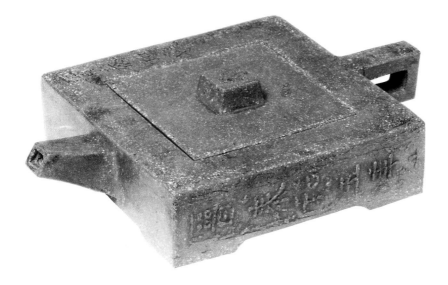

● *Left :* Chinese Yixing stoneware teapot in the shape of a brick, early nineteenth century. Everyday objects, as well as fruit, flowers and vegetables, frequently provide the inspiration for the shapes of teapots made at the Yixing kilns.

The ground-up material that was mixed with the normal porcelain body, or used alone, to produce soft-paste, is called *huashi*, 'slippery stone', and was similar in chemical composition to kaolin.

METHODS OF FORMING THE CLAY

The simplest method of forming a vessel out of clay is to hold a lump of clay in one hand while using the other hand to make a hollow in it, and this method was no doubt employed by the earliest pottery makers in the Far East. However, in the Neolithic cultures of Yangshao in China and Jōmon in Japan, and also in Korea, more sophisticated techniques were employed.

On early wares a paddle or beater was used to draw up the clay and achieve the desired thickness. Because of its physical properties, the shaping of the clay always requires the application of pressure to squeeze the plate-like particles and the water between them so that the mass takes on (and holds) a different shape.

The large bulbous earthenware urns of the Yangshao Neolithic period in China were made by the coiling method. The clay was rolled into a long sausage and then coiled (standing on a mat of woven fabric for ease of turning) into the shape of the pot. The inside and outside of the vessel were smoothed using a rib as the pot was built so that it is very difficult to see the method of construction with the naked eye. The Yangshao pots were then burnished before being painted with earth pigments.

Another quite early method that has remained popular for certain types of ware – its application can still be seen in use today at the 'purple sand' potteries at Yixing in Jiangsu province – is slab moulding. Here the clay is made into slabs of even thickness, which

are then cut to size and, if necessary, bent to the required shape before being luted together (stuck, using a sloppy clay and water mixture) to produce a finished vessel shape. The method is particularly suitable for cylindrical shapes, and also the square- and rectangular-sectioned shapes so favoured by the Japanese.

Hand modelling was used to produce a number of quite different effects. From the sixteenth century onwards in a number of areas in Japan skilfully modelled cups, boxes and jars were produced for specific use in the tea ceremony (see p. 102), and these were especially appreciated for their natural, slightly irregular shapes. Modelling was also used on a number of wares in China to produce elaborate relief decoration, such as the dragons and tigers that disport themselves around the shoulders of funerary jars made at the Longquan kilns in the Song period (960–1279).

Perhaps the most important innovation in the production of ceramic vessels was the use of the wheel, which appeared in China as early as the Longshan Neolithic culture. The heavy circular slab, rotating horizontally on a central axis, could be turned by foot, stick or a variety of other means, allowing the potter to force the clay down on to the centre of the spinning wheel and then draw up an evenly shaped clay vessel. The method was ideal for cups, bowls, jars and many other basically circular shapes. Some shapes with a more complex vertical profile could not be thrown in one piece but had to be thrown in sections and the sections luted together.

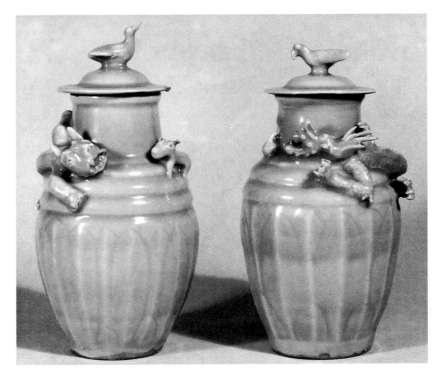

● *Right :* Chinese Longquan celadon funerary jars, thirteenth or fourteenth century. These jars have freely modelled creatures applied to their shoulders. On one is the dragon, which represents the East; and on the other is the tiger, representing the West.

73

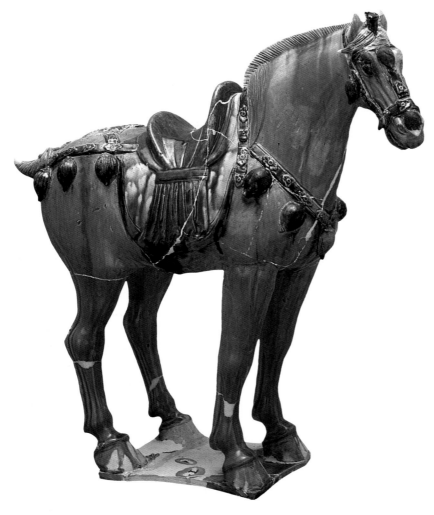

● *Left :* Chinese earthenware model of a horse, with *sancai* glaze, Tang period (AD 618– 907), eighth century. The trappings of this horse have been sprig-moulded and applied. Their style reflects the influence of Sassanian Persia.

● *Below :* Fragments of a Chinese earthenware model of a horse, with *sancai* glaze, Tang period, eighth century. It is possible to see from these fragments the way in which the clay was pressed into the moulds using the fingers, and the way in which the moulded sections were luted together with a plug of clay on the inside to provide added strength.

The practice of luting sections together was also used for the more complex moulded forms. Animals, such as the famous horses and camels of the Tang period (AD 618–907), would be moulded in a number of pieces, then luted together and the joins strengthened using plugs of clay on the inside in those areas that would take the greatest strain. To produce the moulded sections a slab of clay would be placed inside the pottery mould and then pressed in using the fingertips. The method was also suitable for producing complex shapes in vessels, and for figures.

Foliated shapes could be produced by hand, but were more easily made using a twin mould, which ensured not only a regularity of shaping but also a uniformity of body thickness. In this method an inside and an outside mould were made, the difference in their size producing the thickness of the vessel. A slab, or bat, of clay was placed between them, then the excess clay

Right : Chinese Ding ware bowl, Northern Song period (960–1126), twelfth century. The decoration on the inside of this bowl was produced using a mould. The piece has been fired upside-down (*fushao*) and the unglazed mouth rim has been bound with a copper alloy band.

squeezed out and the edges trimmed. A further tidying up, or fettling, was usually required before the item was glazed or fired to remove any ridges produced by the mould joins.

Another method used to ensure that shapes were of even thickness and standard size was the fast wheel and template. A form for the inside of a pot would be fixed in place in the centre of the wheel using a lump of clay. A bat of clay would then be put over the form and the wheel started spinning. A template having the required profile for the outside of the vessel would be held at a fixed distance from the wheel to shave the clay to the desired thickness and shape. The same principle, using a knife instead of a template, was used for finishing the footrims of bowls or cups.

KILNS

The earliest properly constructed kilns known to have been used in the Far East are basic up-draught kilns such as those found at the Yangshao Neolithic site of Banpo, in Shaanxi province, dating to the fifth to fourth millennium BC. The kiln chamber was cut into the earth and the area where the fire was lit was positioned a little lower and to one side of the perforated shelf on which the pots stood. The heat escaped through a hole in the domed top of the kiln.

Thereafter a number of different kiln types were developed and used in the Far East for various wares. The aim was to achieve greater control over temperature and kiln atmosphere, and in some cases to allow a large number of pieces to be fired at one time. Probably the three most significant kiln types were the *mantou* ('bread-bun shaped') or 'horse-shoe' kiln, the 'dragon' kiln and the 'egg-shaped' kiln.

The *mantou* kiln was a down-draught type, drawing the hot gases down through the wares, and was widespread in north China by the Song period. It could reach the high temperatures required, but

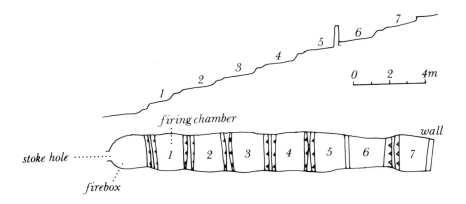

firing chamber

stoke hole

firebox

wall

1 2 3 4 5 6 7

0 2 4m

● *Left*: Cross-section (above) and ground plan (below) of a climbing-kiln of the sixteenth to early nineteenth century at Kitahata, Saga Prefecture, Japan.

● CERAMIC SHAPES
(1) *kundika*; (2) double-gourd flask; (3) moon flask; (4) mallet vase; (5) monk's cap jug; (6) sunflower bowl; (7) bulb bowl; (8) *boshan lu* jar; (9) double-gourd vase; (10) garlic-mouth vase; (11) rouleau vase; (12) baluster vase; (13) pear-shaped vase; (14) arrow vase; (15) brush rest; (16) *kendi*; (17) *meiping* vase; (18) stem cup; (19) leys jar; (20) pear-shaped ewer.

had a relatively small firing chamber. The dragon kiln was effectively a cross-draught kiln, using the natural rise of the hill for a long chamber or series of interconnecting chambers. Some of these could fire more than 20,000 items at a time. This type was used in south-east China for celadon wares, and in Japan for such wares as the Oribe ceramics of the late sixteenth and early seventeenth centuries. The so-called 'split-bamboo' kilns in Korea were also of this climbing-kiln type. The egg-shaped kiln was developed at Jingdezhen for porcelain wares and had the advantages of minimizing heat-loss (thus reducing firing time and saving fuel) and of having different conditions in various areas of the kiln which allowed a variety of wares to be fired at the same time.

High-quality wares were frequently fired in saggars (fireclay boxes) to protect them from kiln debris and allow more even atmospheric conditions around the pot.

GLAZES

The most obvious reason for giving a glaze to a ceramic object is to improve its appearance. A glaze can provide an attractive colour or combination of colours; it can give a pleasing glossy or matt surface; it can provide a good surface on which to apply further decoration; and it can mask imperfections. A glaze can also have practical uses. It can be used to make a porous pot impermeable, not only so that it will hold liquid but also, if applied to the inside of an eating- or drinking-vessel, so that the pot is easier to keep clean.

The first glazing effects were (no doubt) accidental and resulted from the ash from the kiln fire flying about and landing on the shoulders of the vessels. In the heat of the kiln this ash would have combined with elements in the clay body to form a glaze. Even after glazes were deliberately applied, their use was often restricted to the upper part of the vessel, highlighting the decoration already concentrated in this area.

76

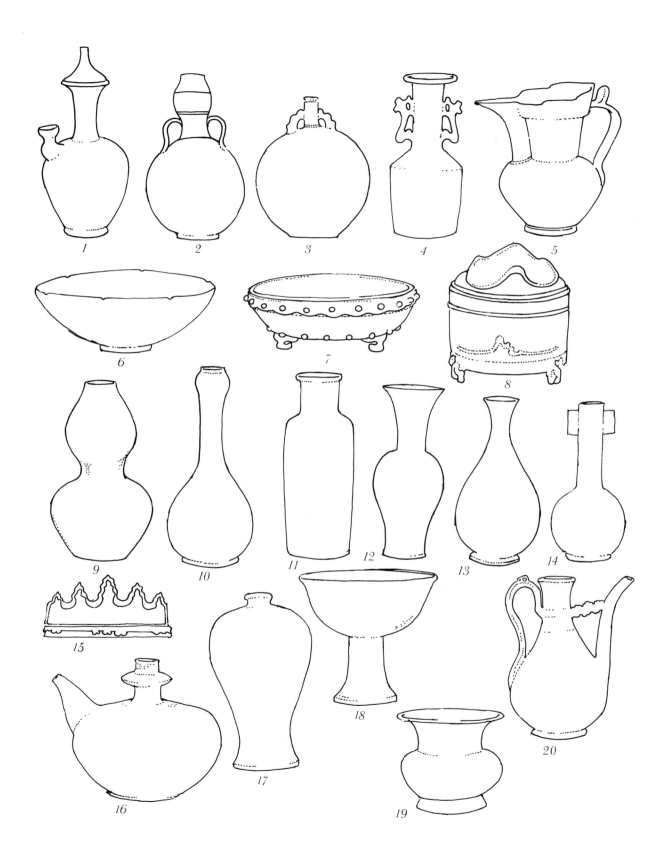

The basic composition of glazes was similar to that of the clay bodies, the major constituents being silica and alumina. In order to make a glaze melt at an appropriate temperature, a flux <u>had to be</u> added, and on low-fired wares this was often lead oxide. The other oxides used to colour the glaze often produced particularly clear, bright colours in a lead glaze, but such a glaze could only be fired at a <u>low</u> temperature. If it was to be used on a high-fired ware, the glaze had to be applied after the first firing and the object fired again at a lower temperature. A further disadvantage in the Han period (206 BC – AD 220) was that lead was used in its raw, highly poisonous state, with a resulting <u>high</u> death rate among the potters.

● *Left :* Chinese earthenware *boshan lu* jar and cover, lead-glazed, Han period (206 BC–AD 220). The decoration on both the lid and base of this jar has been produced using moulds. The original bright green of the glaze has been reduced to silvery iridescence by degradation during burial.

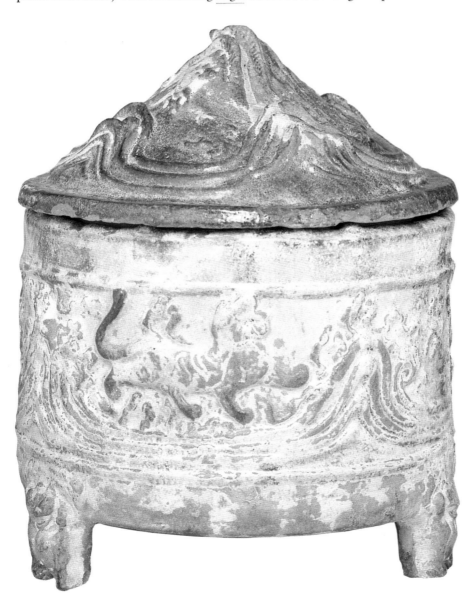

Right : Chinese porcellaneous stoneware wine jar, Ming period (1368–1644), late fifteenth century. The brilliant turquoise is achieved by using copper oxide in an alkaline glaze. The inscription may be translated as 'Sent for use in the Palace'.

In order to apply a glaze to a high-fired ware <u>without</u> the necessity of twice firing, different fluxes such as soda, potash or lime were used in the glaze. It was then possible to produce glazes suitable for a single firing on stonewares and porcelains.

The colour of a glaze is determined by the colouring oxide added to it, whether it is a lead or an alkaline glaze and what kind of atmosphere it is fired in. The two most important colouring oxides used in the Far East were iron oxide and copper oxide. Copper could produce <u>green</u> in a lead glaze and <u>turquoise</u> in an alkaline glaze, while if it was fired in a reducing atmosphere it could produce <u>red</u>. A <u>reducing</u> atmosphere is one in which the air flow is restricted and the carbon monoxide in the kiln combines with the oxygen in the glaze or body material to produce carbon dioxide. This reduces the amount of oxygen in the glaze or body and different-coloured oxides are produced. An <u>oxidizing</u> atmosphere is one in which plenty of air is allowed through the kiln and the surplus oxygen combines with the glaze or body material to produce oxides with higher percentages of oxygen.

Many of the white porcelains of the Far East (the most notable <u>exceptions</u> being those made at Dehua) were fired in a reducing atmosphere and as a consequence tend to have a rather <u>bluish</u> tinge, due in part to the natural occurrence of iron in the raw materials. But perhaps the <u>most famous</u> reduced wares are the 'celadons.' These owe their soft green or greenish-blue colours to the reduction of the small additional quantity of iron oxide in the glaze.

79

DECORATIVE TECHNIQUES

The burnishing of leather-hard bodies is seen on both Yangshao and Longshan wares, and painting with unfired pigments is also seen on the former. The most primitive techniques of decoration on ceramics, however, merely enlivened the surface texture of the object, for instance by pinching or pecking it. On a slightly more sophisticated level, the paddle used to beat the pot into shape could be wrapped in cloth, so leaving textile impressions over the surface. The early Korean pottery is decorated using a combing instrument, while the Jōmon pottery of Japan gets its name from

● *Above*: Japanese earthenware jar, Final Jōmon period (1000–350 BC). The decoration on this vessel has been produced by wrapping cords around it when the clay was still damp and then cutting further designs into the textured surface.

● *Left*: Chinese Cizhou stoneware tiger-shaped pillow, Jin period (1115–1234), late twelfth century. The stoneware clay body of this piece was coated with a pale slip before the dark brown decoration was applied. A transparent glaze was added before firing.

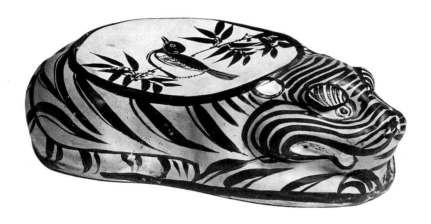

the patterns made by cords that were wrapped around the vessel when the clay was wet, leaving marks on the surface.

It was a short step from this to the kind of decoration made by applying carved stamps to the soft clay, or to the rouletted designs seen on the early Yue ware and Cizhou wares of China. Rouletting involved the use of a small cylinder on which a simple design had been cut. The cylinder was rolled around the pot, producing a continuous band of pattern. This design could be impressed directly into the body which was then glazed, as on the early Yue pieces, or the roulette could be used to cut through a dark slip to disclose a lighter slip beneath, as on some Cizhou examples.

The use of slips (sloppy clay and water mixtures) can be seen in a number of decorative variations. A slip was sometimes used to cover up a less-than-white body, and so provide a better background for a glaze, or to provide a smoother surface on which to apply painted decoration. Some of the Cizhou wares are decorated in this manner, with designs in dark brown slip painted on to a background of white slip applied to a buff body.

At some of the Cizhou kilns the potter also took this a step further and cut part of the design through the top slip to reveal

either the body or another slip beneath. In some cases the design was highlighted by the use of red haematite iron applied to the body. The technique is known as *sgraffito*. Most of the cutting on these wares was done with a bamboo knife, but the background of small rings was produced using the end of a bamboo tube to cut circles through the upper slip. Owing its origins to silver work, it is called ring-matting, or pearl-matting.

Designs incised or carved into the body were employed from early times, and in China they saw their finest expression during the Song period on wares such as the northern celadons and the products of the Ding kilns. In both these cases the carving was done with a bamboo knife held at an angle, so that the carved line was deep and sharp on one side and graded on the other. On the celadon pieces this gave a pleasing shaded effect, since the transparent green glaze ran into the carved lines and appeared darker where the cut was deepest. Both the northern celadon and the Ding potters made use of combing, either to add texture to petals and leaves, or to produce a wave-like effect as a background. A variant of this was practised by the potters making *qingbai* (or *yingqing*) porcelain in the south. They developed a type of dotted combing that was very effective under a transparent blue-tinged glaze.

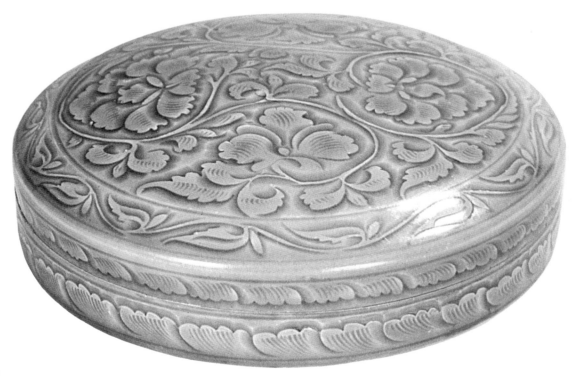

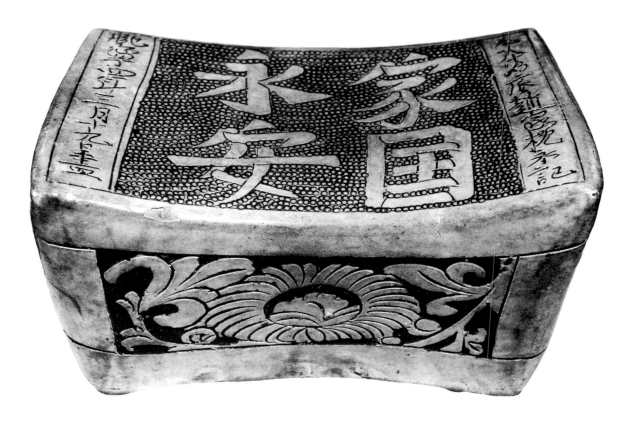

At the beginning of the twelfth century the use of moulds was introduced for providing decoration on the inside of wares made at the Ding and Yaozhou (northern celadon) kilns in north China. The design was cut into a clay mould, which was fired but remained slightly porous. The bat of clay was placed over the mould and beaten down using a paddle so that the inner surface of the clay took up the moulded design and the bowl or dish took on its overall shape. This method allowed the use of semi-skilled labour and enabled the potters to make pieces of exactly similar size, which was essential at the Ding kilns when firing using the *fushao*, or on the mouth rim, method was introduced.

Of the many different glazing techniques developed in the Far East, one of the most dramatic of the earlier types was the *sancai* ('three-colour') lead glaze of the Tang period in China, which was imitated in Japan in the Nara period (AD 710–794). The three main colours, from which the type takes its name, are green, amber and cream, but black and blue were also part of the palette. The glaze, which is seen on a large number of Chinese tomb figures, horses, camels and vessels dating to the first half of the eighth century, has the brilliant colours so often associated with lead-fluxed glazes. It was in most cases applied over a white slip which serves to disguise the pinkish buff earthenware body of the pieces.

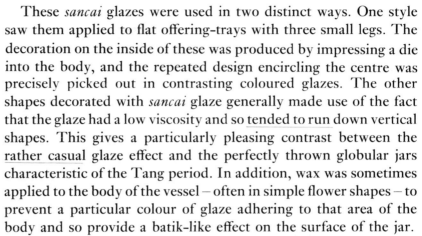

These *sancai* glazes were used in two distinct ways. One style saw them applied to flat offering-trays with three small legs. The decoration on the inside of these was produced by impressing a die into the body, and the repeated design encircling the centre was precisely picked out in contrasting coloured glazes. The other shapes decorated with *sancai* glaze generally made use of the fact that the glaze had a low viscosity and so tended to run down vertical shapes. This gives a particularly pleasing contrast between the rather casual glaze effect and the perfectly thrown globular jars characteristic of the Tang period. In addition, wax was sometimes applied to the body of the vessel – often in simple flower shapes – to prevent a particular colour of glaze adhering to that area of the body and so provide a batik-like effect on the surface of the jar.

A number of glaze types are composed of deliberately applied spots or splashes of a contrasting colour. The two colouring oxides used for these are iron oxide and copper oxide. The two best-known examples of this type of decoration are the Longquan celadons with dark brown iron-oxide spots, known by their Japanese name *tobi seiji*, and the purple/red splashes of copper oxide on the soft blue ash glaze of the Jun wares. On the latter pieces, where there has been a particularly intense concentration of copper, there may be patches of brilliant malachite green in the purple splash.

Among the very dark glazed wares there are several glaze types that rely on differing amounts of iron oxide in the glaze: two glazes with differing amounts of iron oxide, the use of a slip or body material high in iron oxide, or combinations of these. Some of the effects thus produced are particularly attractive, such as the jars from Henan with a glossy black glaze and a sketchily drawn plant motif in matt russet brown where the design has been applied with a high iron-oxide content. The tea bowls from the Jian kilns in Fujian province made use not only of the iron oxide in body and glaze but also of the tendency of the glaze to run and pool to produce the beautiful streaked 'hare's fur' glaze. The mottled tortoise-shell glaze produced at the Jizhou kilns in Jiangxi is another example, this time using two glazes. In the case of the 'oil-spot' glaze found on wares from Henan, the iron oxide in which both underlying slip and glaze were rich actually precipitated out on to the surface in crystalline form to give small patches with a metallic lustre resembling oil lying on the surface of water.

Among the black wares made in north China during the late Song and early Yuan (1279–1368) periods are those on which the glaze was applied to the vessel – usually a globular jar or a pear-shaped vase – and, before it was fired, parts of the glaze were cut away. The design made use of the contrast between the pale matt

● *Left:* Chinese Cizhou stoneware pillow, Northern Song period, dated 1071. The decoration has been cut through the white slip to reveal the darker body colour using the *sgraffito* technique. The pearl-matting background to the characters was produced using the end of a bamboo tube.

● *Below:* Chinese Jian stoneware tea bowl, Southern Song period (1127–1279). Bowls of this type have a dark body rich in iron oxide. The 'hare's fur' glaze effect is also due to the iron-oxide content combined with the tendency of the glaze to run downwards from the rim during firing.

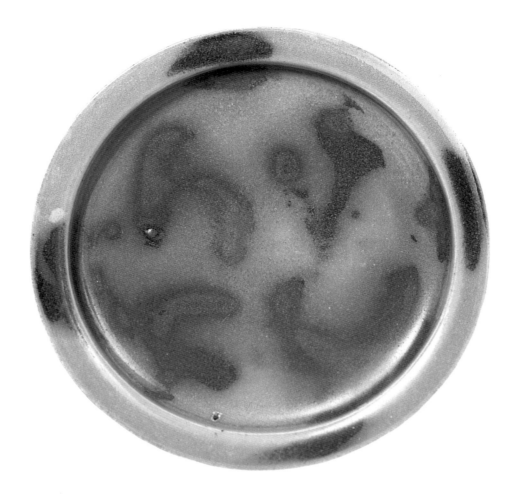

stoneware body of the piece, which showed through where the design had been cut away, and the glossy black glaze. A similar effect is seen on black glazed wares from Jizhou in Jiangxi, where paper cuts were stuck to the body before it was glazed and then pulled off before the glaze was fired, leaving the design in pale areas of the unglazed body.

Two further decorative techniques were used on the inside of tea bowls made at Jizhou in the Song period (often known by the Japanese name *temmoku*). With the first, a dark glaze was applied over the bowl, on the inside of which had been stuck a leaf. The bowl was fired in an oxidizing atmosphere, during which the carbons in the leaf were burnt out to leave a decoration in the leaf shape in pale yellowish brown contrasting with the black glaze. The other technique made use once again of paper cuts – often quite complex ones of phoenixes, or flower sprays, or cartouches containing good wishes, and often a scrolling band around the inner rim of the vessel. In the case of these wares the paper cut was

● *Left :* Chinese Jun ware dish, Jin period, late thirteenth century. The purple splashes on this dish owe their colour to copper oxide. Where the copper is especially dense small patches of malachite green can be seen.

84

applied to the body under a brownish speckled glaze, and they were fired in a reducing atmosphere so that the carbons in the paper were <u>not</u> burnt out and the decoration stands in black against the paler glaze.

The Jizhou kilns also produced in the Yuan period wares on which scrolling designs, like those seen on *guri* lacquer (see p. 166), were painted in slip over the unfired glaze. When the piece was fired, the design appeared in pale buff against the brownish-black glaze. Wares decorated in dark brown on a pale slip were also made in the same area during this period.

The effect of contrasting colours could be achieved in a much simpler way. In the Tang period, and again at the Cizhou kilns in the Song period, a marbled effect was produced. The vessels were made by combining two or three clays of different colours and then covering them with a clear glaze. The same effect could be obtained by using slips of different colours on the surface of the clay body.

As well as moulding an entire object with relief decoration, small decorative elements were individually moulded and stuck on to the surface of a piece. These sprig-moulded elements can be seen on the early Yue wares, in some cases skilfully hiding the join in the rouletted design around the shoulder of a vessel. They were used to great effect in the Tang period, both to produce the ˋjewelled styleˊ that became popular under the influence of Sassanian Persia and to

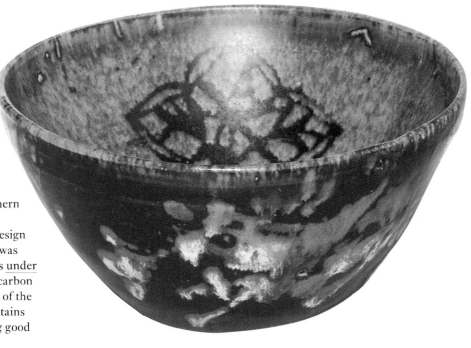

● *Right :* Chinese Jizhou stoneware tea bowl, Southern Song period, twelfth or thirteenth century. The design on the inside of this bowl was produced using paper cuts <u>under</u> the glaze that leave black carbon deposits after firing. Each of the decorative cartouches contains four characters expressing good wishes.

make the elaborate harness and trappings for the *sancai* horses. In the Southern Song period (1127–1279) sprig moulding was used in a more subtle way <u>under</u> the soft green glaze of Longquan celadons, the elements generally being two fishes or a dragon in clouds.

In the Yuan period the flat horizontal area inside the very large dishes allowed a variation on this scheme: the sprig-moulded elements were placed on top of the unfired glaze and, after firing, appeared reddish brown against the soft green background. A similar effect could, however, be achieved on a vertical surface by moulding panels on the vessels and then covering them with wax before the glaze was applied. The glaze did not adhere to the waxed areas, and the wax itself burnt off in the firing.

The technique of leaving areas of the body unglazed and biscuit fired (without glaze) is one that is also seen on porcelains. The dragons and clouds on a number of blue glazed wares of the Jiajing

● *Left :* Chinese Cizhou stoneware ewer, Northern Song period, eleventh century. The marbled effect on this ewer was achieved by combining different coloured clays, which were then covered with a transparent glaze.

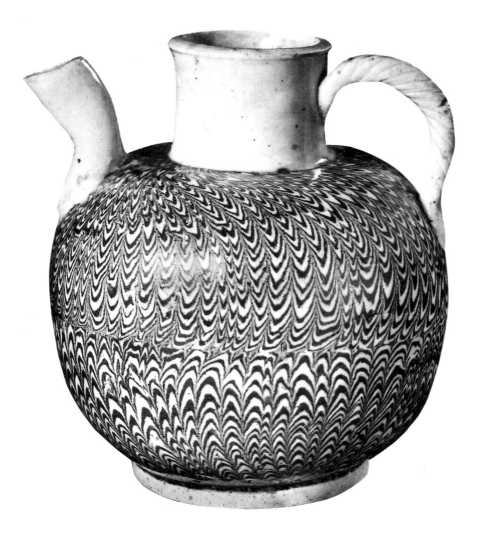

86

● *Right :* Pair of Chinese Longquan celadon armoured figures, Ming period, fourteenth century. These figures were made using moulds and then the lower section was glazed, while the upper section was left unglazed. The unglazed areas turned reddish brown during firing and provide a contrast to the green glaze.

● *Below :* Chinese Yue ware jar, late third or early fourth century AD. The diaper pattern on the shoulders of this jar was produced by rouletting. The small sprig-moulded Buddha figures are early examples of the Buddha depicted on the Chinese decorative arts.

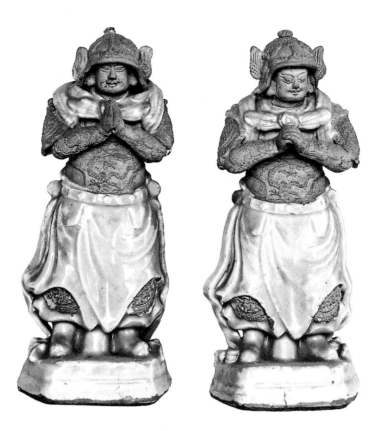

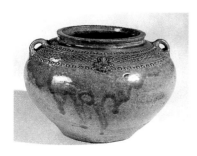

reign period (1522–66) are left in reserve and, after firing, given a coating first of red and then of gold. Both red and gold have frequently become detached from the body, leaving the design in white.

Reserved elements are also seen in combination with another technique, that of piercing. This can be seen on a number of wares including *fahua*, but is at its finest on a number of small bowls of the Wanli reign period (1573–1619), made of white porcelain and pierced through with a minute and precisely cut lattice. The cutting was done with a narrow-bladed knife when the clay was leather-hard and before the glaze was applied. It was of such intricacy that the technique is sometimes known as *linglong* or *guigong* ('devil's work'). The roundels that are usually set within the lattice were biscuit fired and then decorated with unfired pigments, of which usually very little remains. Many of these bowls originally had linings made of silver.

The deliberate crazing of a glaze has been used as a decorative feature in China. The effect of the fall of light on the fissures in the glaze has been likened to jade or to cracked ice. The technique is seen at its most subtle on the Ru wares made for the court in the early twelfth century, but possibly at its best on the Guan wares

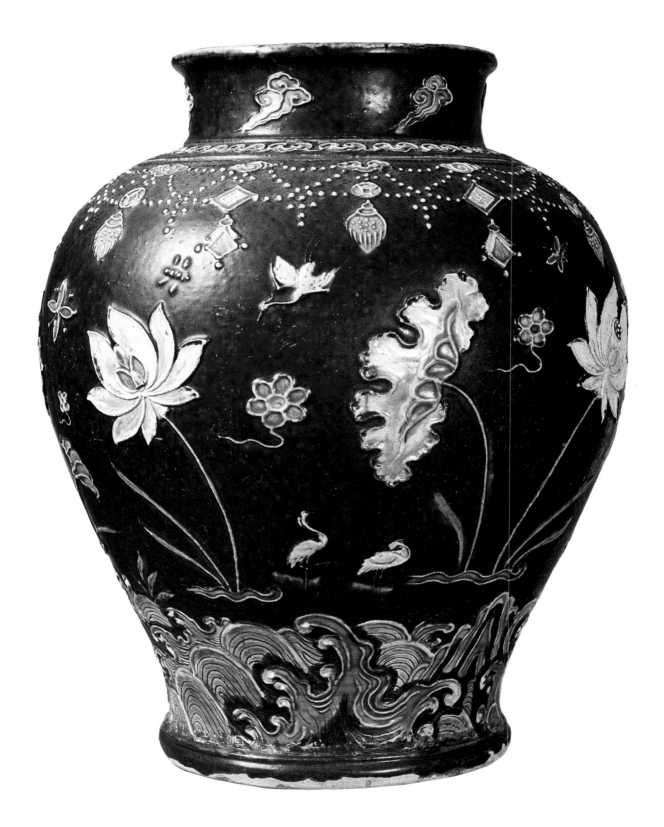

88

● *Left :* Chinese porcelain *guan* jar, decorated in *fahua* enamels, Ming period, *c.* 1500. The outlines of the decorative motifs are produced in thin, raised slip lines. The jewelled design on the shoulders is characteristic of this ware, as is the contrast of the large scale of the main motif – the lotus pond – with the smaller-scale cranes.

● *Right :* Chinese Guan stoneware censer, in archaic bronze *gui* shape, Southern Song period, thirteenth century. The crackle in the glaze on pieces of this ware was deliberately produced and carefully controlled. Shapes deriving from archaic bronze forms were popular in this period.

● *Below :* Korean celadon *mae-pyong* vase, Koryŏ period (918–1392), twelfth century. The decoration was produced by inlaying black and white slip in the *sanggam* technique.

made near Hangzhou in the Southern Song period, most probably under the influence of potters who had worked at the Ru kiln. The finest of these Guan wares has a thin, compact, almost black stoneware body, which is seen on the foot but also shows through where the glaze runs thin at the mouth rim. It has a clear blue-grey glaze of the celadon family, and the layer of glaze is sometimes thicker than the body layer. One of the ways of encouraging the glaze to crackle was by applying several layers of glaze before the piece was fired, and as many as five layers can sometimes be found. It is the different rates of contraction between body and glaze during cooling that is responsible for the crackle, which on the best

pieces is widely spaced and subtle. On some examples the dark body colours the crackle from the inside, but on others the darkening was assisted by staining from the outside after the object had come out of the kiln.

Inlaid decoration is seen at its best in Korea on the celadon glazed wares of the Koryŏ period (918–1392). In this technique (called *sanggam*) the design was incised into the leather-hard clay body and the lines filled with either white or black slip. The object was then covered in a soft green celadon glaze. In the fifteenth century among the Punch'ong wares the technique is seen in another form called *inhwa punch'ong*. These pieces had a stamped rather than incised design, which was again filled with white or black slip before being glazed and fired. The technique was also copied and used on the *mishima* wares made at Satsuma and Karatsu in Japan, but on these the slip was wiped round the surface.

The problems of the application of low-fired glazes to a high-fired body had been overcome in the Tang period by the simple expedient of firing the body first to a high temperature, then adding the glaze and refiring at a lower temperature. This solution was later adopted at the Cizhou kilns for the copper-green lead glaze and the copper-turquoise alkaline glaze that were applied to

slip-painted stoneware bodies. The bright turquoise glaze was seen again in the palette of another twice-fired ware in the fifteenth century known as *fahua*. The design, which was usually on quite a large scale, was drawn with raised slip outlines that worked in rather the same way as the *cloisons* of *cloisonné* enamels (see p. 120). The details of the design were incised into the body; the unglazed porcelain was then biscuit fired, and the coloured glazes were added. The two most popular background colours were copper turquoise and cobalt blue, while manganese purple, copper green, white and yellow were the other colours used. The enamel-on-biscuit technique was also used for the so-called Ming *sancai* wares, which copied the palette of the Tang period examples though on a porcelain body. There were also a number of figures produced in this way, many of which were small but some up to life-size.

In addition to the slip-painted designs on stoneware of the Cizhou kilns, underglaze painted designs in iron oxide or copper oxide can be seen on a number of wares such as some Yue and Changsha stonewares of China, and on the Oribe and Karatsu wares of Japan, while underglaze copper-red designs were seen as rare examples with a celadon glaze during the Koryŏ period in Korea. The question of when underglaze painting was first seen on porcelain in China is a vexed one, the latest archaeological evidence suggesting that it began as early as the Tang period.

Until modern times there were only three colouring oxides that could be fired to porcelain temperature and thus could be used underglaze: iron oxide, copper oxide and cobalt oxide. The one of these that became the most popular is cobalt-blue underglaze decoration. Large quantities – especially from the Jingdezhen kilns in Jiangxi province in China and from the Arita kilns of Hizen province in northern Kyūshū, Japan – found their way to Europe.

The earliest cobalt used in China was imported from the Near East and, indeed, the earliest underglaze blue wares in China in the fourteenth century were mainly made for the Near Eastern market – as attested to by the shapes and motifs used – whether for foreign merchants living in China or for export. The potters of the Near East had used cobalt blue themselves, but they did not have a porcelain body on which to apply it, nor a really suitable glaze with which to cover it. (Cobalt acts as a flux and so has a tendency to run in the glaze.) The Chinese potters, however, had both. The cobalt was finely ground and mixed with water, and the designs were then painted on the unfired porcelain body, which had a fine-grained, smooth surface and was also still porous enough to absorb the water, fixing the cobalt design. A glaze with a slight bluish tinge, developed from the *yingqing* porcelains of Jingdezhen, was applied,

● *Right :* Chinese porcelain dish with bracket-lobed rim, decorated in underglaze blue, Yuan period (1279–1368), fourteenth century. The central area is decorated with blue on white, while the moulded floral scroll in the cavetto is reserved against a blue ground.

90

and then the piece was fired in a reducing atmosphere. The result was a clear blue design against a white background.

While this type of decoration was not appreciated by the Chinese themselves in the mid-fourteenth century, they nevertheless became used to it, and the decorative schemes took on a more Chinese appearance.

For a short period at the end of the fourteenth century the import of cobalt from the West was interrupted by political upheavals as the Yuan dynasty fell and was replaced by the Ming dynasty. During this time underglaze copper-red designs, which had been developed alongside the blue, gained prominence. The copper was, however, very difficult to control and had a tendency to fade to silvery pink, and as a result copper lost favour as soon as cobalt was once again freely available. Native Chinese cobalt began to be used in the fifteenth century. There are a few rare examples of blue and red being used on the same vessel in the fourteenth century, and in the Xuan de reign period (1426–35) there are examples which display a complete mastery of both cobalt and copper. The underglaze copper did not really regain its popularity, however, until the Kang xi reign period (1662–1722).

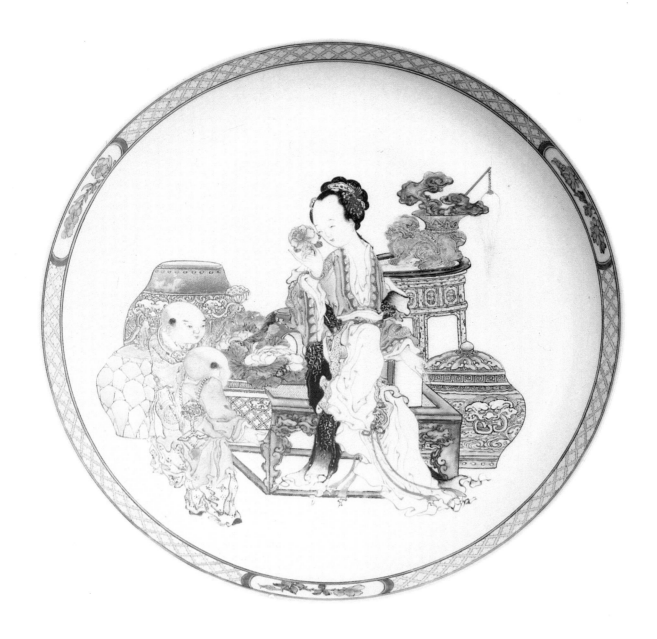

The technique of using underglaze blue on porcelain is traditionally supposed to have been introduced to Japan in the sixteenth century by the potter Shonzui, who learned it in China. After china clay had been found in Izumiyama in the seventeenth century, blue and white porcelains were made in quantity at the Arita kilns in styles influenced by the blue and white porcelains of Chosŏn period (1392–1910) Korea, whence came a number of potters in Hizen province.

The first use of overglaze enamelling – the application of low-firing glaze colours over an already fired glaze on a stoneware or

92

● *Left*: Chinese porcelain dish, decorated in *famille rose* enamels, Qing period, Yong zheng (1723–35). This ruby-backed dish shows the delicacy that could be achieved using the *famille rose* palette.

● *Right*: Japanese porcelain wine pot, decorated in enamels of the *Kakiemon* palette, *c*. 1680. The wine pot is moulded and incised in the form of a lotus bud. Its overglaze enamel colours are typical of the *Kakiemon* palette.

porcelain body – was seen in the Jin period (1115–1234) at the Cizhou kilns in north China. The two main colours used on these wares were copper green and iron red, with some additions of yellow and black. The red and black were both matt colours and did not adhere well to the glaze beneath, so have tended to wear off in places. With the resurgence of interest in polychrome wares during the Ming period, a number of new techniques were developed. One of these is called *doucai* ('dovetailed colours') and was developed in the fifteenth century. On these wares the outlines

of the design were painted in underglaze blue, the pieces covered in a porcelain glaze and fired to porcelain temperature. The outlines were then filled in with overglaze enamel colours and re-fired at a lower temperature.

A technique that produced a similar polychrome effect, but did not require the same skill in the decorator, was seen on *wucai* ('five-colour') wares. On these pieces certain elements in a design, such as water-weed or clouds, would be produced in underglaze blue, but the overglaze design would provide its own outlines in red or brown. This technique had the advantage that outlines incorrectly drawn could be wiped off the fired glaze, unlike the underglaze cobalt outlines of the *doucai* pieces. There, the water and colourant were immediately absorbed into the still-porous body and mistakes could not be rectified.

In the mid-seventeenth century the Japanese, once again absorbing both initial styles and technology, began to produce

overglaze enamelled wares. Although overglaze enamelling was first seen at Kyoto, this was on low-fired wares, and the two main styles that emerged on high-fired wares came from experimentation at the Arita kilns. These styles were known as *Ko-Imari* (old Imari, or Arita) and *Kakiemon*. Both were exported in quantity to Europe, where they were much imitated. A third style, known as *Ko-Kutani*, is seen on pieces which, like the *doucai* and *wucai*, included elements of underglaze blue in the decorative scheme.

In the Kang xi period in China a new style of overglaze painting was established, known in Europe as *famille verte*. This is typified by very delicate painting in a basically transparent palette in which a variety of greens predominated. It is in this palette that overglaze cobalt-blue enamel can first be seen – replacing the underglaze cobalt painting. The two opaque colours of the palette were red and black: the former was used to outline the faces of the figures in these designs, while the black was often used to provide a stippled effect which gave texture to the ground. Because of their transparency, and the fact that these enamels tended to flow, they were used in a wash-like manner, and the colours could not be combined.

● *Left* : Chinese porcelain fish bowl, Ming period, Long qing (1567–72). This large fish bowl is decorated in the *wucai* style, combining underglaze blue elements with overglaze enamels.

● *Right :* Chinese stoneware wine jar, Yuan period. The plant scrolls and geometric bands that decorate the upper part of this jar were produced by cutting through the glaze before it was fired to reveal the paler body beneath.

Another overglaze enamel palette emerged in the first quarter of the eighteenth century and eventually took over from the *famille verte*. This was the *famille rose* palette, so called because of the purplish pink that was used. This colour – the so-called purple of Cassius – was introduced into China from Europe by the Jesuit missionaries. It was an opaque colour, as was the other significant addition: an opaque white that could be mixed with other colours to give pastel shades and allow blending in the painting style. If *famille verte* may be likened to water-colour painting, then *famille rose* may be likened to oil painting.

Gilding was used to enhance a number of wares - polychrome and monochrome – from both China and Japan. In China gold scrolling designs were stuck on to a monochrome glaze using an adhesive and then lightly burnished. This was not a very secure way of applying gold to a glazed surface, and the gilding has often rubbed away.

DECORATIVE MOTIFS

The first designs painted on Neolithic pottery in China were abstract, geometric or concerned with everyday activities such as hunting, fishing and gathering food. Overall, however, most popular motifs on Far Eastern ceramics are floral or plant-inspired.

Floral scrolls are seen in some form on the vast majority of

95

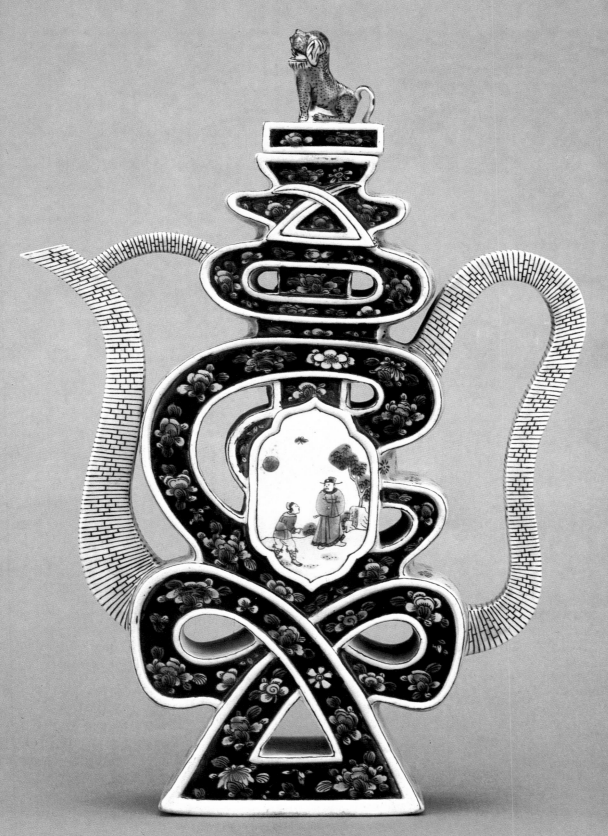

● *Left :* Chinese porcelain ewer, decorated in *famille noire* enamels, early twentieth century. The ewer has been made in the shape of the *shou* 'longevity' character. The spout and handle have been painted in imitation of basketwork.
● *Right :* Chinese porcelain plate, decorated in *famille verte* enamels, Qing period, Kang xi, probably *c.* 1715. This dish, with its brocade border and central design featuring a bird on a branch, is one of a series of plates thought to have been made for the sixtieth birthday of the emperor in 1715. The four characters within the border may be translated as 'ten thousand years of long life without end'.

ceramic wares in China. Of these the most popular are the lotus scroll, the peony scroll and the chrysanthemum scroll. These three flowers, together with the prunus (a very popular flower, particularly in association with the New Year, but less common in scroll form), make up the Flowers of the Four Seasons: winter-prunus, spring-peony, summer-lotus, autumn-chrysanthemum. The theme is further expanded into the Flowers of the Twelve Months: prunus, magnolia, peach, rose, crab-apple, peony, lotus,

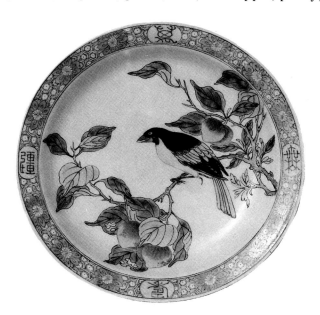

pomegranate, mallow, chrysanthemum, orchid and narcissus. In the eighteenth century sets of 12 cups were produced in particularly delicate *famille verte* enamels, each cup depicting one of the flowers with an appropriate inscription on the other side.

The Three Friends – pine, bamboo and prunus – are symbolic of longevity, winter and the qualities of a gentleman. They also represent the three religions of China: Daoism, Buddhism and Confucianism. Together they form a motif that has been greatly favoured since the fifteenth century. A similar theme is found in the Three Abundances which depicts a peach, a pomegranate (partly peeled to reveal some of its seeds) and a Buddha's hand citron. They are symbolic of long life, many sons and happiness.

Bird and flower painting was popular not only in the fine arts but as decoration on ceramics. The designs were usually carefully drawn and show either one or more birds sitting on a flowering branch. In some cases the design has been copied from the illustrations of a botanical text. A variation on this theme is the design of ducks on a lotus pond. The lotus leaves provide a

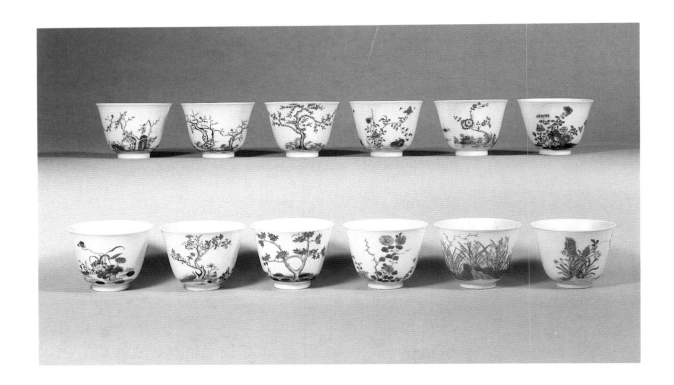

splendid umbrella-like shape, and a pair of mandarin ducks is symbolic of conjugal felicity.

Various other birds have also provided inspiration for the decoration, such as cranes – symbolic of longevity – parrots, quails – symbol of courage – geese, and the phoenix – symbols of the empress. A number of mythical creatures appear as decoration on porcelain. The *qilin*, with its cloven hooves and scaled body, for instance, is often depicted on blue and white wares. The dragon is the most popular motif of all; from the powerful writhing *long* dragon, often seen in pairs chasing a flaming pearl, to the newt-like *zhi* dragon, with its bifurcated tail, and the less common *feiyu* dragon – a sea dragon with bat-like wings and fins rather than legs. Unlike the Western dragon, the Eastern dragon is an auspicious and admired creature, and it is also the symbol of the emperor.

Some creatures were included in designs only partly for their aesthetic appeal, but mainly as part of a rebus. The word for 'bat' (*fu*) in Chinese, for instance, is pronounced in the same way as the word for 'happiness'. Thus a single bat may stand for happiness, while five bats are the Five Blessings – long life, riches, tranquillity, a love of virtue and a good end to crown one's life. Butterflies, too, were used in a punning way. As well as being highly decorative, in Chinese they are pronounced *die* – which is a homophone of double or twice-over – and they thus double any good wish.

● *Above :* Set of twelve Chinese porcelain cups, decorated in underglaze blue and overglaze *famille verte* enamels, Qing period, Kang xi. Each of these delicately potted cups is decorated with one of the Flowers of the Twelve Months and bears an appropriate inscription on the other side.

98

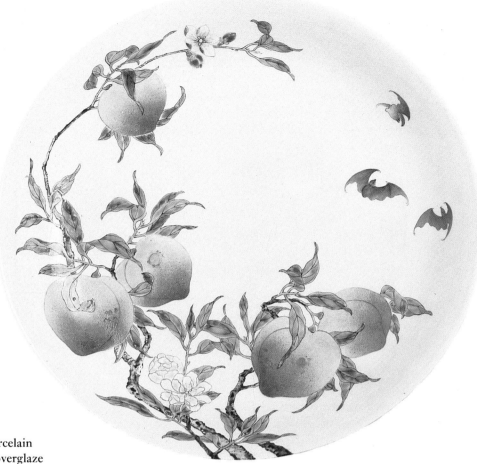

● *Right :* Chinese porcelain dish, decorated with overglaze enamels, Qing period, Yong zheng. The design on this dish includes peaches, which are symbolic of longevity, and red bats, symbolic of happiness.
● *Below, top :* The Eight Trigrams.
● *Below, bottom :* The *yinyang* symbol.

The carp was a popular motif, not only because it was admired for its beauty, but because the carp leaping the Dragon Gate and turning into a dragon signifies success in examinations.

A number of decorative motifs have religious origins. The Eight Daoist Immortals are often seen riding over the waves, and each is identifiable by his or her attributes. These eight are often seen in combination with Shoulao, the Star God of Longevity, who is shown with a peach, a crane, a spotted deer and sometimes a *lingzhi* fungus. Any one of these may also stand as a symbol of longevity.

The philosophical or religious theme is continued with the *yinyang* symbol of a circle divided in two by an S-shaped line, one half dark, the other light. The dark, or *yin*, half represents the female, earth, moon, dark side of nature and is balanced by the *yang* half representing the male, heaven, sun, light side. It is a dual symbol representing the Daoist view of the balance and harmony of the universe. Buddhist guardian lions, or lion dogs, are a popular motif on painted wares, as well as being produced in the round as

incense-stick holders. They are usually shown in pairs, the male with one of his front paws resting on a beribboned brocade ball and the female with a playful cub.

Eight is a popular number for groups of significant items, probably stemming from the Eight Trigrams (eight groups of three broken and unbroken lines) which are traditionally supposed to have been invented by the legendary hero Fuxi and used in divination and philosophical reasoning. The emblems of the Eight

● CHINESE EMBLEMS
Top two rows : The Eight Daoist Emblems : (1) gourd and crutch of Li Tieguai; (2) fan of Zhongli Chuan; (3) flower basket of Lan Caihe; (4) drum and rods of Zhangguo Lao; (5) lotus of He Xiangu; (6) sword of Lu Dongbin; (7) flute of Han Xiangzi; (8) castanets of Cao Guoqiu.
Middle two rows : The Eight Buddhist Emblems : (1) *cakra* or wheel; (2) conch shell; (3) umbrella; (4) canopy; (5) lotus; (6) vase; (7) pair of fish; (8) entrails or endless knot.
Bottom two rows : The Eight Precious Objects : (1) jewels; (2) circle enclosing a square or cash; (3) open lozenge with ribbons; (4) pair of books; (5) solid lozenge with ribbons; (6) musical stone; (7) pair of horns; (8) artemisia leaf.

● *Below :* Chinese porcelain *meiping* vase, decorated in underglaze blue, Yuan period, fourteenth century. The scene illustrated on the vase is from *The Story of the West Chamber* : Lady Zheng (left) rebukes the sobbing maid.

Daoist Immortals were used alone as the Eight Daoist Emblems. There are also Eight Buddhist Emblems, which are sometimes known as the Happy Omens, as well as Eight Precious Objects. The Eight Horses of Mu Wang (King Mu of Zhou, *c.* 950 BC) have also been used to great effect as a decorative motif on ceramics.

Garden scenes, or simply garden elements, are often depicted on ceramics, and they almost invariably include an ornamental rock of the kind so beloved of Far Eastern gardeners. The garden scenes that include figures – either scholars or ladies – often use a fence as a device for indicating recession. These garden scenes, landscapes with pavilions and genre scenes tended to be influenced by the painting fashions of the time. They often also depict particular persons, scenes or series of scenes from history, popular plays or novels – three of the most favoured being *The Dream of the Red Chamber, The Story of the West Chamber* and *The Water Margin.* On large rouleau vases an ideal space was provided for paintings of festivals; one of the most popular of these reproduced on ceramics, especially of the Kang xi period, was the Dragon Boat Festival.

The lovely forms of characters were used as a decorative device as well as for writing inscriptions. Some characters were used alone, such as the *shou* ('longevity') character, or the *shuangxi* ('double happiness') character often used for weddings. They can also be seen in four-character phrases, perhaps the most usual of which are *Chang ming fu gui* ('long life, riches and honours') and *Wan shou wu qiang* ('a myriad longevities without end').

CERAMIC SHAPES

The shapes of Far Eastern ceramics were in part determined by their function and in part dictated by the style of the time in which they were made.

In China a number of edicts were issued at different periods stipulating that ceramic roof tiles should be used in certain areas as a fire precaution. Lead-glazed roof tiles were used from the Bronze Age in China and have continued to be used: the yellow glazed tiles of the Forbidden City in Beijing (Peking) are still a striking feature of its architecture today. It was the half-cylinder ridge-tiles that allowed the ceramic craftsmen greatest scope, with the animals and figures that stand upon them, while the circular end-tiles often had moulded relief designs. Rectangular tiles with moulded designs have also been found in tombs of Han period China, and those from Sichuan province show some of the earliest depictions of recession in landscape. Glazed tiles have also been used extensively on screens, walls, gateways and pagodas.

A number of shapes were intended for use during particular ceremonies or occasions. The splendid *sancai* figures and animals made to be placed in the tombs of the Tang dynasty aristocracy are only some of a whole range of vessels and figures produced specifically for funerary use. Altar sets, too, were often produced in ceramics, comprising pricket candlesticks, vases and censers of archaic shape.

The drinking of tea and the ceremonies that accompanied it have been an important stimulus to the potter. In China tea drinking became popular in the south in the Han period and gained steadily in popularity. During the Tang period the habit spread to north China. It was also adopted by Zen Buddhists as an aid to meditation and for its medicinal qualities. Tea drinking required ewers with long spouts for the hot liquid and cups from which to drink, and a pestle and mortar for grinding the dried tea when it was used in powder form. Cup stands were developed originally in lacquer or silver but were also made in ceramics – to hold the hot handle-less cups – and eventually, of course, there was the teapot. Tea wares became a speciality of some kilns.

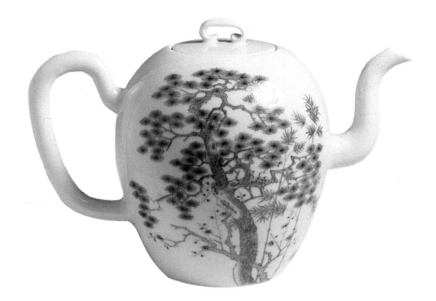

● *Left* : Chinese porcelain teapot, Qing period, Yong zheng. This teapot is decorated in *doucai* style using the underglaze blue outlines with overglaze enamel colours. The motif is the popular Three Friends of Winter.

The glaze colour was also dictated by the tea connoisseur. Celadon wares were felt to complement the colour of the green tea but when, in the Song period, whipped tea became popular, the dark colours of the Jian and other black glazed tea bowls were thought to contrast in a pleasing manner with the white froth on the top of the tea.

These Jian bowls were much valued by the Japanese. They took them back to Japan, where they exerted considerable influence on the appearance and texture of the wares made for the Japanese tea ceremony. Raku wares, for instance, were highly regarded not only for their 'natural' shapes but for their lightweight, low-fired, iron-rich bodies; also for their red, black or occasionally white lead-fluxed glazes, fired in small single-chamber kilns. These wares were believed to change their character with use, and were pleasing to hold in the hand.

The tea ceremony was a complex procedure. At its most formal it was divided into several parts, known as *chanoyu*. It was held in a special building or partitioned area, so constructed and decorated as to provide a tranquil atmosphere in which to enjoy the tea. There were specific times of day most suitable for holding the ceremony, depending on the season of the year, and the number of guests was usually limited to five. The ritual involved in the ceremony included the serving of a thick pasty tea called *koicha* and a foaming tea called *ushucha*, and also a light meal (*kaiseki*) consisting of soups, rice, fish and vegetables, as well as cake. Among the utensils required to prepare and serve these were *futaski* ('rests for kettle lid or ladle'), *kensui* ('jars for waste water'), *chaire* ('tea caddies'), and vases, jars, square, straight-sided dishes, trays and tea bowls. While

大明宣
德年
製

The mark most often seen on Chinese wares is the (so-called) 'reign mark'. This was commonly placed on the bottom of a piece, although it may also be found around the rim or on the shoulder of a vessel. Reign marks are most frequently made up of six characters, or occasionally of four, giving the name of the dynasty and the name of the reign period in which the piece purports to have been made. Sometimes a cyclical date is also given. Such marks should be treated with caution as they may be deliberately misleading, for instance in the case of Japanese pieces with Chinese marks. In other cases they merely indicate that the object was made in the style of an earlier period. Reign marks were most often produced in underglaze blue, but they may also – according to the ware on which they were inscribed – have been incised into the body under the glaze, or have been painted in overglaze red, or blue enamel, or even have been moulded in relief.

Some of the most interesting inscriptions are those which form a dedication, for they often provide not only the names of the persons involved, but also the date and place of the occasion. A number of marks, often placed in the same position as the reign marks, are 'hall marks' – not in the European sense, but indicating a hall temple or pavilion where the piece was to be used.

● *Above :* The reign mark of the Xuan de period (1426–35).
● *Right :* Chinese porcelain table screen, with underglaze blue decoration, Ming period, Zheng de (1506–21). The cartouche on the screen contains a Koranic inscription in Arabic script.

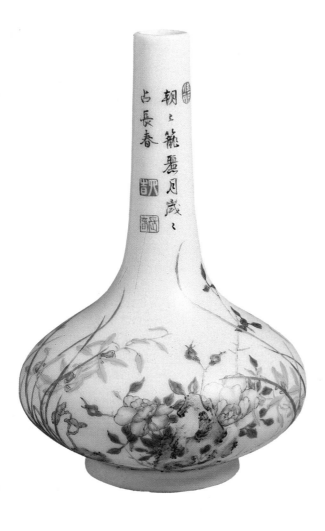

朝上籠盒月歲
占長春

● *Left :* Chinese porcelain vase, decorated in *famille rose* enamels, Qing period, Qian long (1736–95). The floral decoration on the body of this vase is complemented by the inscription and seals on the neck.
● *Right :* Chinese porcelain figure of a *luohan*, with on-biscuit enamels, Ming period, dated 1484. This figure of a Buddhist disciple is life-size and dated by an inscription on the side of the pedestal.

Good wishes of some kind were also sometimes added as an inscription, and occasionally a piece includes an indication of the use to which the vessel was to be put. On a number of pieces, particularly eighteenth-century high-quality *famille rose* examples, a well-written poem was added to complement the painted decoration. The scheme is very like that seen on paintings, even to the extent of the addition of vermilion seals.

Lastly, there are some inscriptions that are not in Chinese characters. The influence of Lamaistic Buddhism can be seen on the pieces inscribed in Sanskrit '*Om mani padme hum*', 'Oh jewel in the heart of the lotus'. Particularly in the sixteenth century in China a number of pieces were made for the Moslem eunuchs serving at the court, and these were sometimes inscribed with quotations in Arabic from the Koran or had secular inscriptions in Persian.

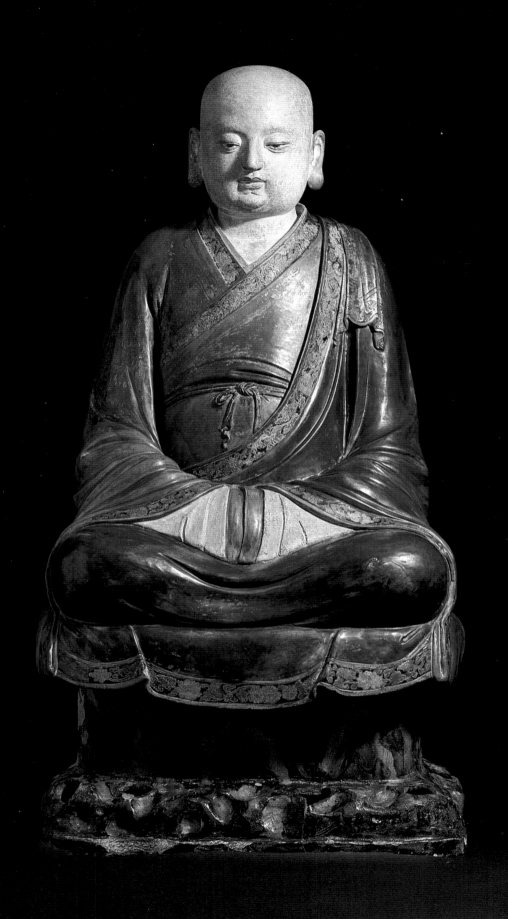

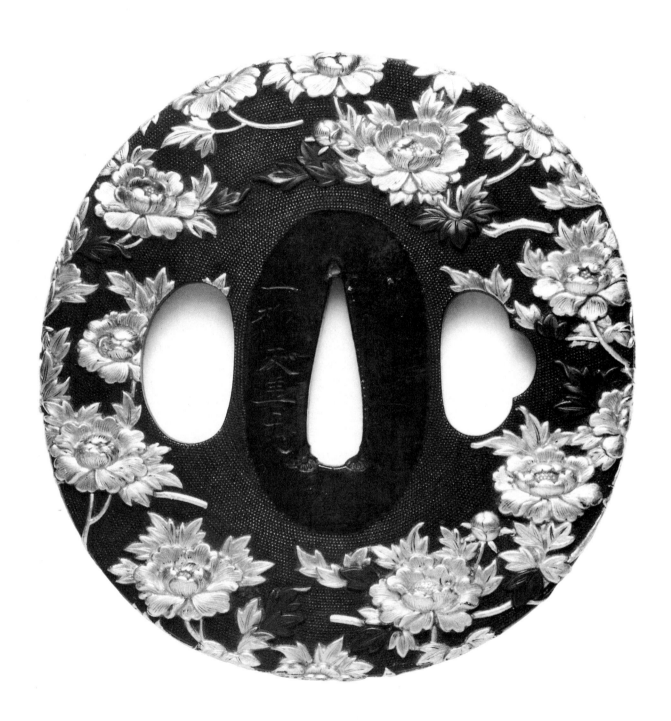

Chapter 4
METALWORK

WHEN man accidentally discovered that by heating certain rocks in a fire or kiln they yielded a substance which cooled and hardened to form a metal, the effect on primitive society was profound. This is reflected in the fact that the terms Bronze Age and Iron Age have come to be applied to those periods of history during which bronze, and subsequently iron, was the predominant metal in use.

Bronzes have been found at archaeological sites in China dating from around 2000 BC, and articles of iron from some time during the sixth century BC. In Japan, metallurgy and the use of bronze dates from somewhat later, around the second century BC, followed shortly afterwards by that of iron.

The fact that an object was primarily functional did not, in itself, preclude decoration, and it was a natural progression for a craftsman to want to embellish what he had made. Growing technical skills went with a greater understanding of, and control over, the material. This, in turn, enabled the metalworker to produce decoration of an increasingly sophisticated nature. The hallmark of a wealthy, stable society is the existence of objects which serve a utilitarian purpose but which are also pleasant to look at. Therein lies the fundamental difference between, say, a bronze arrowhead and a bronze mirror.

● *Above :* Chinese bronze ritual vessel, *li*, for the preparation of food, fourteenth or thirteenth century BC. With the pairs of prominent eyes set amongst hooks and curls in ribbon relief, the lower part of the decoration represents an early form of *taotie* monster mask.

● *Left :* Japanese *shakudō*, *shibuichi* and gold sword guard, *tsuba*, signed Hitotsuyanagi Tomoyoshi, early nineteenth century. The *tsuba* is decorated with peony sprays in gold and the copper alloy *shibuichi* on a *shakudō nanako* ground.

BRONZE

Bronze, the first artificial alloy used by man, is made up of copper and tin, frequently with the addition of lead in early Chinese bronzes. Copper is soft; tin and, to a lesser extent, lead increased the hardness of the metal and also served to lower the melting-point of the alloy. Lead was a cheap substitute for tin and was possibly used for this reason, though it also helped to make the molten metal more fluid and prevent bubbles forming on the surface.

The proportions of the metal constituents in early Chinese bronzes varied considerably, even amongst objects of the same type and style, and this had little relation to their date of manufacture. It seems probable that the variation represents different practices at the various foundries and differences in the raw materials.

Although China does not have abundant resources of copper,

copper ore in sufficient quantity to satisfy the needs of a primitive bronze industry was found in most Chinese provinces. Tin and lead, on the other hand, occur in significant quantities, particularly in Yunnan and the south west in general.

The most important process in the manufacture of bronze was smelting, which involved combining the metal ores with charcoal in a furnace. Together they were heated to a high temperature to bring about a chemical reaction, the result of which was to release the metal from the ore. The molten metal then flowed to the bottom of the furnace, while the remainder, known as slag, collected at the top. Once the metal had cooled and hardened, it was generally necessary to refine it further by heating it in a crucible. The bronze was then ready to be turned into prepared moulds. In the case of large objects, where portable crucibles were not practical, casting channels were used which connected the furnace or crucible with the mould.

TECHNIQUES OF BRONZE WORKING

The earliest coherent group of Chinese bronzes, which date from around the nineteenth to the sixteenth century BC, attest to a high level of technical skill and sophistication, though there is no evidence of an early, experimental phase of bronze working. This would seem to imply an external source for the knowlege of bronze working. And yet the method of bronze casting which was used in the Near East and the West – the *cire perdue*, or lost-wax, method – was, contrary to what might be expected, unknown in China until around 500 BC.

The lost-wax method of bronze casting involved making a model of the object to be cast in wax over a clay core. An outer clay mould, which included inlets for the liquid bronze and vents for the escape of air, was then built up to cover the wax. The thickness of the wax corresponded to the intended thickness of the metal body. The

● *Below :* Chinese woodblock prints, two double-page spreads from the *Tian gong kai wu* by Song Yingxing, first published in 1637. The two pages on the left illustrate the scale of bronze casting during the late Ming period (1368–1644): seven blast furnaces operated by piston bellows supply molten bronze to the moulds through clay channels. The third page depicts the casting of iron pots, a process similar to that of casting bronze vessels: molten iron is being ladled from the furnace to the moulds and, in the foreground, moulds are being repaired. The fourth page shows a craftsman incising decoration in the wax model of a bell, which has a clay core; in the foreground the outer mould sections are being prepared.

 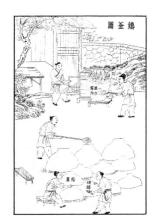 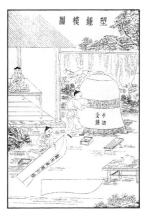

● BRONZE CASTING BY THE LOST-WAX METHOD

The casting of a Buddhist figure:
Left: the mould-assembly with the wax in place ready for baking: (1) the wax model; (2) a layer of fine clay to take the impression of the surface decoration on the wax model; (3) an outer mould of coarse clay; (4) grass cords; (5) wooden rods.
Centre: the molten bronze being poured in to take the place of the melted wax: (1) channels formed when the rods are removed; these allow the melted wax to escape and subsequently act as inlets for the molten bronze; (2) vents formed when the grass cords are extracted; these allow air and other gases to escape; (3) metal rods which hold the core in position after the wax has melted.
Right: after the bronze has cooled and hardened, the outer moulds are broken away to reveal the finished object.

whole assemblage was then heated, during which the inner and outer clay moulds baked hard, while the wax melted and ran out through escape holes. Liquid metal was then poured in to replace the wax. Surface decoration of the wax model was achieved by means of a negative impression on the outer clay mould, which, in turn, made a positive impression on the bronze surface.

Since the core became unstable once the wax had melted, it was necessary to devise some means of fixing it in position. This was achieved by means of metal rods or wires, known as chaplets, which were secured at either end in the core and in the outer mould, and which were cast into the body of the finished bronze object. Once casting was complete, it was necessary to break the outer mould to remove the finished bronze object. Thus, new wax models and moulds had to be made for each object to be cast.

Overwhelming evidence for the use of piece-moulds in the manufacture of bronzes during the Shang (*c.* 1600–1027 BC) and Western Zhou (1027–771 BC) periods was provided by their discovery, in large numbers, at Xiaotun in 1928, and subsequently in other places around Anyang, Henan province, the site of the last capital of the Shang. These fragments of baked clay reveal a negative impression of the type of decoration associated with contemporary bronzes. What distinguished them from mould fragments of the lost-wax method was the fact that some of them had flat edges which could be fitted together, indicating that they were moulds for part, and not all, of the object.

The first stage in this method of casting was to make a model of the desired object, usually in clay or wood. Elements of decoration in high relief were usually added separately. Surface decoration

111

was painted on to the model and subsequently incised into it. Clay was then pressed on to the model to form the negative mould, which was divided into convenient sections before being removed. Joining edges of the sections were finished so that they fitted tightly, and they were secured by means of mortise and tenon joints. The finest details of the surface decoration were incised directly in the relevant mould sections at this stage. The moulds were then fired.

The negative piece-moulds were re-assembled around a clay core, which was sometimes the model, pared down to make the casting space. In order to ensure that the core was kept in a fixed position, chaplets or spacers were positioned at regular intervals between the core and the outer moulds. When a clay spacer was used, this was removed after casting, leaving a small opening in the body of the finished metal object. This appears to have been common practice in casting the type of vessel known as a *gu*, which frequently has a cruciform hole in the lower section of the body. Most bronze vessels were cast upside down, the legs accommodating pouring channels and risers. Flaws caused by trapped air and gases were thus likely to appear in the legs, which could be replaced without difficulty.

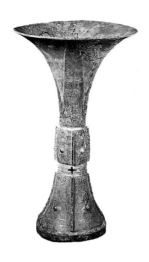

The complex shape and surface decoration of Shang and Zhou bronze vessels necessitated a high level of technical skill in the pottery industry to make the clay moulds. Because of the high degree of co-operation that must have existed between the bronze and pottery workshops, it is hardly surprising that, initially, Chinese bronzes often reveal a similarity to the shape and decoration of ceramics. Incising, for example, was one of the simplest methods of decorating clay. Since the piece-moulds for bronze casting were negative moulds, the end result of the bronze surface was the same design as the mould but in thread relief.

The fact that comparatively sophisticated kilns, which were capable of reaching high temperatures, were already in existence, undoubtedly influenced furnace design of the early bronze industry.

Piece-moulds readily lent themselves to the manufacture of objects of a heavy and architectural quality, such as the *fang yi* vessel. As it was necessary to build up the vessel in sections, it became customary to divide the decorative surface area into horizontal bands corresponding to the different sections of the moulds. In addition, the small seams caused by some of the liquid bronze escaping through the joins in the moulds were made into a special feature. During the late Shang and early Zhou periods many bronze vessels were made with vertical flanges of a highly ornate nature.

It is often thought that the appearance of some of these early bronzes has been greatly enhanced by the formation of a rich patina in green, blue or red. The patina represents corrosion of the bronze resulting from oxidizing conditions brought about either by burial of the objects in the ground or else in damp hollow tombs.

● BRONZE CASTING BY THE PIECE-MOULD METHOD
The casting of a *ding*:
Left: the assembled piece-moulds prior to casting (at this point the *ding* is in an inverted position): (1) the clay core; (2) the outer clay mould with a negative impression of the surface decoration; (3) the pouring inlet for the molten bronze; (4) air vents; (5) the thin walls of the bronze vessel; (6) joins of the piece-moulds.
● *Right*: a *ding*, of a type dating from the eleventh century BC, with ornate surface decoration.

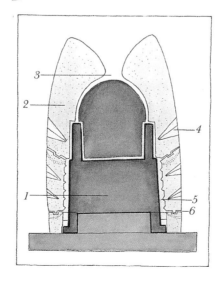

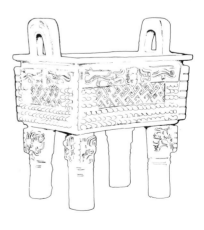

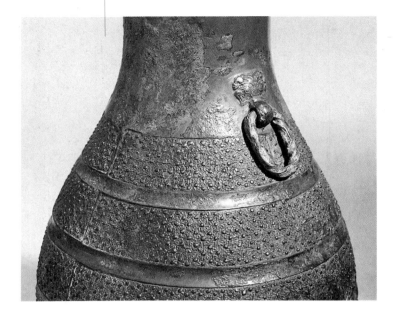

● *Left :* Detail of a Chinese bronze ritual vessel, *hu*, for wine, fourth or third century BC. The horizontal bands of decoration are composed of intertwined animals, their bodies and eyes reduced and stylized to a recurring abstract design. The vertical seam joining two pieces of the cast is clearly visible on the left. Patina, formed by corrosion of the bronze, can be seen on the uppermost, undecorated band.

TYPES OF BRONZE VESSELS

The most striking artifacts of the Shang and Zhou periods are the bronze vessels. Their main function was for the offering of food and wine in sacrificial rites, frequently in veneration of an ancestor. A large proportion of bronze vessels bear inscriptions: these may include the name of the vessel and of the ancestor and, occasionally, the name of the donor.

Inscriptions found on bronzes of the Zhou period, which tend to be the more informative, indicate that some vessels were used by the wealthy in everyday life or were given by feudal rulers to deserving subjects. The vessels were also placed in the tombs of important and wealthy persons, probably for the dual purpose of supplying the deceased with material comforts, and, at the same time, providing offerings of food and drink for the gods and spirits. It is due to this custom that early bronze vessels have survived in such large numbers to the present day.

The majority of bronze vessels conform to standard shapes, and they fall into two main categories: those connected with food and those connected with drink. Vessels used to prepare and contain sacrificial food include the *ding, li, xian, gui, yu, xu, fu, dui* and *dou.* Amongst those used to hold liquid are the *jiao, jia, jue, gu, zun, lei, pou, hu, you, fang yi* and *guang*; other vessels, such as the *pan*, were used for water. Whereas certain forms, such as the *ding, li* and *gui*, were derived from pottery of the Neolithic period, others, such as the *fang yi*, evolved within the bronze industry and from the limitations imposed by the medium.

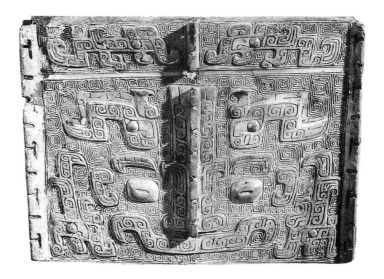

● *Right* : Detail of a Chinese
bronze ritual vessel, *fang yi* or
square *yi*, twelfth or eleventh
century BC. The designs are
characteristic of late Shang
bronze decoration, the
predominant feature being the
taotie animal mask, centred on a
notched flange. Clearly visible
are a pair of eyes in high relief,
eyebrows, horns, ears and upper
jaw. The main features of the
design are portrayed in low relief
against a background of sunken
leiwen scrolls.

● *Below* : Chinese bronze bell,
zhong, from a graduated set of
bells, fifth century BC. The bell
was struck on the external row of
nipples. The main areas of
decoration represent interlaced
dragons, the forms of which have
been reduced and stylized into
recurring motifs covering a large
part of the surface area. The
lower band is decorated with an
animal mask in high relief.

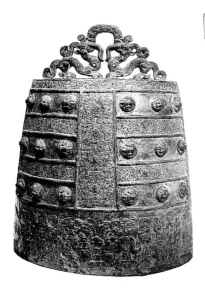

Other items made from bronze, particularly during the Eastern
Zhou (771–256 BC) and Han (206 BC–AD 220) periods, include
belthooks and bells. The latter, used in ceremonial music, were
made in graduated sets. Having no internal clapper, they were
designed to be struck on the external rows of nipples.

Bronze mirrors have been found buried in tombs in significant
numbers, dating from around the fifth century BC onwards. These
are in the form of bronze discs, highly polished on the reflecting
surface and decorated, usually in low relief, on the other. A pierced
boss in the centre of the decorated side was used for attaching a
cord to hold or suspend the mirror. Mirrors dating from the Han
period frequently reveal decoration of a mythological or cos-
mological nature. Of particular note is the TLV mirror, so called
because elements of the design resemble these capital letters and
appear to represent the relationship between heaven and earth.

On account of its hardness, bronze was a suitable material for
tools and weapons, including axes and arrowheads, knives,
halberds, spears and swords. It was also used for the components of
a chariot, notably the shaft-holder, axle-cap and linch-pin.

BRONZE DECORATION

From an early date Chinese bronzes had decoration of a highly
sophisticated nature. Animals, both real and imaginary, featured
prominently: commonly the vessel itself was modelled in the form
of an animal or an animal formed part of the design.

Characteristic of Shang bronzes is the inclusion of the so-called
taotie monster mask. The most prominent feature of the *taotie* is a
pair of eyes in high relief, generally raised above the level of the rest
of the design. The *taotie* takes the form of a conventionalized

animal face, with extensions on either side representing the body. The whole scheme is symmetrical about a vertical flange, which marks the centre of the mask. It is usually possible to distinguish eyebrows, ears, horns, claws and an upper jaw with fangs set into it, while the lower jaw is invariably missing. Elements of the *taotie* are often set against a background of sunken rounded or squared spirals, known as *leiwen* ('thunder pattern').

Early representations of the dragon may be found as part of the *taotie*. The horns of the mask, for example, were sometimes modelled in the form of a pair of dragons confronting one another, each portrayed in profile with a single paw, upturned nose and gaping jaws.

During the late Shang and Zhou periods the animals were frequently combined with designs of an abstract nature, such as whorl circles, vertical ribbing and lateral projections in high relief. Indeed, decoration consisting of entwined animals with snake-like bodies was gradually broken down on some later bronzes, and reduced to an abstract interlaced design, which sometimes retained an animal head.

During the Eastern Zhou period copper, gold and silver inlays, as well as encrustations of semi-precious stones, were amongst the main forms of bronze decoration. Although the use of inlays was not new, it nevertheless represents a departure in a bronze-casting tradition which at that time already stretched back over 1,000 years. It may well have reflected a feeling on the part of the craftsmen that they had exploited bronze casting to the full. At the same time, iron was increasingly used for tools, weapons and items of everyday use. The fact that iron was more widely available and cheaper must

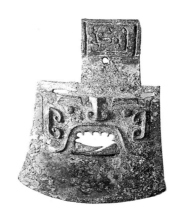

● *Above:* Chinese bronze axe, *yue*, in the form of a human face with sharp teeth, twelfth or eleventh century BC. This type of axe is thought to have been used for decapitating human sacrifices at the burial of important persons. Such implements have been found in the outer trenches of burial sites at Anyang, the last capital of the Shang dynasty, and in Hebei and Hubei provinces.

● *Left:* Chinese bronze vessel, *bian hu*, with silver inlay, fourth or third century BC. The *bian hu*, or flat *hu*, a vessel for holding wine, first appeared in about 400 BC. In this example the areas of design consist of the broad lines of an essentially geometric pattern contrasting with the fine lines that make up the hooks, spirals and scrolls; these were cut out of the bronze surface and inlaid with silver.

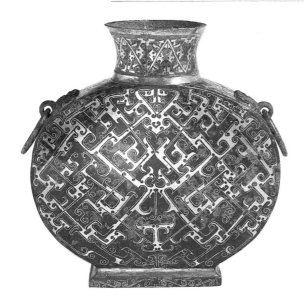

116

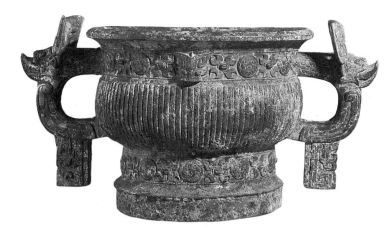

● *Right* : Chinese bronze ritual vessel, *gui*, for holding food, late eleventh century BC. Characteristic of the late Shang period and early Zhou period (1027–256 BC) is the vertical ribbing with bands of abstract designs (including the whorl circle) together with the heavy, zoomorphic handles with a downward projection. This particular example is frequently referred to as the Kang Hou *gui*.

● *Below* : Chinese bronze *qilin* with cloud scrolls in gold and silver parcel-gilding, Han period (206 BC–220 AD). A *qilin* is an imaginary animal. Parcel-gilding was quicker and cheaper than inlaying with gold and silver, though a less durable form of decoration.

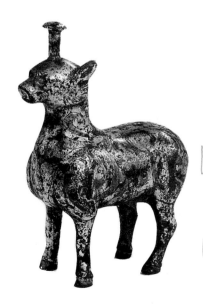

have been devastating to a bronze industry already in decline. Indeed, bronze vessels of the Han period, by comparison with those made earlier, seem competent but somewhat uninspired.

The way forward lay with new metalworking techniques, such as parcel-gilding. This involved combining gold or silver with mercury to form an amalgam which was painted on to the surface of the bronze to form part or all of the decoration. The object was then heated to vaporize the mercury, leaving the gold or silver behind. The initial effect was striking, but the surface did not wear well.

Although ancient bronzes were periodically admired by Chinese scholars, it was not until the Song period (960–1279) that they began to receive serious attention. This was reflected not only in the acquisitions of eminent collectors and in various publications at that time, but also in the attempts to reproduce the bronze vessels of antiquity in bronze and in other materials, including porcelain and jade. It is a great tribute to the bronze casters of the Shang and Zhou periods that archaistic bronzes are, for the most part, technically inferior to their ancient models.

GOLD AND SILVER

Although gold and silver were highly prized in the Far East, they never achieved the same degree of importance as in the West. They were, for the most part, overshadowed by other metals – bronze in China and iron in Japan – while a status comparable to that of gold and silver in the West was accorded to the finest examples of jade, lacquer and porcelain. The Tang period (AD 618–907), however, saw enormous technical advances and innovations in the craft of the goldsmith, and some of the finest examples of Chinese gold and silver were produced at that time.

The Tang period was one of military conquest, with China extending her borders into Central Asia. A wide variety of goods were brought to the Tang capital, Chang'an, present-day X'ian, from regions to the west of China by way of the Silk Route (see

p. 182), and the influence of Central Asia is clearly reflected in the exotic arts being produced there.

Among the foreign craftsmen resident at Chang'an were Sassanian goldsmiths. It was undoubtedly their expertise which provided the great stimulus to the manufacture of gold and silver wares in Tang China. Chinese goldsmiths evolved a style which incorporated features from the work of Sassanian Persia and India, as well as the lands of Central Asia, together with traditional Chinese motifs. This is reflected in certain forms of Tang gold and silver wares, such as the stem cup, ewer and lobed bowl, and in elements of design, including palmettes, floral scrolls and ring-punched backgrounds.

Gold and silver were not readily available in China, and they were always expensive commodities. For this reason Chinese goldsmiths worked with thin sheets of metal and frequently sought to make economies. This could be achieved, for example, by gilding a base metal or even by using silver, which was cheaper than gold. There was no standard minimum content of gold or silver so that the percentage of other metals, such as copper, tin and lead, that the precious metals contained varied considerably.

Gold is extremely malleable and can be beaten out into a thin sheet. Silver, on the other hand, is less malleable, and prolonged hammering distorts the crystalline structure, making it hard and brittle until, eventually, it breaks. By annealing the metal, which involves reheating it to a dull red heat and allowing it to cool, a new crystalline structure is formed, leaving it soft and malleable once again. The process might have to be repeated several times during the working of an object.

Any method of working these metals which involved hammering is generally termed 'chasing.' 'Raising' is a particular method of chasing which was commonly used to make bowls, cups, spoons and other rounded forms. Starting with a circular sheet, the goldsmith beat it with a hammer, working from the centre outwards. In this way the sides were worked up and shaped to form the outline of an object. For more complex shapes, individual sheets were hammered out to the desired size and thickness, and were then soldered together, using an alloy of silver with copper. Other articles were made by casting, though this method was used for forming only a small quantity of gold and silver wares. It was common, however, for certain parts of an object, such as the handles and stem, to be cast and then soldered on to the main body.

The most widespread type of surface decoration found on Tang gold and silver wares was known as 'tracing.' This was executed by means of a blunted chisel, which was beaten with a hammer against

the metal to produce an indentation on the surface. With each successive blow of the hammer the tool was driven into and along the surface, displacing the metal slightly but never cutting it away. This method contrasts with engraving, a technique in which lines of the design were actually cut away with a sharp tool. During the Tang period engraving was rarely used, possibly because the goldsmith used such thin sheets of metal, and then only to add details of the design.

One of the most characteristic features of Tang gold and silver ware is the background of small and tightly packed circles. These were probably executed by beating with a small stamp bearing numerous raised circles. Since tracing produced motifs in outline

● *Right :* Underside of a Chinese silver bowl with parcel-gilding, Tang period (AD 618–907). The lotus petals on the body of the bowl were formed by *repoussé* work, which combines embossing and tracing. Tracing was also used for the main elements of the design, many of which owe their origin to sources outside China. These are set against a ring-punched ground.

form which were comparatively plain and flat, a textured ground pattern of circles was used to complement and contrast with it, such a contrast also helping to create an illusion of relief.

Relief in the true sense was provided by means of a combination of embossing and tracing, a technique known as *repoussé*, and it is frequently found on the back of Tang mirrors. Using punches and hammers, the metal was pushed out into rounded shapes, such as lobes and bosses.

CLOISONNÉ ENAMELS

Enamel is a glossy, vitreous substance which is fused to a metal surface by heat. The principal types of decorative enamelling are *champlevé*, *repoussé* and *cloisonné*. The *champlevé* technique involved carving out the cells to be filled with enamel from a thick metal surface, while in *repoussé* enamelling they were hammered into the metal. In *cloisonné* enamelling thin wires were attached to a metal base to form the cells, or *cloisons*, and it was this technique that was widely used in the Far East

Early examples of enamelling in the West, which date back to the second millennium BC, are thought to have been produced to simulate the effects of gold inlaid or encrusted with semi-precious stones. In the course of time, however, enamelling became an art form in its own right. Even though a knowledge of metallurgy and of glass technology, essential to the practice of enamelling, existed in China by the fifth century BC, *cloisonné* enamelling was not developed in China until the Yuan period (1279–1368), with almost all surviving examples dating from the fifteenth century onwards.

The base material for *cloisonné* enamelling was usually copper or bronze. The metal used from the Ming period (1368–1644) onwards had the constituents of brass, which is an alloy of copper containing zinc, but modern usage permits objects of artistic merit in this material to be referred to as bronze. The base was shaped

either by casting or by chasing, which involved hammering out metal sheets and soldering them together. Since copper is <u>more</u> malleable than bronze, copper was often used for articles formed by chasing, while bronze was used for exposed surfaces, such as the rim. An extremely wide range of articles were made in *cloisonné*, including archaistic bronze-vessel shapes.

In the early history of Chinese *cloisonné* enamelling the wires were cut from hammered bronze sheets. They were bent to the required shape and then soldered on to the metal base. During the second half of the seventeenth century copper was used instead of bronze, and, at much the same time, a labour-saving method of making the wires was introduced. It involved drawing the metal through a die and resulted in wires of a more even thickness. By the eighteenth century the soldering of wires had been largely superseded by the use of a <u>rice paste</u>. This burned away during firing, leaving the wires held in place <u>by</u> the enamels.

The main function of the wires was to help the enamel to adhere, since enamel (on its own) was liable <u>to break away</u> from the metal surface. Where the wires were not used in the design to separate areas of colour, they were shaped to provide interesting additional surface detail, for example in the form of scrollwork.

When *cloisonné* enamelling became popular in Japan, at a <u>later</u> date than in China, Japanese craftsmen were able to make use of the <u>latest</u> scientific research. Because of the improved fusion between enamel and body, for example, the ratio of enamel to wire could be increased. From 1880 onwards it became possible to use even fewer wires by employing sulphuric acid to remove some of them after

● *Right :* Chinese *cloisonné* enamel incense burner, sixteenth century. The shape is based on that of the ancient bronze *ding*, or tripod. The rim, handles and feet are all later gilt-bronze additions. The floral designs are in turquoise, green, white and dull red enamel. The wires have been distributed evenly over the entire surface to help the enamels to adhere to the base.

firing. Then, in 1889, the first wire-less *cloisonné*, known as *musen-jippō*, was produced by a process which entailed removing the wires before firing. Ultimately, a technique was perfected in which the body was removed altogether. This was achieved either by dissolving the body in acid or by using a backing sheet of a material such as mica, to which the enamels would not adhere and which was easily removed. This technique, known as *plique à jour*, had the pleasing effect of allowing light to pass through the translucent enamels.

The enamel paste was made up of such materials as sand, soda or potash, in varying proportions. When heated, they melted to form a type of glass known as 'frit.' Although the frit was naturally tinged with blue or green, a range of colours could be obtained by the addition of a colouring agent, usually in the form of metal oxide. In China, during the fifteenth century, the range was limited to blue, turquoise-blue, dark green, red, yellow and white, and gradually this was extended. Other colours were produced by mixing different-coloured pastes together within a *cloison*.

The greatest advance in the use of colours occurred in Japan. With the establishment of the Ahrens Company in Tokyo in 1875, the owner procured the services both of the leading *cloisonné* artist, Tsukamoto Kaisuke, and of Gottfried von Wagner, one of the Western technologists brought to Japan to help improve native arts and crafts. As a direct result of Wagner's experiments, enamelling took a major step towards becoming a modern, scientific art with the introduction of new, chemically constructed enamels.

Before it could be applied to the metal body, the frit was powdered and washed thoroughly. The design was painted on to the body and the metal wires were attached to correspond to these areas. The enamel pastes were then pushed down into each cell formed by the wire, generally with one colour to a cell.

Cloisonné enamels were fired in small clay ovens known as muffles. The temperature required to melt the enamel paste varied according to the type of enamel, some having a higher melting-point than others. It was customary to fire those enamels with a higher melting-point first, then add other enamels and lower the temperature with each subsequent firing. Since heat caused the enamel to shrink, it was necessary to press in additional paste after each firing. The object was then carefully rubbed down to expose the wires once again, to remove any surface defects and to provide a uniformly flat surface. Finally, the lengthy process of polishing, using progressively finer powders, helped to bring out the lustre and inherent beauty of *cloisonné* enamelling.

● *Above :* Japanese opaque enamel vase with the metal backing removed, *c.* 1900. A vase with a wisteria design in mauve, green and grey enamels. The exposed metal parts are in gilt bronze and *shakudō*.

JAPANESE SWORDS

The course of Japanese history was marked by repeated civil wars. The manufacture of arms and armour was therefore essential; more than this, however, the sword gradually assumed a position of symbolic importance in Japanese society.

The manufacture of a Japanese sword required the utmost skill and experience and, because of the esteem in which it was held, the making of a sword became an event of profound significance, steeped in ritual. For tempering the blade, the final and most crucial part of the process, the swordsmith wore ceremonial dress, complete with a small black lacquer hat. A *shimenawa*, or rice-straw rope, was stretched across the entrance to the smithy to ward off evil spirits.

A combination of iron and steel was widely used in the manufacture of Japanese swords, but the finest were considered to be those made from steel alone. Iron was obtained by smelting rock with a high iron content. Smelting produced a metallic iron mass with the highest carbon content at the bottom and the lowest at the top. This was broken up into small pieces to remove the slag. In order to obtain a workable material, it was necessary to forge the metallic iron. This was achieved by heating the metal until red hot and hammering it on an anvil. Steel is an alloy of iron with the addition of a small amount of carbon. Low carbon steel, often referred to as wrought iron, contains less than 0.5%, and high-carbon steel, known as cast iron, has up to 5%.

● *Right :* Japanese woodblock colour print by Kuniyoshi (1797–1861), *c.* 1840. No. 99 from the Hundred Poets series, depicting the Emperor Go-Toba forging a sword. The emperor is seen hammering the red-hot metal on an anvil. He is wearing ceremonial dress with a black lacquer hat, which is frequently associated with the final stages of making a sword blade. Across the entrance to the smithy is a rice-straw rope, or *shimenawa*.

To manufacture a steel blade, two or more strips of steel, frequently of different grades, were superimposed and welded together, forming a billet. This was folded in on itself down the middle, raised to a welding heat over a pine-charcoal fire, and hammered out to its original dimensions. In order to prevent the conversion of the steel to a softer iron by oxidization of the carbon, the billet was covered with a thin layer of clay sprinkled with straw ash before being heated. At the same time care was taken to keep the anvil clean and to avoid touching the metal by hand lest impurities were worked into the metal, which would have caused imperfections in the finished blade.

The process of folding, welding and hammering was repeated some 15 to 20 times and resulted in several thousand layers of steel. On occasions, three or four billets were welded together and the complete folding cycle was carried out five more times.

The difference in hardness between iron and steel could be exploited to produce a composite blade with a hard outer skin and a softer inner core. The steel from the outer skin was hammered out and then broken into small, evenly sized pieces to remove any remaining slag. Next the pieces were heated and hammered out to form a bar. The bar was folded in on itself, welded and hammered, the procedure being repeated between 15 and 20 times.

The folding cycle could also be carried out some 12 times on the low-carbon steel which was to form the core. The inner core and outer skin were then welded together, either by wrapping the skin round the core or by making a V-shaped indentation in the skin to take the core. The resulting compound was hammered out to a long bar and, through repeated heating and hammering, the swordsmith was able to shape the sword, providing the blade with a curve and creating the cutting edge.

Apart from removing impurities from the metal and making sure that it was even and consistent, the folding process also produced a

●THE JAPANESE SWORD
Above: Japanese sword with scabbard and fittings. *Below:* the unsheathed sword.
(1) *kashira*, pommel; (2) silk braid, usually dark in colour; (3) nodular skin of ray-fish; (4) *menuki*, decorative fittings; (5) *fuchi*, collar; (6) *tsuba*, guard; (7) *seppa*, oval washers; (8) *habaki*, collar; (9) *kōgai*, handle of a skewer-like implement; (10) *yakiba*, tempered steel edge; (11) scabbard; (12) *kojiri*, butt.

'grain', which was the crystalline structure formed by heat. The experienced swordsmith was able to control the appearance of this by using iron and steel of different qualities and by repeatedly folding them in on themselves. In addition, during the final stages of forging he could gouge out small areas in the surface of the billet or dent it by hammering. When the billet was subsequently hammered flat, the different layers of metal were revealed at various angles to great advantage. The different types of grain had names such as *mokume*, which resembled wood grain, and *masame*, which had the grain in parallel lines. However, the grain was not fully visible until the blade had been polished.

After forging, a scraper and file were used for fine shaping of the blade. It was at this stage that the signature of the swordsmith was chased on to the blade, as well as any other inscriptions or small decorative carvings, frequently in the form of dragons and Buddhist figures or symbols.

The crucial tempering of the blade involved coating it with a heat-resistant mixture of ferruginous clay, sand and charcoal powder. A sharpened bamboo stick was used to move this mixture inwards, away from the edge of the blade, and to create a straight, wavy or irregular inner outline.

Once the mixture had dried and hardened, the smith held the tang, that would fit into the handle, with pincers and lowered the blade into the fire. He left it there until the required temperature was reached: with the aid of bellows this was usually only a matter of minutes. With the forge darkened, the smith could tell the exact moment when it should be withdrawn by watching the colour of the glowing blade where the metal was exposed near the tang. The blade was then plunged into a trough of water, vertically in the case of a straight blade and horizontally if it were curved. The exact temperature of the water and the length of time the blade was immersed was a matter of judgement based on experience.

The unique quality of a Japanese sword lay in the hard-tempered, razor-sharp cutting edge where the clay and sand mixture had been removed. This contrasted with the remaining area, which had been covered by the mixture and was therefore soft tempered. The area between the edge of the sword and the limit of the clay and sand mixture was known as the *yakiba*, or tempered-steel edge. This took the form of a pearly lustrous band, about 6 to 12 millimetres wide, which ran along the edge of the blade. It was considered to be of great aesthetic beauty and one of the features greatly admired by connoisseurs of Japanese swords.

At this stage the sword blade was carefully checked for flaws and imperfections; the smith had no hesitation in destroying one if it

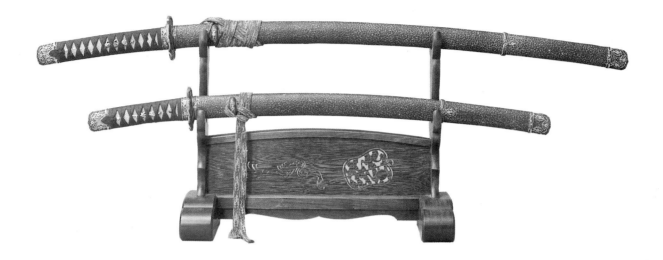

was not in his opinion perfect. Next the cutting edge was ground and sharpened, while other areas were burnished. The blade was then polished, a lengthy process in which different types of stone, graded from coarse to fine, were used. The polishing was carried out initially by holding either end with cloths and rubbing the blade backwards and forwards along a whetstone. For the final polishing, however, the stone was rubbed along the blade. The proof of a good sword was in its 'practical' application and professional sword-testers subjected new swords to stringent tests on condemned criminals or corpses.

In the history of Japanese swords the year 1600 is taken as an artificial division between swords of old and swords of more recent type. Those produced before 1600 are known as *kotō* ('old sword') and those after as *shintō* ('new sword'). Of the various types of swords and daggers, those worthy of particular mention are the *katana* and *wakizashi*.

The *katana* and *wakizashi*, together referred to as the *daishō* ('large and little') were worn by samurai as symbols of their position during the Edo period (1615–1868). The *katana*, the most important fighting-sword in Japan, was approximately 90 centimetres long and slightly curved. It was worn thrust through the belt, with the cutting edge up.

For practical reasons, the sword blade needed to be fitted with some type of handle, or hilt, together with other sword fittings and a protective outer case, or scabbard. When mounting a sword, a *habaki* was first slipped round the blade. This was a collar which

● *Above:* Japanese *daishō*, iron, gold and other metal alloys, lacquer and wood, sixteenth, seventeenth and eighteenth century. A *katana* (long sword) and a *wakizashi* (short sword), together referred to as *daishō*, mounted on a decorated wooden stand. The *katana* is signed Umetada Yamato Daijo Minamoto Yoshinobu, who was active during the early seventeenth century. The *tsuba* of both swords are identical; they date from the early eighteenth century and were made by a member of the Gotō family. The blade of the *wakizashi* is of the *kotō* type (before 1600). The swords have matching mounts and scabbards.

126

● *Above :* Japanese *fuchi-kashira* (sword pommel and collar), signed Tsu Shumpo, late eighteenth century. Copper and gold crabs and waterweed on *shakudō nanako* ground.
● *Below, left :* Pair of Japanese *menuki* (decorative sword fittings), signed Gotō and Mitsuyo (Jōha) late seventeenth or early eighteenth century. Bows, arrows and quivers in *shakudō*, gold and silver.
● *Below, right :* Japanese *tsuba* (sword guard), signed Takahashi Okitsugu, early nineteenth century. An eight-lobed *tsuba* made up of layers of different copper alloys. The surface has been carved with scrolls so as to reveal the succession of layers.

held the end of the blade and the beginning of the tang. The *habaki* was generally made of copper and was frequently gilded. Its main function, when the sword was in use, was to transmit the strain back to the hilt. In assembling a sword, next came the *seppa*, a pair of oval washers, each of which had an aperture to receive the tang. They were positioned on either side of the *tsuba*, or sword guard.

The *tsuba* was an important fitting because it protected the hand and, above all, it provided an accurate centre of gravity for the whole assemblage. It was also the fitting which received the greatest decorative attention. In the form of a flat disc, it was generally round, oval or elliptical in shape. At the centre was an opening for the tang, and on either side there were often secondary perforations to admit the *kozuka* and *kōgai*. The *kozuka* was the flat oblong handle of a small knife, though the term was frequently applied to both knife and handle. The *kōgai* was a skewer-like implement used as a personal accessory.

The hilt was composed of two pieces of carved wood, generally magnolia, which were glued together leaving a recess for the tang. The hilt was frequently covered with the nodular skin of a ray-fish, over which a dark silk braid was wrapped. This was done in such a manner as to obscure most of the skin except where it showed through regular diamond-shaped openings in the braid. Partly concealed and held in place by the cord were a pair of small ornaments, or *menuki*, one placed slightly higher than the other. These are thought to have derived from the ornamental ends of pegs used to secure the tang in the hilt, and they served to improve the grip. The *fuchi* and *kashira* were designed to strengthen the hilt at either end. The *fuchi* was a collar fitted round the hilt at the guard end, while the *kashira* covered and protected the other end.

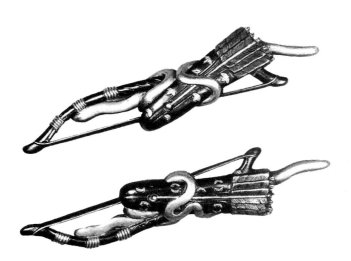

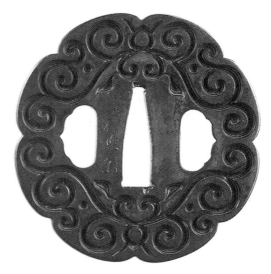

127

The scabbards of certain types of sword, though generally not the *katana*, had slots to carry such implements as the *kozuka* and *kōgai*. Their handles protruded from the scabbard towards the sword hilt as far as the upper side of the guard, which consequently had two openings through which they passed. The scabbard was made of wood in two halves, with the inside carved to fit the blade. It was generally lacquered, in subdued colours, to strengthen it.

The majority of sword fittings were made of metal, although examples survive in materials such as ivory, wood and lacquer. Since many of the early fittings were made by swordsmiths and armourers, iron was originally the material <u>most</u> frequently used. With the emergence of specialist metalworkers, however, the range of metals greatly increased, particularly during the Edo period. It included gold and silver, bronze, brass and copper, together with three special copper alloys, *shakudō*, *shibuichi* and *sentoku*, which were <u>peculiar</u> to Japan. All three were treated with acidic solutions in pickling baths which produced splendid colours. *Shakudō* contains 95%–99% copper and 1%–5% gold, with small amounts of silver, antimony and arsenic, and occasional traces of lead. Pickling produced colours ranging from blue, purple and brown to black. *Shibuichi* is made up of copper with up to 25%

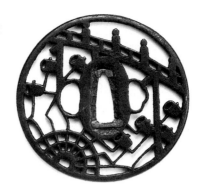

● *Above:* Japanese iron *tsuba*, sixteenth or seventeenth century. A *tsuba* in openwork iron with a positive silhouette of a water-wheel and bridge.
● *Left, top:* Japanese *kozuka*, signed Gotō Mitsunaga (1533–72). Gold dragon chasing a pearl in silver waves on a *shakudō nanako* ground, enclosed by a gilt border.
● *Left, bottom:* Japanese *kōgai*, signed Kikuoka Mitsutoshi, c.1825. Gold lion on a *shakudō nanako* ground.

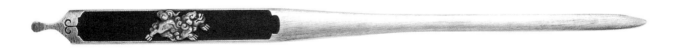

silver, and it is frequently a light shade such as grey. *Sentoku*, a variety of brass containing some lead and tin, is a yellow metal.

It was not until the fifteenth century that a significant quantity of sword furniture began to be decorated, reaching a climax during the Edo period. The fact that some of the finest examples of sword fittings were produced during this long period of <u>peace</u> is not surprising. In times of war it was necessary to manufacture weapons that performed their primary function, and decoration of the surface was minimal. Only in times of peace could time and expense be spent on embellishments.

● *Right :* Reverse side of a
Japanese *tsuba* in *shibuichi* and
other metals, by Tomonaga,
1864. A dog barking under a
crescent moon. Since part of the
tsuba is in openwork, the viewer
has a tantalizing glimpse of the
elements of design on the main
side, which shows the priest
Yuten Shonin exorcising the
ghost of Kasane.

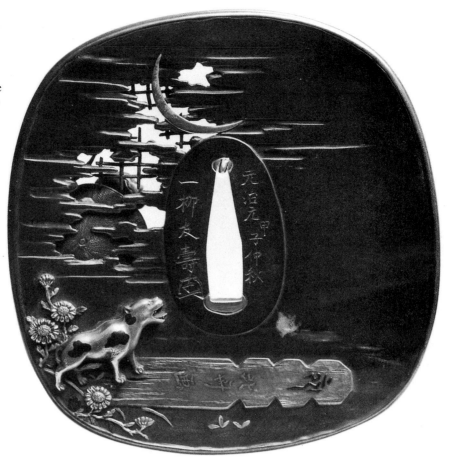

Openwork designs executed with a fretsaw were amongst the earliest type of decoration on sword guards. These were either in the form of a negative silhouette, with the outline formed by pierced lines, or they were in the form of a positive silhouette. With the latter, the outline was left in metal and the intervening areas removed, which resulted in a higher proportion of openwork than metal. Many sword fittings, however, simply had small areas of the design in openwork.

The Japanese metalworker used a wide variety of tools to carry out designs by means of carving, in low and high relief, chasing and engraving. A technique known as *katakiri* engraving was introduced by Yokoya Sōmin. This involved cutting a groove into the surface which, in cross-section, had one straight line and one sloping. It produced an effect in metal similar to that of brushstrokes in painting.

Other sword fittings have designs executed in inlay or overlay. The former was achieved by hammering a thin piece of metal into a shallow, shaped depression. Overlay was made by scoring a metal

surface so as to make it sufficiently rough for other pieces of metal to adhere when hammered on. The use of metal encrustations was also widespread. It was a practical way of using minute amounts of gold and silver to great effect.

Another method of decorating sword furniture was to use the metal surface to imitate another medium. A lacquering technique known as *guri* (see page 166) was imitated in metal by superimposing sheets of different metals and alloys one on top of the other. Scrolls, which were V-shaped in cross-section, were then cut into the surface to reveal the different layers beneath. Other kinds of

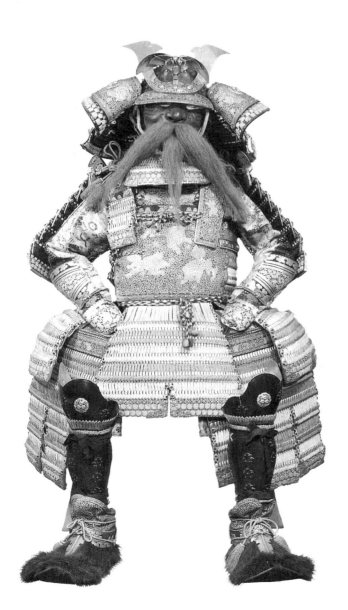

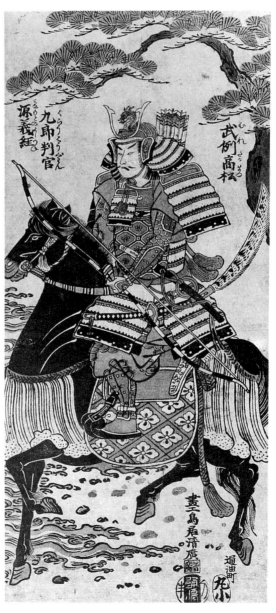

surface decoration included the imitation of wood grain or regular rows of tiny circles punched into the metal surface resembling fish-roe known as *nanako*.

The decoration on Japanese sword fittings was varied and was frequently inspired by nature. The Gotō family of metalworkers frequently based their designs on Kanō school paintings, while others reproduced well-known Ukiyo-e woodblock prints. The focus of decorative attention on sword fittings during the Edo period resulted in a proliferation of metalwork schools, probably the most notable of which was the Gotō, which could be traced back to the fifteenth century. Since it was customary for swordsmiths and specialist metalworkers to add signatures to their works, it has been possible to identify some 3,000 craftsmen and at least 60 distinct schools.

ARMOUR

Another important article employing the skills of Japanese metalworkers was armour. Although iron was the principal material used, the making of a suit of Japanese armour required the expertise of various craftsmen in addition to the metalworker, including the specialist in leatherwork and silk cords, and the lacquerer. The finished effect was a spectacular contrast between the black lacquer and coloured silk cords, the stencilled leather-work and decorative metal fittings.

Japanese armour was made up of various sections which fitted round the body and which had protective pieces attached to them. The body armour consisted of numerous iron and leather strips closely laced together with silk cords and leather thongs and lacquered for greater strength.

There were particular styles of armour for the various different forms of combat: while some fell from use altogether, others were modified and improved to meet changing needs. For example, the body armour of the *ōyoroi* style was composed of two main pieces, with four thigh-guards, shoulder-protectors, a helmet and a broad neck-guard. It was designed to be worn on horseback by warriors of high rank during the late Heian (794–1185) and Kamakura (1185–1392) periods. The *dōmaru*, composed of one main piece with a greater number of smaller thigh-guards, was worn by footsoldiers. With the decline of mounted combat, samurai began to reject the *ōyoroi* style of armour in favour of the *dōmaru*, but incorporated the shoulder-guards and helmet of the former. During the fourteenth and fifteenth centuries a simpler and more lightweight armour came into use which dispensed with helmet and shoulder-guards.

With the introduction of firearms by the Portuguese in 1543,

● *Far Left*: Japanese suit of armour, *ōyoroi* style, by Myōchin Mondo Ki no Muneharu, dated 1859. The main body of the armour consists of small leather plates and lacquered iron, laced together, with a breast-plate of stencilled leather, iron chain-mail on the sleeves, and leg-guards. The iron helmet has gilt fittings with horns and a forecrest, as well as a neck-guard. The sides of the helmet are turned back to reveal stencilled leather.

● *Near left*: Japanese woodblock colour print by Kiyohiro (died 1776), c. 1750. A print showing the fearsome warrior Yoshitsune, from a series entitled *Mure takamatsu* ('Tall pines amongst the ranks of warriors'). He is dressed in full armour, including a stencilled leather breast-plate and a helmet with horns, forecrest and neck-guard. Also visible are the *katana* and *wakizashi* swords, as well as a bow and arrows.

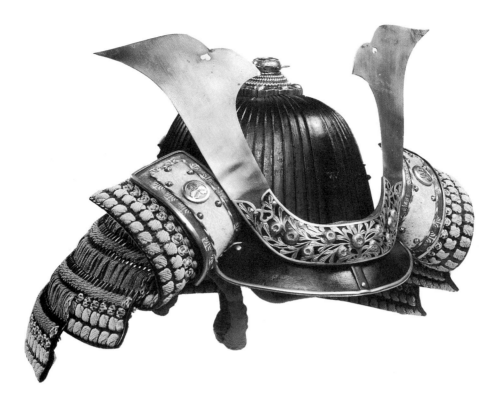

attention was centred on trying to make the traditional Japanese armour bullet proof. Certain modifications were brought in, such as stronger helmets, shoulder-guards made of sheets of wrought iron and iron masks which covered all or part of the face. On occasions the numerous small plates of traditional Japanese armour were abandoned for larger solid plates of iron of Western origin, particularly for the chest armour.

Since the Edo period was one of peace, there was a demand for armour for ceremonial use rather than for combat. Practicality of material and design thus became secondary to outward display. There was a renewed interest in the appearance of armour of the past and in using the different styles in combination there was an obvious lack of understanding of their underlying principles.

The helmet was considered the focal point of a suit of armour during the Momoyama (1568–1615) and Edo periods. It was composed of numerous metal plates, occasionally numbering 100 or more, which were shaped and riveted together along vertical joins; they radiated from a central point at the top of the crown. Some helmets were fitted with the additional features of horns and a forecrest. The whole effect was offset by an iron mask, often with a ferocious countenance and complete with whiskers. Cumbersome and ostentatious helmets and masks of this kind were certainly unsuited to anything but ceremonial use.

● *Above :* Japanese helmet and neck-guard, signed Myōchin Nobuie, sixteenth century, with nineteenth century mounts. The helmet is made up of 62 iron plates, with gilt copper horns and a forecrest decorated with openwork chrysanthemums. The neck-guard consists of small lacquered plates arranged in four rows and laced together with blue, red and multi-coloured silk braid. Where the neck-guard turns back, the stencilled leather facing is exposed.

132

● *Right, top :* Japanese articulated wrought-iron dragon, with copper tongue and gilt eyes, signed Myōchin Nobumasa, nineteenth century. Almost every part of this figure, including the individual scales, is fully articulated, which enables it to be moved in a life-like manner.

● *Right, bottom :* Japanese articulated wrought-iron snake with gilt eyes and tongue, signed Myōchin Munenobu, nineteenth century.

The sixteenth century witnessed the rise of some of the great families of armourers. Notable among them was the Myōchin family, reputed to have been founded by Myōchin Munesuke during the twelfth century, which specialized in ironwork for both armour and sword furniture. Since the latter part of the nineteenth century saw the end of armour as a necessary adjunct to modern warfare, and since from 1876 onwards samurai were no longer permitted to carry swords, the Myōchin and other armourers found it necessary to diversify in order to maintain their livelihood. Instead of producing arms and armour, they turned their skills to metalwork of a purely decorative nature. They were particularly noted for the manufacture of articulated animals – insects, birds, dragons and crayfish. These were made up of numerous small plates of iron which were joined together in such a way as to allow them to be moved in a realistic manner.

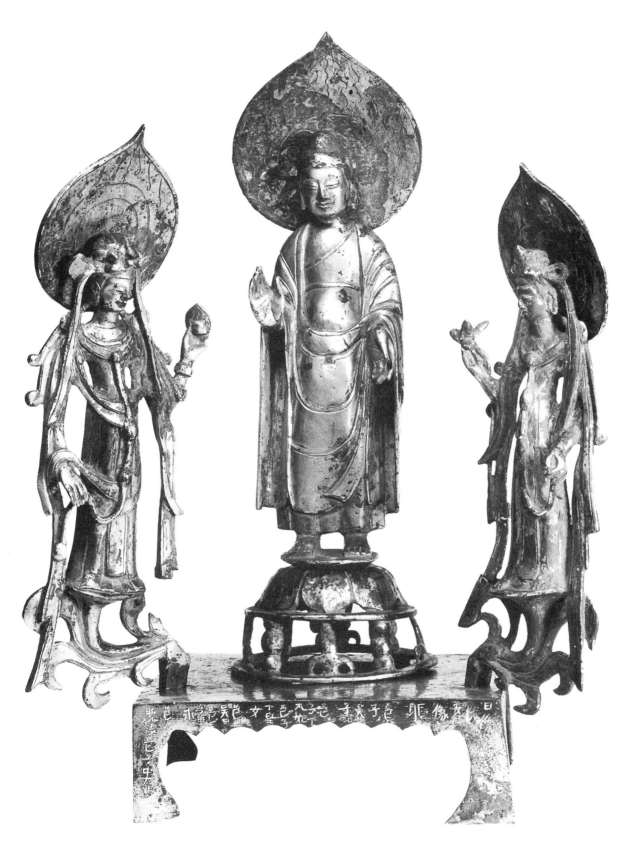

134

Chapter 5
SCULPTURE AND CARVINGS

THREE-DIMENSIONAL representations, whether in the round or in relief, and made in a wide variety of materials, are categorized as 'sculpture' or 'carvings'. Those executed in a hard material, such as stone, wood or metal, are generally referred to as sculpture, the term referring to a type of representation, such as a religious image, rather than the manner in which it was shaped. Those which could conveniently be worked or held in the hand, and which were formed by carving or a related technique in materials such as ivory, wood or jade, are generally described as carvings. There is, however, no sharp division between the two: a piece of sculpture may have been carved, just as a carving may be considered to be a piece of sculpture.

BUDDHIST SCULPTURE

The most coherent group of sculptures in China and Japan is that associated with Buddhism. The religion, which had its origins in India in the fourth century BC, spread along the Silk Route of Central Asia (see p. 182), reaching China during the second century AD. Nearly four centuries of comparative peace came to an end with the fall of the Han dynasty in AD 220. External threats and internal strife led to years of insecurity as petty princes fought for power. Buddhism, promising personal salvation through the intercession of a host of deities, answered a spiritual need <u>not</u> provided for by existing religions and philosophies. It reached Japan by way of Korea later, the official date given as 538 or 552.

Buddhism arrived as a <u>complete</u> religious system, with holy scriptures (*sūtra*), priests, monastic orders and ritual observances, a flourishing art, and a detailed iconography. Since the main Buddhist texts brought from India were in Sanskrit, this was the language which provided Buddhism with its basic terminology.

To most Westerners the iconography of Buddhist art is <u>unfamiliar</u> and needs some explanation. The Buddhist pantheon includes numerous deities, who appear in a variety of forms, central to which is the Buddha. The Buddha denotes one who has achieved complete enlightenment and who represents the highest level of existence. He is portrayed with a number of distinguishing

● *Above :* Japanese stained ivory netsuke with inlaid eyes, late eighteenth century. A Mongolian archer.

● *Left :* Chinese gilt-bronze figures, dated 597 AD. Śākyamuni Buddha with two attendant Bodhisattvas, possibly Maitreya and Avalokiteśvara, holding a lotus and flaming jewel respectively. The solid and somewhat austere appearance of Śākyamuni on the lotus pedestal contrasts with the graceful, undulating bodies of the Bodhisattvas, supported on curved brackets.

135

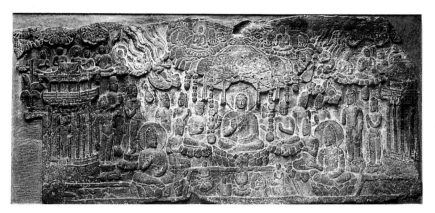

● *Left :* Chinese grey limestone *bas-relief,* Northern Qi (AD 550–577). Amitābha, seated on a lotus throne with his right hand raised in *abhayamudrā*, welcomes the newly born souls emerging from lotus blossoms.

● *Below left :* BUDDHA
(1) *uṣṇīṣa,* or bump on the top of the head ; (2) *ūrṇā,* which gives out a ray of light ; (3) lengthened ear lobes ; (4) fleshy folds of neck ; (5) priestly robes, covering the left arm and draped over the right shoulder ; (6) *mudrā,* or symbolic position of the hands ; (7) *āsana,* or symbolic position of the feet ; (8) lotus throne.

features, such as lengthened ear lobes, an *ūrṇā*, or raised spot between the eyebrows from which emanates a ray of light to illuminate the world, and an *uṣṇīṣa*. This is a bump on the top of the head which accommodates the superior wisdom acquired by the Buddha on attaining enlightenment.

The Buddha is generally depicted wearing priestly robes, which cover his left arm and shoulder and are partly draped over his right. He is portrayed standing or seated, in the latter case with his legs crossed in a position of meditation. When standing, the Buddha, as well as other divinities, is depicted on a lotus pedestal, and on a lotus throne when seated.

● *Near right :* MUDRĀ
Symbolic hand gestures :
(1) *abhayamudrā,* right arm held up with palm facing out in a gesture granting absence of fear ; and *varamudrā,* left arm hanging down with palm out in a gesture of giving ; (2) *bhūmisparśamudrā,* a gesture of touching the ground ; (3) *dhyānamudrā,* a gesture of meditation ; (4) *dharmalakramudrā,* representing the turning wheel of the Law ; (5) *vajramudrā,* a gesture of knowledge ; (6) and (7) *vitarkamudrā,* a gesture of discussion or appeasement.

● *Far right :* ĀSANA
Symbolic positions of the legs :
(1) *dhyānāsana,* representing the lotus posture of meditation ; (2) *lalitāsana,* position of relaxation ; (3) *bhadrāsana,* frequently used as a position of Maitreya, often also shown with ankles crossed ; (4) *mahārājalīlāsana,* position of 'royal ease'.

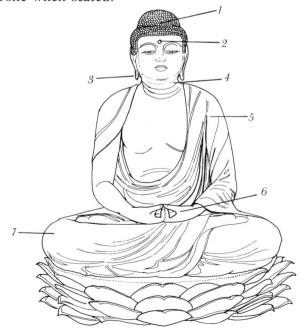

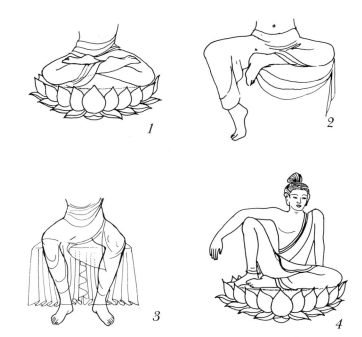

During the first century AD a school of Buddhism developed known as the Great Vehicle (Mahāyāna), while all other types were referred to as the Little Vehicle (Hīnayāna). According to the Mahāyāna doctrine there were many Buddhas in existence at the same time. It is often possible to distinguish between them by the position or gestures of their hands (*mudrā*) and of their legs (*āsana*). For example, the historical Buddha Śākyamuni (Japanese: Shaka) is frequently portrayed with his right hand raised, palm outwards in a gesture of reassurance or blessing. His left hand generally hangs down, palm outwards in a gesture of giving.

Amitābha (Chinese: Amituo; Japanese: Amida) was the Buddha who presided over the Western Paradise. The compassionate nature of Amitābha, together with the direct appeal of the Western Paradise, made him extremely popular in the Far East from the mid-sixth century onwards. He is frequently portrayed with his hands in the same positions as Śākyamuni.

The Buddha able to cure physical and spiritual ailments was Bhaiṣajyaguru (Japanese: Yakushi). He is frequently shown with a medicine pot in his left hand and with his right hand raised, palm outwards. In Japan, he is frequently portrayed with his Bodhisattva attendants, Nikkō and Gakkō. Nikkō, the Bodhisattva of the sun, is identified by a sun in his crown, while Gakkō, the Bodhisattva of the moon, has a moon in his crown. Mahāvairocana (Japanese: Dainichi or Roshana) was popular in Japan during the seventh and eighth centuries as the main deity of Esoteric

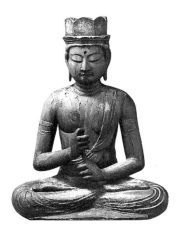

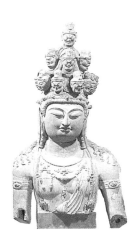

Buddhism (Japanese: Mikkyō), a sect which found favour in Japan as a result of the widespread corruption which existed at that time.

A Bodhisattva is one who possesses all the necessary spiritual qualities to become a Buddha. According to the Mahāyāna doctrine he has actually achieved enlightenment but, before entering *nirvāna*, or eternal bliss, he strives to relieve the suffering of mankind. A Bodhisattva is generally shown as an Indian prince and represents the historical Buddha, Śākyamuni, before he became a Buddha. He is generally portrayed as a splendid figure, adorned with jewellery and wearing a crown. The upper part of his body is either left bare or is loosely draped with thin silk.

The Bodhisattva Avalokiteśvara (Chinese: Guanyin; Japanese: Kannon) was thought to embody compassion and, for this reason, was popular in both China and Japan. Although Guanyin was first portrayed as a man, by the Song period (960−1279) in China he had assumed many female characteristics. Guanyin is identifiable by the ambrosia flask containing the nectar of immortality, or by the lotus flower held in the hand and the small figure of Buddha in the headdress. Guanyin appears in many different forms, being popularly portrayed in Japan with 11 heads, or with many arms to represent the Thousand-armed Kannon.

Kṣitigarbha (Chinese: Dizang; Japanese: Jizō) was thought to save those suffering in hell, and in Japan he became the guardian of children. Unlike other Bodhisattvas, he was generally depicted dressed as a priest, holding a staff in his right hand and a jewel in the left.

Maitreya (Chinese: Miluo; Japanese: Miroku) was the Buddha of the Future, who was expected to appear and lead mankind to salvation. A disciple of Śākyamuni, he was reborn to the Tuṣita Heaven, where he was to remain until the time came to return to earth. He was sometimes portrayed after he had become a Buddha, but he was most commonly seen as a seated Bodhisattva meditating in Tuṣita, with his ankles crossed. Maitreya was the most popular

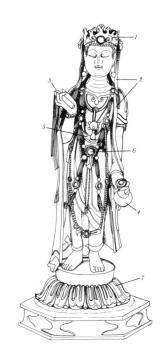

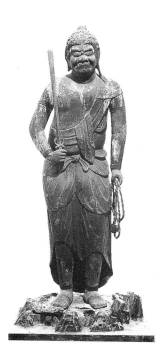

● *Below :* Japanese carved wood figure, eleventh century. Fudō Myō-O, a fierce divinity. Apart from a frightening facial expression, he is distinguished by his two main attributes : a sword in his right hand and a rope in his left. These were used in the fight against evil.

Buddhist image in early Chinese sculpture, to be succeeded by Amitābha in the period after the Northern Wei (AD 386–535).

The various Buddhas and Bodhisattvas were shown individually or as a group, which usually consisted of a Buddha and two Bodhisattvas. Maitreya, for example, was either portrayed on his own seated in meditation or as part of a trinity, standing on the left of Śākyamuni. In representations of Maitreya meditating in the Tusita Heaven he might be accompanied by two standing Bodhisattvas, two kneeling monks, two guardians and two lay figures worshipping.

The Buddhist pantheon also includes examples of heavenly beings and fierce divinities. Examples of the former were the Guardian Kings of the Four Quarters. In order to protect the four quarters of the universe, they were dressed in armour, carried weapons and assumed a fearsome aspect.

Fierce divinities were introduced to Japan during the Heian period (794–1185) and figured prominently in Japanese Esoteric Buddhism. Frequently depicted in a group of five with Fudō as the most important among them, they manifested the wrath of the Buddha Dainichi against evil. Fudō was generally identified by a sword, which he carried in his right hand, and by a rope which he carried in his left.

SCULPTURE IN STONE, BRONZE AND CLAY

The main materials used for Buddhist sculpture in the Far East were stone, bronze, clay, dry lacquer and wood. Depending partly on availability and on local skills, some of these materials were more widely used at particular periods.

Examples of Japanese Buddhist sculpture made from stone are comparatively rare since no suitable stone was to be found there, but in China it was the most widely used material. The practice of cutting cave temples into the rock was transmitted to China and Korea from India, and a great many Buddhist sculptures in China were carved directly into the rock face. By the time Buddhism reached Japan it had already become customary to build rather than carve out the temples and to create free-standing images. The first of several cave temple complexes at Yungang, in northern Shanxi province, was hollowed out of the sandstone cliffs between AD 460 and 494, and there was another period of activity between AD 500 and 535. It consists of a series of caves and a number of enormous images. The largest of them, in Cave XX, measures 14 metres from top to bottom and was cut into the side of the cliff.

The return of the pilgrims from India during the seventh century marked the beginning of a new period of religious activity

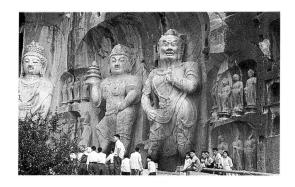

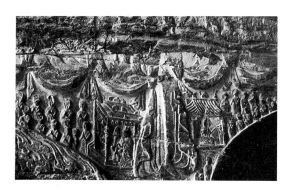

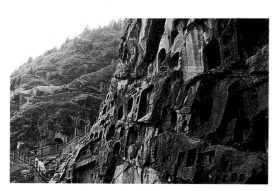

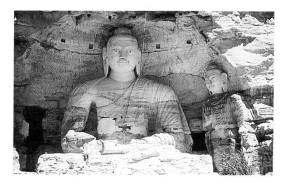

● *Above*: *In situ* illustrations from the grey limestone cave-temple complex at Longmen, near Luoyang, Henan province: (top left) heavenly guardians with attendant Bodhisattva on the left, after AD 672; (top right) cave ceiling, showing the haphazard way in which numerous Buddhist images, paid for by donors, were crammed into the available space; (centre left) detail showing the ordered arrangement of the cave wall, above the main images, into horizontal rows with surrounding canopies; (centre right) general view of the south-facing cliff at Longmen, showing caves and niches. From the red sandstone caves at Yungang, near Datong, Shanxi province: (bottom) colossal Buddha, probably Śākyamuni, and attendant Bodhisattva, possible Maitreya, *c*. AD 466.

in China. The result was a complex of cave temples at Longmen in Henan province. It is apparent from the sculpture that the dense grey limestone of Longmen was more suited to fine detail than the coarse sandstone of Yungang.

A complex of cave temples generally consisted of one or more main caves, together with a number of lesser ones. Since a donor 'bought' whatever space he required, the entire surface of the inner cave walls was crammed with images, either in horizontal registers or in a more haphazard fashion, and of varying quality and size. At one end of the scale the Tang emperor Gao zong commissioned the main figures at the Fengxian temple at Longmen. The central figure, Vairocana Buddha, measures approximately 15 metres from

● *Right :* Chinese white marble stele, Northern Qi (AD 550–577). Maitreya as the Buddha of the Future, with hands in the *abhayamudrā* and *varamudrā* and ankles crossed in the *bhadrāsana*. The Seven Buddhas of the Past surround the halo, with flying *apsarases* (heavenly beings) hovering above them.

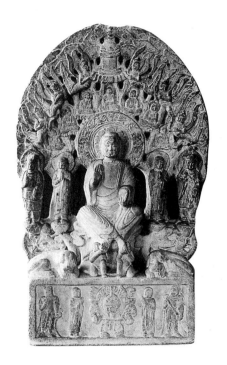

● *Below :* Reverse side of a Chinese limestone stele, *c.* AD 535–540. The entire surface is carved in high or low relief and broken up into horizontal registers, with worshippers, guardians and attendants around niches for Buddhas and Bodhisattvas.

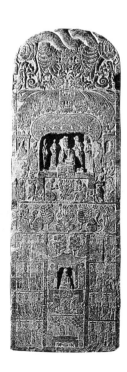

top to bottom and took stonemasons and sculptors three years to complete. Over the years a large number of images and friezes from Chinese cave temples were removed and have made their way into Western collections. When looking at these it should be remembered that they were never intended to be viewed in the round.

Another type of Chinese stone sculpture is represented by the 'stele,' which commonly took the form of a rectangular monolith. The stele was already used during the Han period (206 BC–AD 220) to carry commemorative inscriptions. The format was subsequently adopted as a Buddhist art form, though frequently without the inscriptions. The large surface area was broken up into horizontal registers executed with designs in low relief, together with small niches hollowed out to make the figures appear in high relief. This overall 'architectural' arrangement was similar to that found on the inner walls of the cave temples. The top of the stele, however, was a hangover from its earlier Han prototype. It was generally rounded and carved with the intertwined bodies of dragons. Within the context of Buddhism the stele served a votive or propitiatory function, or as a commemorative monument.

Apart from the stele, free-standing stone sculpture did not become widespread until the Sui period (AD 581–618) and later. Notable areas of production were in the region of Dingzhou and Baoding, in Hebei province, where sculptors made use of local micaceous white marble.

Bronze was a material widely used in China, Korea and Japan for early Buddhist sculpture. By the time Buddhism was introduced into China, bronze casting already had a long history, reaching a peak of technical and artistic refinement during the late Shang (*c.* 1600–1027 BC) and Zhou (1027–256 BC) periods. Indeed, some of the finest Zhou bronzes, such as the zoomorphic vessels, may be regarded as examples of sculpture in their own right .

The lost-wax process was the most common method of casting early bronze Buddhist sculptures. After casting, details were cut or finished with a chisel. To add to the decorative effect many bronze statues were gilded.

Bronze was successfully used to produce a wide range of sculpture, from cheap, standard cult images to some of the finest examples of Buddhist art. In Japan, the manufacture of the Great Buddha of the Tōdai-ji, Nara, which measures 16 metres in height, was an enormous technical feat, taking as much as four years to complete.

Clay was a material used in both China and Japan, particularly during the Tang (AD 618–907) and early Nara (AD 710–794) periods. The modelled images differed from pottery figures in that the clay, applied to a wood frame, was left unbaked.

The process comprised applying a layer of coarse clay mixed with straw to a wooden core, the straw acting as a ground to hold

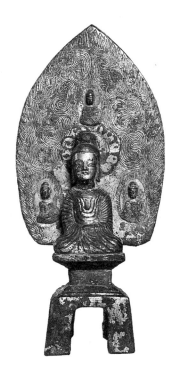

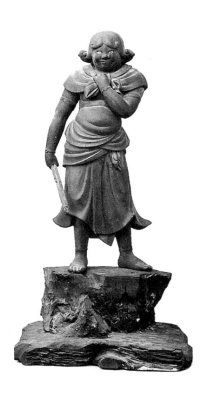

the clay. Wire was used instead of wood to form details, such as fingers. Next, a layer of finer clay was applied, followed by even finer clay mixed with paper. The final surface could then be painted or covered with gold leaf. The fact that these clay sculptures were heavy and easily damaged or broken has resulted in the loss of a large number of them.

This technique was revived during the Song period in China, whence it was reintroduced to Japan during the thirteenth century and successfully used for portrait sculpture. During the Song period, however, a new method was employed: two layers of clay were applied to a wooden core, and the surface was then coated with lacquer before being painted.

DRY LACQUER AND SCULPTURE IN WOOD

An alternative method of producing images was by what is known as the dry lacquer technique. This was used in China by at least the second half of the sixth century and was introduced to Japan during the early seventh century. The method involved laying several layers of hemp or linen cloth soaked in lacquer over a clay core. When these had dried, the resulting shell was cut open and the core removed. A wooden frame was then inserted into the hollow interior to add strength to the whole. Surface details were modelled with a paste made from a mixture of lacquer with incense powder, mud, kaolin or sawdust. The whole object was then lacquered and coloured or gilded.

During the second half of the eighth century a simpler method was developed. This involved making a wooden core that roughly corresponded to the required size and shape. The lacquer paste was applied to it and modelled as before.

The dry lacquer method, like the technique of working in clay, lent itself to fine and delicate modelling. However, since each layer of lacquer had to dry out thoroughly before the next was applied, it was an expensive and time-consuming method. There was an additional problem in that when dry lacquer was applied to a core made from a solid block, cracks were likely to appear on the surface produced by the tensions in the wood. In order to overcome this, Japanese craftsmen from the eighth century onwards began to hollow out the sculpture either from the bottom or from the back. This enabled the wood to shrink without splitting the outer lacquer surface, and also had the advantage of making the sculpture lighter and decreasing the time it took for the lacquer to dry.

In Japan, by far the largest group of sculptures was executed in wood. From the eighth century onwards the use of bronze, clay and lacquer declined and wood became prominent. Japan has a varied

● *Far left :* Chinese gilt-bronze seated Buddha, dated AD 451. The Buddha is surrounded by small Buddhas set in a flaming aureole. The facial expressions and the stylized treatment of the drapery still reveal the influence of Indian Gandhāran sculpture.

● *Near left :* Japanese lacquered wood figure, Heian period (794–1185). Seitaka Doji, attendant to Fudō. The sombre tone of the lacquered wood is offset by traces of gilt, the glass eyes and a bronze bracelet.

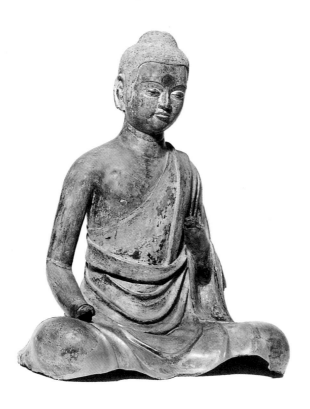

and abundant supply of wood, the types most suited to carving being cypress wood, zelkova, pine and cherry. With the early sculptures in wood, figures were carved from a single block except for parts of the hands and the ends of the legs, which may have been added separately. A wooden block was first cut to the approximate size and shape by means of an axe. Next, flat and curved chisels were used to model the form roughly. It was then finished by whittling or paring away the surface with a knife.

A single block of wood was liable to split along the grain once it had dried. From the second half of the ninth century craftsmen sought to overcome this by splitting the sculpture into two halves down the grain. These were then hollowed out before being joined together again. By the mid-eleventh century a new technique had been developed, known as *yosegi zukuri*, in which pieces of wood were joined together. This involved preparing a sufficient number of individual blocks to correspond to the main form of the sculpture. Each block was then hollowed out before being re-assembled. The final surface of the sculpture was worked in the normal fashion. Objects produced in this manner tended to be thin and light, which precluded any deep surface carving. Once the craftsman was no longer restricted by the size of a single block of wood, it made possible the production of sculpture of a larger size.

The Japanese also made frequent use of crystal eyes, which were

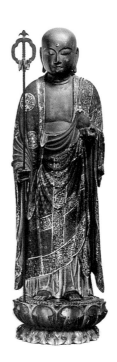

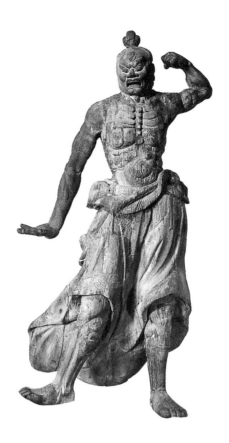

● *Right :* Japanese carved wood figure, thirteenth century. A Buddhist guardian, one of a pair.

inserted inside the head. They were made up of concave crystal with a pupil painted black on the inside and the whole backed by paper to give the eye a white appearance.

There were various ways in which the surface of a wood sculpture could be treated. It could, for example, be left undecorated, relying on the natural grain and beauty of the wood, with the details added in light touches of ink and colour. Alternatively, the wood could be painted, gilded or lacquered.

SCULPTORS IN CHINA AND JAPAN

The majority of Chinese sculptors have remained anonymous. They were, for the most part, skilled craftsmen who had little detailed knowledge of Buddhist iconography, and it is easy to understand that iconographic mistakes occurred.

Just as Indian sculptors worked in China for a while after the introduction of Buddhism, so too did Chinese and Korean craftsmen work in Japan. One of the earliest references is to a Shiba Tatto, who arrived in Japan in 522. One of the most celebrated sculptors of early Buddhist sculpture in Japan was Tori Busshi, who was liberally rewarded for his work by Prince Shōtoku.

In Japan, there existed schools or families of master sculptors and assistants, many of which flourished for generations. During the Nara period each of the main monasteries had an office responsible for the making of images. Although the majority of sculptors were not directly connected with a specific monastery, they were often rewarded with some form of religious title. Jochō, who is credited with perfecting the method of making wood sculpture from multiple blocks, was the recipient of one, for example. Training was also given by master sculptors in private workshops.

Buddhist sculptures served to propagate the faith and, by commissioning religious works of art, its followers attempted to gain favour and salvation. Thus, it is not uncommon to find examples of Buddhist sculpture with inscriptions relating to the donor, as well as to the purpose of the object and its date of manufacture.

The finest examples of Buddhist sculpture in China and Japan undoubtedly belong to the early history of the religion. Thereafter the most important examples of Buddhist art were in other fields: in painting, as executed by monk painters of the Chan (Japanese: Zen) sect of Buddhism. As regards sculpture in the broadest sense, the achievements of the later periods were in the carving of wood, ivory, as exemplified by Japanese netsuke, and jade.

JADE

Although jade has been worked in many different countries of the world, it is most closely associated with China, where it has been worked continuously for several thousand years.

The earliest jade to reach Europe in significant quantity was from Mexico and Central America. Amongst the Spaniards who brought it over jade was reputed to have medicinal properties, particularly efficacious in treating diseases of the kidneys. It was for this reason that jade came to be known as *piedra de los riñones*, stone of the kidneys, or *piedra de ijada*, stone of the loins. From the latter description the stone became known as *le jade* in French and subsequently jade in English.

In 1863 a certain Alexis Damour discovered that what had up till then been referred to as jade was in fact two distinct stones, jadeite and nephrite. They were similar in appearance but dissimilar in chemical composition. Nephrite is a silicate of calcium, magnesium and aluminium, and it belongs to the amphibole group of minerals. The term derives from the Latin version of *piedra de los riñones*, that is, *lapis nephriticus*. It is similar in composition to the minerals tremolite and actinolite, but heat or pressure have altered its crystalline structure and, as a result, the long fibres are closely matted together to form a hard mass. It registers a hardness of 6.5

● *Right, top :* Chinese jade Buddha's-hand citron vase, eighteenth century. This vase, in pale greenish-white jade, is in the form of a spray with leaves encircling large and small fruit with raised 'fingers'. This type of fruit is frequently referred to as the Buddha's hand.

● *Right, bottom :* Pair of Chinese jade bracelets, Qing period, probably Qian long (1736–95). The upper of these two grey-white jade bracelets has been carved from a solid piece of stone into three entwined loose strands. While the other looks the same, it has in fact been carved as a single continuous strand.

146

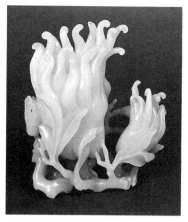

on the scale proposed by the Austrian mineralogist Frederick Mohs, and it has a specific gravity of around 3.

Jadeite is a silicate of sodium and aluminium, and belongs to the pyroxene group of minerals. It is made up of tiny interlocking crystals and registers 6.75 on the Mohs scale; it has a high specific gravity of 3.33 and is slightly harder than nephrite.

Even after jadeite and nephrite have been worked and polished, it is not always possible to distinguish between the two by eye alone. Apart from the fact that certain colours are more commonly associated with one or other stone, jadeite has a vitreous appearance after polishing, while nephrite is more oily. In addition, the colour of jadeite tends to be more translucent and vivid. Despite their different chemical compositions, both jadeite and nephrite were worked in the same way. For this reason the term jade is retained when referring generally to either stone.

Both jadeite and nephrite can be white or colourless. The white nephrite referred to as 'mutton fat' in traditional Chinese sources was particularly prized. The colour commonly associated with jade is green, but it also occurs in a wide range of other colours, including grey, blue, mauve, brown, red and yellow, usually due to the presence of such elements as iron, chromium and manganese. It is also not unusual to find different colours combined in one stone, particularly in the case of jadeite. Jade that has been exposed to the elements or that was buried in the ground after having been carved, as in a tomb burial for example, undergoes chemical changes that alter its surface colour.

Although jade has been worked in China since the Neolithic period, no deposits of jadeite and nephrite have ever been found there. Jadeite was first imported from Burma in the eighteenth century, until which time it was virtually unknown in China, while the main sources of nephrite in antiquity were Khotan and Yarkand in eastern Turkestan.

Khotan lies at the foot of the Kunlun mountains and its two main rivers, the Yurung-kāsh (White Jade River) and Kara-kāsh (Black Jade River), brought down water-worn pebbles and boulders from the mountains. These were then collected from the more accessible river beds. Later, nephrite was also obtained by quarrying in the mountains. Yarkand supplanted Khotan as the main supplier during the seventeenth century; later still, nephrite was also imported from around Lake Baikal in eastern Siberia.

In each case the raw material was brought to China from a considerable distance. Khotan and Yarkand, for example, were some 3,200 kilometres away, and the journey necessitated passing through some of the most hostile terrain. This was to become one

河玉綠

亦 亦 把 國
力 力

● *Left* : Chinese woodblock print, from *Tian gong kai wu* by Song Yingxing, first published in 1637. This print shows women searching the Green Jade River for jade pebbles and boulders brought down from the mountains.

of the most important trade routes across Central Asia, known as the Silk Route.

JADE CARVING

The term 'carving' as applied to jade is something of a misnomer since it was not possible to carve jade in the same way as, for example, wood. The crystalline structure of jade, with its closely matted fibres, is such that it is a hard stone and extremely difficult to work. Since it <u>could not</u> be cut by metal, it was worn down by friction using abrasive sands. The most widely used of these, which needed to be harder than the jade to make any impression on it, were quartz powder (reading 7 on the Mohs scale), crushed garnets (7.5) and corundum (9). They were prepared by pounding, grinding and sifting the stones, and making them into pastes by adding water. During the 1920s, these were superseded by carborundum, which was <u>artificially</u> made.

148

Apart from the introduction of metal tools as a vehicle for the abrasives, the method of working jade has changed little over a period of several thousand years. In the case of quarried stone the first stage was to cut the large slabs into smaller, workable pieces. The jade was placed on a wooden base and a person on either side pulled a toothless saw backwards and forwards across it using a moistened abrasive. It would have taken several weeks simply to cut through the slab to make a piece of less than half a metre square.

Next, the jade worker used a lathe to reduce the stone to the required size and shape. The lathe consisted of a horizontal bar fixed parallel to a table. A tool was attached to one end, while a leather strap was wrapped round the bar and fixed at either end to a set of treadles under the table. When the treadles were operated the leather strap was pulled backwards and forwards, causing the bar and tool to rotate. Abrasive sands were applied along the cutting edge of the revolving tool, and the surface of the jade was incised or shaped by friction. When using the lathe, both hands were left free to manipulate the jade block and apply the sands.

The tools used in conjunction with the lathe included a graduated series of metal discs with sharp edges, which were used to form the general outline of an object. A tubular drill, made of a short iron tube, was used to hollow out a piece of jade. This left behind a core of stone which, since jade was an expensive material, might be used to make another, smaller object. Surface decoration was generally produced by means of lap wheels, which were extremely small metal discs resembling nail heads. Apart from the tools fitted to the lathe, the jade worker also used a drill with a diamond point fixed to the end to make perforations. These could be enlarged by means of a wire saw.

The final stage in working jade involved smoothing down the surface and removing any scratches left by the tools. The polishing tools required for this purpose, which were made from wood, gourd skin and ox leather, were attached to the lathe and used with a paste made from ruby dust, which was extremely hard. Polishing brought out the intrinsic qualities of jade, in particular a tactility which especially appealed to the Chinese. It was admired for being warm and pleasant to handle, particularly when cupped in the palms of the hands.

Jade was used by many Neolithic cultures of the world, and it has been worked in China from at least the third millennium BC. It was of great importance during the Neolithic period because it was found to be hard and tough, and could take a sharp edge, while it was not prone to chipping or flaking. Archaeological evidence has indicated that jade was favoured by the Neolithic cultures of

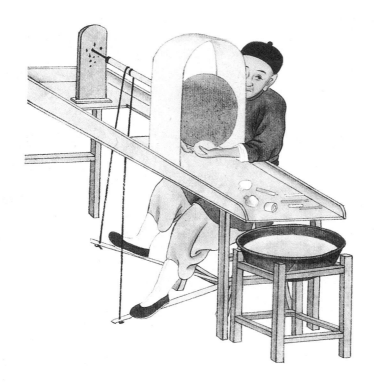

● *Left :* Chinese water-colour, nineteenth century. A page from a book on trades and occupations entitled *Scenes of Chinese life, being coloured pictures of various types of society with descriptive texts.* It shows a craftsman operating, by means of foot treadles, a lathe for carving jade. One end of the lathe is fitted with a large metal disc, around which is a protective guard. Abrasive sands, which are in a container at the near end of the table, were applied along the cutting edge of the disc in order to carve the jade. Examples of the craftsman's work, such as snuff bottles, are shown lying on the table.

● *Below :* Chinese jade axe, Neolithic period, Longshan culture, *c.* 2500–2000 BC. Green jade with brown veining.

eastern China, such as that of Longshan in Shandong province, to produce tools and weapons of the highest quality. With the onset of the Bronze Age, when metal began to replace stone, jade continued to be worked on a large scale, for it had assumed a special significance. The excavation of jade discs, rings and curved ornaments dating from the Neolithic period suggest that it was used in the manufacture of ceremonial objects. In time it became the prescribed medium for ritual objects. These included *bi* discs, which were flat with a central hole, as well as a curved, arc-shaped pendant known as a *huang.*

The *zong,* on the other hand, was of distinctive form but uncertain function. It was tall and rectangular in cross-section, while the centre was penetrated by a vertical cylinder which protruded slightly at the top and bottom. The square edges were frequently divided into horizontal bands and notched. Equally enigmatic was a type of notched disc with curved projections. .

From an early date in China jade was accorded powers of healing and of conferring good health and even immortality. During the Han period carved jade plugs were used in tomb burials to stop up the seven main orifices of the body and a jade cicada was placed on the tongue in order, it was believed, to preserve the corpse. The most splendid expression of this belief in the properties of jade is to be found in the jade burial suits which were made only for those of

150

● *Right :* Chinese jade *bi* disc, fifth, fourth or third century BC. Light brown and green jade. The designs of dragons and spirals were derived from contemporary bronze decoration. The spirals, forming what is often referred to as a 'grain' pattern, were carved by working the jade in criss-cross lines, leaving rounded, raised areas at regular intervals.

● *Below, top :* Chinese jade *zong*, probably Eastern Zhou period (771–256 BC). Dark brown jade with red, green and light brown markings.

● *Below, bottom :* Chinese jade bird pendant, thirteenth, twelfth or eleventh century BC. Calcified jade with dark markings. The incised motifs, as well as the notched crest and tail, are derived from similar contemporary bronze decoration.

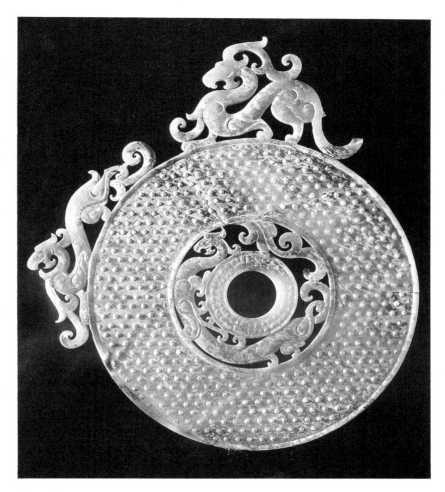

the highest rank. That of the princess Dou Wan, which was excavated from her tomb at Mancheng, Hebei province, consists of 2,160 jade tablets differing in size and thickness, and joined together with gold wire.

Jade continued to be used for ceremonial and ritual articles and, from the end of the Han period onwards, it was increasingly used for objects of personal adornment and for items of luxury.

An important development at this time was the appearance of three-dimensional jade carvings, usually representing animals. The carvings frequently reflect great economy in the use of the material and a minimum of waste, for the jade worker was able to utilize small pieces of stone and those of an unusual shape. The animal was often portrayed with its legs tucked under the body and its head turned back over the body. The result was a compact form that fitted well into the palm of the hand, and many such carvings are thought to have been fondling pieces.

The decoration of jade objects varied from simple incised details to carving in low or high relief, as well as openwork. By repeated

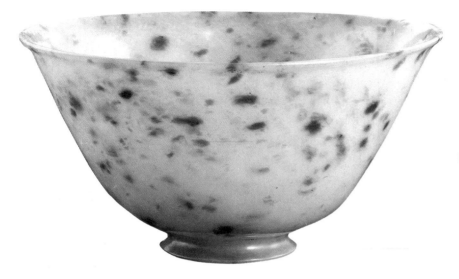

● *Left*: Chinese jade bowl, thirteenth century. Greenish-white jade spotted with brown. It was common practice at that time to produce plain, undecorated wares which relied on the inherent beauty of the form and the material, be it jade, porcelain, lacquer or metal, for their effect.

drilling and cutting, a skilled jade worker could even produce a ring which could move freely while still being attached to the body, or even a chain of joined movable rings, from a single piece of jade. From the Song period onwards jade vessels appeared which were simple in form and plain: they had no surface decoration, relying for effect on the natural appearance of the jade itself. Such objects contrast with many jades of the Qing period (1644–1911) which were ostentatious and displayed an exaggerated concern with technical virtuosity. The great number of jade carvings produced at this time is a reflection of the relative abundance of the material, with supplies coming from both Central Asia and upper Burma.

There are various hardstones which have been worked in China in a manner similar to jade, partly because of their intrinsic beauty and partly because they were cheaper and more readily available than jade. These include transparent stones, such as rock crystal and rose quartz, and translucent ones, as exemplified by the various forms of chalcedony, agate being the most common in China. Among the most spectacular were undoubtedly turquoise and lapis lazuli. Soapstone was also widely used, mainly because it was comparatively soft and was thus easy to cut with metal tools.

IVORY

Strictly speaking, ivory is the material which makes up the tusk of an elephant. Sometimes, however, the description is extended to include substances with a similar appearance, such as the teeth of the hippopotamus, walrus and sperm whale, walrus tusks, vegetable ivory and bone.

● *Right :* Chinese jade water pot, probably eighteenth century. This is in the form of a black lotus flower, with a duck, insects and lotus buds in shades of grey, using the natural colour of the piece of stone to best advantage. On the black lotus, for example, an insect is carved from a section of grey stone, while on a grey bud there is a black insect.

● *Below :* The upper surface and underside of an ivory wrist rest, signed 'carved by Xianglin', second half of the eighteenth century. The upper surface is carved in low relief depicting geese by the water's edge, with an incised inscription. The concave underside, which, on acount of its curved shape, carries the full thickness of the ivory, is carved in high relief, with a design showing the Eighteen *Luohan* (enlightened beings) crossing the sea.

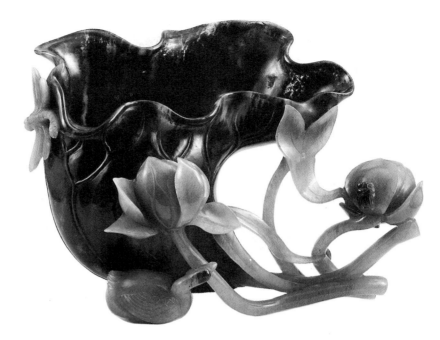

True ivory is obtained from three sources, namely, the Indian elephant, the African elephant and the mammoth. The Indian elephant was originally indigenous to many regions of China but, over the years, the areas it inhabited were reduced until the species finally died out there. Long before this happened it became necessary to import supplies of ivory from all over Asia, from Thailand in particular, and from parts of Africa. Fossilized mammoth tusks were also used in China, both from native sources and imported from Russia.

Elephant tusks are a pair of modified upper teeth which emerge from the skull. As they grow, they increase in both width and length, with the oldest part at the tapering end. About a third of the tusk is embedded in the skull and this root section has a cavity which is filled with soft pulp. The hollow part of the tusk was suitable for making a brush pot or, cut into sections, wrist rests. The remainder of the tusk is solid, except for a tiny hole running more or less up the middle. This has to be incorporated into the design, or disguised as part of it; alternatively, it was plugged with an ivory pin or filled with a mixture of ivory dust and fish glue.

Enclosed within a thin layer of enamel, the main part of the tusk is made up of minute tubes. It is the arrangement of these tubes, when seen in cross-section, which serves to distinguish ivory from other materials. Emanating from a central point, they curve out and round, eventually intersecting to produce a characteristic pattern.

153

The size and quality of the tusks vary enormously, and as a general rule those of the African elephant are longer. Although ivory is warm and creamy in appearance, there are variations determined by the species and diet and, in dead ivory, by exposure to light and the effects of body oils caused by handling. In time this produces an attractive mellow golden colour. The fact that ivory is strong yet pliable, and does not easily split, made it an ideal material for carving.

As ivory was an expensive material in China, it was unusual to use the whole tusk for a single carving. Instead, it was cut into pieces with a saw, the different sections being suitable for particular purposes. Since the enamel outer shell was almost twice as hard as the rest of the ivory, it had first to be removed. This could be done by alternately applying heat to the ivory and then cooling it in order to crack the enamel, beating it with a hammer, or using a grinding stone or chisel.

Having selected the piece of ivory and marked out the rough outline in ink, the craftsmen then set to work carving the object. Surface detail was added by engraving or by carving patterns and textures in relief. The ivory was then polished with increasingly fine abrasives, ending with a cloth, in order to remove the marks left by the tools, smooth the surface and bring out the natural gloss of the material. If the ivory was to be stained or coloured, this was carried out as the final stage.

Ivory, used in China for nearly 7,000 years, is an extremely versatile material and was used in the manufacture of a wide variety of objects, from utilitarian items, such a brush pots, wrist rests, fans and seals, to carvings of Buddhist and other deities.

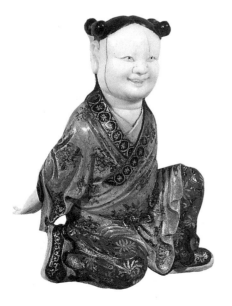
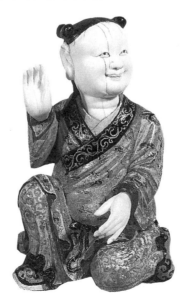

● *Left :* Pair of Chinese polychrome-painted wood and ivory figures, eighteenth century. Probably the twin gods of Mirth and Harmony.

154

● *Right* : Chinese carved bamboo bowl, eighteenth century. This simple form is skilfully carved in such a way as to exploit the grain of the bamboo for its pleasing decorative effect.

● *Below* : Chinese carved and stained ivory figure, *c.* 1580–1644. Zhongli Quan, one of the Eight Daoist Immortals, with his attributes, a fan and a tortoise. The figure is carved along the natural curve of the tusk, but the movement is offset by the contrasting attitude of the head.

Figure carvings of the Ming (1368–1644) and Qing periods, moreover, frequently exploited the natural curve of the tusk, incorporating it into the overall design. During the latter part of the Qing period objects of considerable technical virtuosity were produced, such as the intricate carvings made for the Western market, consisting of numerous freely moving concentric balls, which continue to be made today.

The appearance of the natural ivory was so fine that some objects were left undecorated. The surface might be incised and the design emphasized in ink, but the most common decoration was in the form of carving in either low or high relief. Because of its close, dense grain, ivory was also a suitable medium for the technique of undercutting, and for pierced and openwork decoration.

The tools used to carve ivory, saws, files, chisels, gouges, drills and knives, were basically the same as those used to work materials such as wood, bamboo, amber and horn. Rhinoceros horn was popular in China from the Ming period onwards, especially for making libation cups. The widespread use of wooden masks for the different forms of Japanese drama, such as Bugaku and Nō, as well as for religious festivals, led to a specialist craft in which carving and painting were combined. The masks, in the form of stylized character types frequently display exaggerated human emotions.

JAPANESE NETSUKE

Since the traditional Japanese garment, the kimono, had <u>no</u> pockets, everyday necessities were carried in various types of container, such as the *inrō* (see p. 176), tobacco box, pouch and money pouch, suspended from the *obi*, or sash. These containers were attached to silk cords which passed under the belt, the ends being secured in a netsuke, which hung over the top of the *obi*. Since the netsuke was designed to 'anchor' the various pouches to the belt and keep them in place, it was, of necessity, small and bulky, but without any sharp projections which might be caught or broken. The Japanese did not make use of jewellery as such, and the netsuke and *inrō* fulfilled a comparable role. Although netsuke were <u>only made during the Edo period</u> (1615–1868), they include some of the finest examples of Japanese carving.

Of the various different types of netsuke, the *katabori* was the most common. This took the form of a three-dimensional carving, usually of animal or human figures. It was fitted with two holes, one slightly bigger than the other, through which to pass the cord and accommodate the knot. The *kagamibuta* netsuke had a bowl-shaped lower part, usually made of ivory, bone or horn, with a convex metal disc fitting on top of it. The cord was secured to a

loop on the underside of the metal and passed through a hole in the other half of the netsuke. The *manju* netsuke took its name from the *manju* bun, which is generally round and flat. Netsuke of this type were either made up in two halves or were solid, with relief or pierced decoration. The cord was fixed inside the netsuke or, alternatively, to a metal ring at the back of the netsuke.

The most common materials employed in the manufacture of netsuke were wood, especially cypress and boxwood, and ivory, though lacquer, horn, porcelain and metal were also used.

The range of subjects used in the decoration of netsuke was <u>enormous</u> and included the main categories found in other forms of Japanese art. Representations of animals were common, whether real or mythological, depicted singly or in a group. Historical

● *Above, top:* Japanese stained ivory *manju* netsuke, nineteenth century. Autumn plants against a full moon, carved in openwork.
● *Above, centre:* Japanese stained ivory netsuke, signed Seiki? nineteenth century. A thwarted ratcatcher.
● *Above, bottom:* Japanese stained ivory netsuke, nineteenth century. A tiger on a bamboo stem.
● *Left:* Japanese stained ivory netsuke, eighteenth or nineteenth century. A rat on a capsicum.

● *Below, left :* Japanese Nō mask of a blind man, carved wood with gesso, late sixteenth or early seventeenth century.
● *Below, right :* Japanese woodblock colour print, 1784. A print illustrating a mask carver, from the book *Saiga shokunin burui* by Minkō, original edition 1770. To the craftman's right are the necessary tools, including gouges, chisels and a mallet.

scenes, scenes of figures connected with Buddhism and scenes from everyday life were also portrayed. Some were humorous in character, others grotesque or even mildly erotic.

The netsuke was either bought from a retailer or commissioned directly from the netsuke artist. In some cases the netsuke formed part of a set with an *inrō* and an *ojime*, or sliding bead; they may have been made from the same material and almost certainly had decoration of an identical or related subject. The owner commonly had a number of them, which could be used in conjunction with different containers and interchanged at will.

It was customary for the netsuke artist to sign his work, though the signatures are not always proof of authenticity. The majority of artists were attached to schools which flourished in Edo, Kyoto, Osaka and Nagoya.

With the Westernization of Japanese dress, during the latter part of the nineteenth century the netsuke gradually fell from use. In order to maintain their livelihood Japanese wood and ivory carvers used their skills to produce small decorative carvings, known as *okimono*, particularly for the Western market.

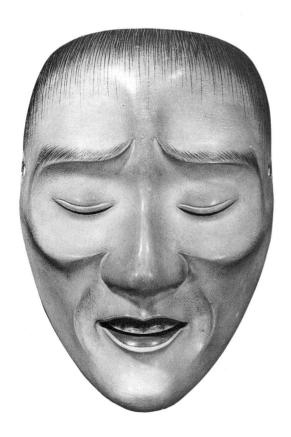

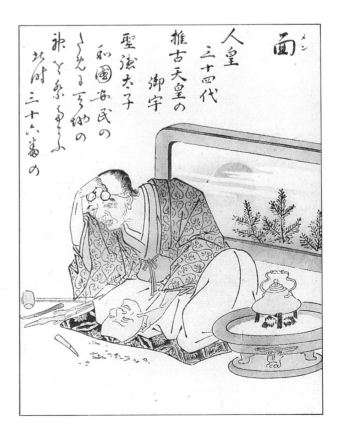

157

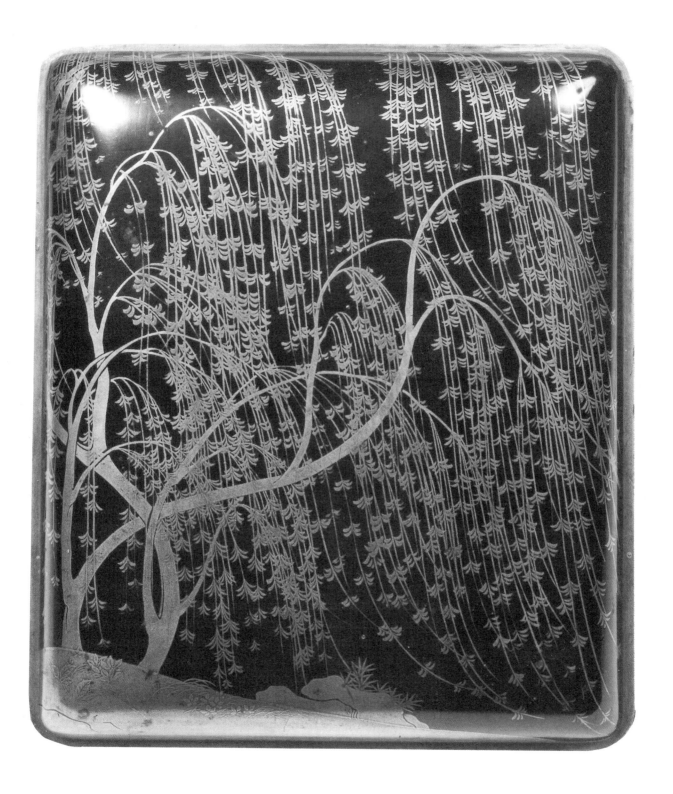

Chapter 6

LACQUER

LACQUER is closely associated with the Far East since true lacquer is obtained from trees that grow <u>only</u> in East Asia. The earliest lacquerware was produced in China, and it was copied at an early date in Korea and Japan, though with considerable and characteristic differences. When, at a later date, Europeans became acquainted with the lacquer techniques of the Far East, the term they used, 'japanning', reflects the unrivalled skills of the Japanese lacquerers, even though they were <u>not</u> the inventors and original masters of the art of lacquering.

True lacquer is the sap obtained from a species of tree which grows in <u>most</u> countries of East and South-east Asia. In Western japanning an artificially made substitute was used for the raw lacquer. Raw lacquer is obtained from various trees of the *rhus* species, principally *Rhus verniciflua* because of the superior quality of its sap. Indigenous to China, the species was later <u>introduced to</u> Korea and, subsequently, to Japan, sometime between the third and the sixth century AD, together with the sophisticated skills associated with working lacquer. Simple lacquered artifacts had been made in Korea and Japan before this with the inferior sap of the trees *Rhus succedanea* and *Rhus trichocarpa*, which were indigenous to Japan and Korea respectively.

Lacquer trees grow wild, but from early in the history of lacquer they were planted commercially. The quality of the sap <u>depended</u> on the type of soil in which a tree grew, the climatic conditions that prevailed during the period of growth, as well as the age of the tree and the season during which the sap was taken. The optimum time for collecting the sap was during the warmer months between spring and autumn, when the tree was between five and eight years old. A tree yielded sap of various qualities, the best being obtained by tapping, or cutting notches into the growing bark, and collecting the viscous matter in containers as it oozed out. At first it was a creamy-grey colour but, on exposure to light and warmth, it turned a matt black. Sap of an inferior quality was obtained by boiling the smaller branches of the tree in water.

Once the raw lacquer had been extracted from the tree, it was strained to remove any impurities. Then it was stirred for several

● *Above :* Chinese six-lobed box, carved marbled lacquer, fifteenth or sixteenth century. The uppermost lacquer ground is made up of eleven layers of lacquer: red, green, orange, magenta, yellow, red, green, orange, magenta, yellow and red. These are not deeply carved, so the finished effect is more like that of uncarved flat marbled lacquer.
● *Left :* Japanese lacquer cosmetic box (*tebako*), early seventeenth century. Willows in gold *hiramaki-e* on a black lacquer ground. Because there was no protective outer layer of transparent lacquer, some of the gold lacquer has worn away in places.

hours whilst being heated in shallow containers so that the excess water evaporated. It was at this stage that the thickened lacquer could be coloured by the addition of vegetable and mineral dyes. These included red derived from either mercury sulphide or iron oxide, black from iron, green from a chromium compound, white from lead and yellow from cadmium, ochre or gardenia extract. Stored in air-tight containers, the lacquer could be kept for several years until it was required.

The unique qualities of lacquer are due to its physical and chemical properties. The process responsible for transforming the liquid into a solid is the polymerization of the urushiol which makes up some 74% of the lacquer. The enzyme laccase, also present in raw lacquer, acts as a catalyst for the hardening of lacquer.

For the oxidization of lacquer to take place, that is, for the lacquer to harden, certain conditions had to be fulfilled precisely. Firstly, the presence of oxygen was essential. Then, a temperature of between 25°C and 30°C and a high atmospheric humidity of around 80% to 85% were also required. The fact that lacquer would not harden if the conditions were too dry is an apparent contradiction. If the lacquer was applied too thickly, a thin top layer would set but the lacquer beneath would remain liquid. It was for this reason that lacquer had to be applied in extremely thin layers and each allowed to harden completely before the next one was added. In order to create the right conditions artificially, a wooden drying-cabinet was used which was airtight and which could be dampened with water as necessary.

The enormous popularity of lacquer was almost wholly due to its inherent properties. Once lacquer had hardened, it sealed the surface to which it had been applied, making it impervious to liquids. Indeed, it is this very characteristic that accounts for the preservation of a large number of Chinese lacquered objects from the Warring States (481–221 BC) and Han (206 BC–AD 220) periods, such as those found in the Changsha tombs in Hunan province, where the subsoil was completely waterlogged'. It was also discovered that lacquer has a high resistance to heat and strong acids, and that it is a good insulator against electricity; its adhesive qualities have also been used to repair ceramics.

LACQUER TECHNIQUES

The stages involved in making a lacquered object were highly complex and time-consuming. The manufacturing process, which could take years to complete, broadly fell into three stages: the construction and preparation of the base; the application of layers of lacquer to seal, protect and strengthen the base; and the decoration

● *Right*: Japanese tools and materials used in the production of lacquerware, together with eleven sample *sake* cups from a set of 35, late nineteenth century. The tools include brushes, spatulas, bamboo tubes with a mesh at one end for sprinkling the powders on to the lacquer surface, and tools for incising. Samples of different types and qualities of lacquer and gold powders are contained in small tubes. The *sake* cups illustrate some of the stages in producing an object decorated in *takamaki-e*, from the wooden core through to an intermediate stage of applying the decoration. The sequence runs from left to right and from top to bottom.

of the surface. Each stage had its own specialist craftsmen.

Lacquer was applied to a variety of surfaces, including paper, cloth, plaited bamboo, leather, tortoise-shell, metal and, above all, wood. The most suitable woods were those that were soft, free from knots and contained little resin. In Japan, cypress (*hinoki*) was the wood most widely used for this purpose.

The wood was shaped according to the type of object required, while any cracks or joins were filled before the surfaces were smoothed down to provide a uniform ground to receive the lacquer. The importance of the base was such that, if it was not expertly prepared, it might warp or crack, thereby destroying the covering it supported. After shaping, the base was primed with a mixture of inferior-quality lacquer and other materials such as clay. These preparatory steps were intended not only to strengthen the wooden base but also to provide a barrier to prevent the sap from the wood seeping out and the lacquer seeping in. For larger objects the base was further strengthened by the application of cloth held in place by a mixture of rice paste and lacquer.

Successive layers of lacquer were applied, with the lacquer craftsman ensuring that each had completely hardened before the next was added. Each layer was polished smooth, using materials such as ground stone, clay, charcoal or deer's horn ashes,

● *Above :* Japanese bamboo container and protective gloves used in the collection of sap for lacquerwork, and two branches of the lacquer tree *Rhus verniciflua*, acquired for research in the late nineteenth century. Lacquer trees were tapped by cutting notches into the growing bark; the sap was collected in containers as it oozed out. Since raw lacquer is highly toxic, the use of protective gloves was essential.

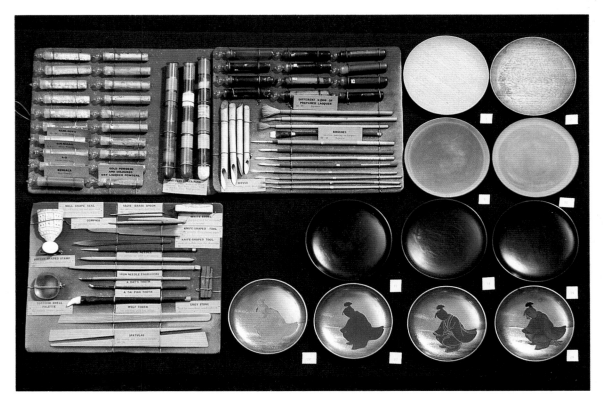

depending on the type of lacquer and its proximity to the uppermost surface. A piece of good-quality lacquer required some 30 layers before it was ready to be passed to the most skilled lacquer artists to execute the surface decoration. From an early date, craftsmen began to exploit the potential of lacquer as a decorative medium. The main lacquer techniques practised in the Far East included painting, carving, inlaying and incising, as well as the *maki-e* ('sprinkled picture') work of Japan.

LACQUER PAINTING

Painting in the Far East, as described in Chapter 1, made use of ink as well as pigments which were combined with water. The painting was executed with a brush on various surfaces, generally paper or silk. Lacquer painting differs essentially in that the pigments were combined with lacquer instead of water. Using a brush, the lacquer compound was applied to wood or lacquer and only rarely to paper. Since lacquer altered the colour of certain pigments with which it was combined, the colours employed in lacquer painting have, until comparatively recently, been restricted to red, green, yellow, brown and black, as these remained unaffected by the lacquer.

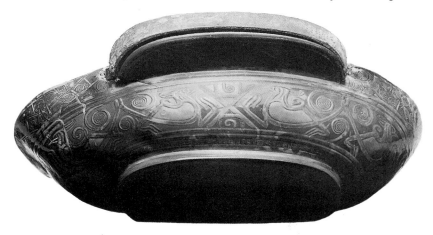

● *Left :* Chinese oval eared cup, painted lacquer with gilt-bronze mounts, dated AD 4. The cup bears a 67-character inscription, which includes the name of the factory, the date, a detailed description of the various stages of manufacture, and also the names of the craftsmen and various factory officials. It was made at the Western Factory of the Shu Commandery, near Chengdu in Sichuan province, which specialized in ribbon-line lacquer painting, as in this example, as opposed to fine-line painting. This cup is quite remarkable for the information contained in the inscription and serves to emphasize the importance of the lacquer industry at that time, as well as the degree of specialization.

In 1972 the excavation of the tomb of the Lady Dai at Mawangdui, near Changsha, which is dated to the second century BC, yielded a collection of lacquer wares in an excellent state of preservation. Toilet boxes, eared cups, bowls, ladles and a food container were among the wide range of objects; they mostly reveal painted lacquer decoration, with interlaced designs of dragons, clouds and waves similar to those found on contemporary inlaid bronzes. It was not only the scale of the find that was remarkable, more than 180 items of lacquer being recorded, but the degree of sophistication in the types of vessel and their decoration.

In addition to lacquer painting, a number of the objects from

Mawangdui have decoration executed in oil paint. Oil was used as the binding agent instead of lacquer in order to extend the limited range of colours that could be obtained in true lacquer painting.

The earliest surviving example of lacquer painting in Japan, the seventh-century Tamamushi Shrine of the Hōryū-ji Nara, also reveals areas of oil painting. In Japan, the most common form of oil painting on a lacquer base is known as *mitsuda-e* ('litharge painting'). The medium consisted of pigments combined with vegetable oil, with the addition of lead oxide, or litharge, to speed up drying.

In China, from the sixth century onwards, lacquer painting was largely overshadowed by the development of other lacquer techniques, particularly lacquer carving. Then, during the sixteenth century, there appeared a number of lacquered objects decorated with polychrome lacquer painting, generally depicting floral or picture subjects, together with basket-weave panels. These undoubtedly stimulated a renewal of interest in lacquer painting in Japan during the early Edo period (1615–1868). Although true lacquer painting and litharge painting were frequently combined on a single object, a related technique, known as *Jogahana-nuri* ('Jogahana lacquer'), was also developed. This made use of pigments combined either with oil or with a mixture of oil and lacquer, but without the addition of litharge. The name derives from that of a village in present-day Toyama province, where the technique was first used extensively in Japan. It is reputed that a certain Yoshinaga learned the process from Chinese craftsmen working in Nagasaki during the late sixteenth century and, on his return home, introduced his version of it.

Although the technique of lacquer painting on paper is thought to have been a long-established one, it did not gain prominence in Japan until the nineteenth century; even then it was practised almost exclusively by one painter and lacquer artist, Shibata Zeshin. It might be thought that lacquer painting on paper would have none of the qualities of ink painting. Ink, being fluid, allows for spontaneity both in the individual brushstrokes and in the overall design, while the viscosity of the lacquer medium and its inherent intractability would seem to deny this. It was, however, precisely the effect of spontaneity that the lacquer artist succeeded in producing.

LACQUER CARVING

Carving, the decorative technique most widely associated with Chinese lacquer, was not perfected until comparatively late. Since lacquer would not harden if applied to the base too thickly, it was

163

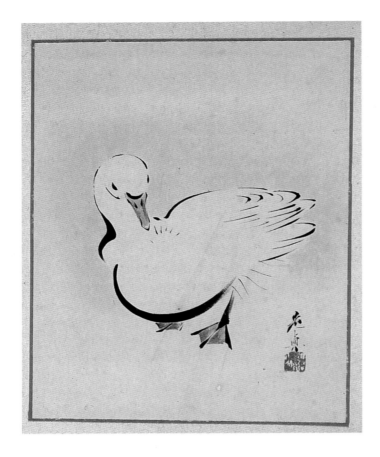

● *Left :* Japanese painting in black, brown and yellow lacquer on paper, by Shibata Zeshin (1807–91), *c.* 1875. Zeshin has succeeded in capturing the fluidity and spontaneity of ink painting in the viscous and intractable lacquer medium.

traditionally laid on in the form of a thin coating. A certain depth of lacquer was needed for carving and only after much experimentation was it discovered that this could be achieved by superimposing layer upon layer of lacquer, each one being allowed to harden completely before the next one was applied. The earliest surviving Chinese lacquer carvings are to be found on the leather scales of armour from Miran in eastern Turkestan, dating from the eighth century. It was not until the Yuan period (1279–1368), however, that carved red lacquer (*ti hong*) was produced in the form in which it is widely known today.

The standard procedures involved in the manufacture of carved lacquer in the Yuan and early Ming (1368–1644) periods are well documented. The wooden base was covered with a thick layer of black lacquer, which had been combined with ash to promote hardening, and this provided a smooth surface for subsequent layers. Next came layers of yellow lacquer, followed by layers of red, each generally less than 0.05 millimetres thick. There were usually between 100 and 200 layers, and perhaps as many as 300. Among the earlier, lower layers of red lacquer were several of black, which would later serve as a marker. When the craftsman carved

● *Below :* Chinese carved red lacquer throne, second half of the eighteenth century. The throne of emperor Qian long. The decorative panels are surrounded by five-clawed dragons, which are normally reserved for imperial use, and flaming pearls amongst stylized clouds. Scrolls and floral motifs also form part of the overall design.

164

● *Above :* Detail of a Chinese round box and cover, carved red lacquer, fifteenth century. The decoration depicts a landscape with figures, with the main elements carved in high relief against a diaper ground. The convention of distinguishing between land, water and air by using different diapers is well illustrated by this example.

down into the lacquer, he knew to stop carving when he reached the marker level. In this way he was able to produce without difficulty a flat background of uniform depth.

An assortment of chisels and knives were used for carving, and needles for fine detail. During the sixteenth century gouges were increasingly used instead of knives to save the craftsman time and effort, though this resulted in some loss of detail and precision. Another difference was that the soft and smooth polished surfaces of Ming carved lacquer gradually gave way to unpolished surfaces on wares of the Qing period (1644–1911), which were, as a result, sharp and spiky in appearance.

Characteristic decoration of Ming carved lacquers were floral designs, which may include a pair of birds, dragons, and figures in a landscape, frequently surrounded by a floral border. From the late fourteenth century onwards it became customary for the main elements of the design to be set against a diaper ground, three different types being used to represent land, sea and air. From cylindrical boxes, bowls and trays, the range of carved wares was gradually extended to include pieces of furniture that are amongst the finest examples of Qing lacquer carving.

The colour of carved lacquer was by no means restricted to red, though red remained the most widely used. By building up the lacquer surface in layers of different colours, the skilful lacquer

● *Right :* Chinese carved polychrome lacquer dish, dated 1593. It is decorated with a dragon and a phoenix chasing a flaming pearl amongst stylized clouds and mountains on a diaper ground. The main panel is surrounded by the Eight Precious Objects, with border panels of birds on flowering sprays.

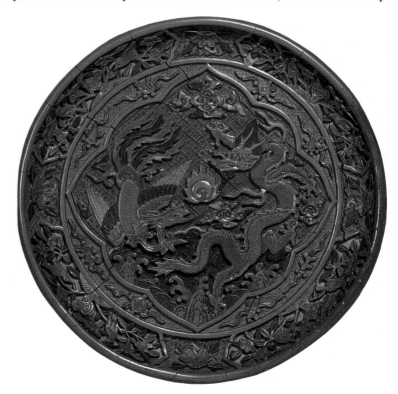

165

artist could carve down to the required colour for each part of the design and so achieve a polychrome effect. Indeed, the carvings made in Japan at a later date are described by their predominant colour: *tsuishu* ('heaped-up red'), *tsuikoku* ('heaped-up black') and *tsuiō* ('heaped-up yellow').

There are numerous references to Chinese carved lacquers being sent to Japan during the fourteenth century and, particularly during the fifteenth century, they were greatly admired there. During the fifteenth century the Tsuishu Yōsei became established in Japan, a family of lacquer artists who specialized in lacquer carving up until the twentieth century. The Japanese, however, never acquired the same degree of technical expertise as the Chinese, who remained the masters of lacquer carving.

It is hardly surprising that both the Chinese and the Japanese sought to achieve an effect similar to that of carved lacquer by methods that were quicker and easier. In a process referred to as *dui hong* a mixture of lacquer and ash was applied to a wooden base. This compound was shaped by moulding and by the use of abrasives before a coating of lacquer was applied on top. An alternative process involved applying several layers of lacquer to a base made of carved wood. In the early history of Chinese lacquer, during the Shang (*c.*1600–1027 BC), Warring States and Han periods in particular, this was the only available method of producing two- and three-dimensional lacquer decoration. Later, after true lacquer carving had become established as a technique, it was used specifically to imitate carved lacquer.

In Japan, the technique of applying lacquer to a carved wooden base was probably not in use before the end of the fourteenth century. It was known there as *Kamakura-bori* ('Kamakura carving') after the town in Sagami province which was the principal place of manufacture. It gradually developed as a decorative technique in its own right, becoming more than a poor substitute for carved lacquer. Red lacquer was sometimes applied over the black so that, where the surface was rubbed away, the black lacquer showed through and provided a splendid contrast with the red.

The techniques of carved marbled lacquer and flat marbled lacquer were both related to true lacquer carving. The former, known by the Japanese term, *guri*, originated with the eighth-century armour from eastern Turkestan already referred to. In its fully developed form, the process involved building up the surface with layers of different-coloured lacquer. Characteristic curved and spiral patterns, as well as the cloud-collar motif, were then carved into the surface, with cuts which were U- or V-shape in cross-section, to reveal the sequence of underlying colours.

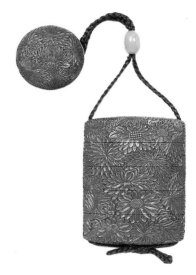

● *Above*: Japanese *inrō* ('seal basket') and matching netsuke in carved red lacquer (*tsuishu*), with an *ojime* ('sliding bead') of blue glass, early nineteenth century. Although this is technically a fine piece, the depth and detail of the carving of the chrysanthemum design is inferior to some of the earlier examples of Chinese carved lacquerware.

● *Below*: Japanese rectangular box and cover, wood carved and lacquered in red and black (*Kamakura-bori*), fifteenth or sixteenth century. Peony scroll design. Where the red lacquer has worn away, it reveals the black lacquer beneath, producing a pleasing effect.

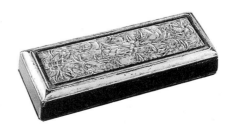

● *Above:* Japanese round box and cover, carved *guri* lacquer, *c.* 1800. Signed Zhang Cheng, after the late fourteenth century Chinese master of carved lacquer. The upper layers of lacquer are made of ten repeated layers of red, black, green and yellow, ending with red on top.
● *Right:* Cover of a Japanese writing box (*suzuribako*), with spirals of *Wakasa-nuri* in gold, brown and black lacquer, late nineteenth century.

Whereas in China the top layer was frequently black, in Japan it was often red.

Flat marbled lacquer does not appear to have been made before the sixteenth century. Layers of different-coloured lacquer were applied to a deliberately uneven ground and, when the surface was polished smooth, the uneven layers beneath were revealed in such a way as to create a marbled effect. By carefully planning the depth and disposition of the compound used to make the base uneven it was possible to make scroll patterns appear in the finished marbled surface. In Japan this technique was known as *Tsugaru-nuri* ('Tsugaru lacquer'), after the name of a district in the extreme north of the main Japanese island of Honshū.

Wakasa-nuri ('Wakasa lacquer') was a Japanese technique which was related to *Tsugaru-nuri*. Layers of lacquer, usually brown or black in colour, were applied to an uneven ground. Gold or silver foil was then pressed down into the pitted surface, and the whole of it was covered with a transparent yellow-brown lacquer.

GOLD AND SILVER LACQUER TECHNIQUES

If carved lacquer is regarded as the greatest achievement of the lacquer artist in China, then the *maki-e* ('sprinkled picture') technique must be considered as such in Japan. The term *maki-e* is used to describe techniques in which gold and silver powders were sprinkled on to a wet lacquer surface to form an element of the decoration. Since gold and silver were expensive and subject to sumptuary laws, alloys were frequently used instead.

During the Nara period (AD 710–794) in Japan there was much experimentation with the lacquer medium, particularly in connection with the use of gold and silver powders. Techniques in which metal powders were combined with lacquer or glue and brushed on to a lacquer surface proved <u>un</u>satisfactory and largely fell from use. *Maki-e* showed itself to be a more reliable and successful method of achieving a similar effect. The earliest surviving example of the use of *maki-e* is to be seen on an eighth-century sword and scabbard in the Shōsōin Imperial Repository in Nara. Whether or not the objects were actually manufactured in China, as has been suggested, the future development of the technique lay in Japan.

There were three main *maki-e* techniques: *hiramaki-e*, *takamaki-e* and *togidashi*, the earliest being *togidashi*. Since lacquer is a viscous and intractable medium, the outline of the design was drawn on a sheet of fibrous paper, rather than directly on to the lacquer surface. This was placed face down on the lacquer and, by applying light pressure, the outline of the design was transferred on to it and the paper was then removed. Gold and silver powders were sprinkled on to the design while the lacquer ground was still wet. The decorated areas were thus slightly raised.

In the case of *togidashi* ('cause to appear by rubbing'), the intention was to make the areas decorated with gold and silver powder level with the background. The entire surface was covered with layers of lacquer of the same colour as the background, which was usually black, temporarily obliterating the decoration. The effect of this was to raise the level of both the decorated areas and the background. When the entire surface was polished flat, many of the metal particles that formed the design were exposed, which resulted in a rich, smooth, and often sparkling, effect.

There were certain artists who specialized in *togidashi*, most notably members of the Shunshō family, which established itself in the mid-seventeenth century. Some of the later Shunshō artists produced lacquerwork with designs based on Ukiyo-e woodblock prints, using colour pigments as well as gold and silver powders.

The *hiramaki-e* ('flat sprinkled picture') technique which emerged during the latter part of the Heian period (794–1185) involved sprinkling the design with gold or silver powder, as with *togidashi*, but then covering it with layers of transparent lacquer. Finally, the entire surface was polished so that the decorated area was only slightly raised above the background.

The third *maki-e* process, *takamaki-e* ('high sprinkled picture'), had made its appearance by at least the early fourteenth century. It differed from *hiramaki-e* in that areas of the design were raised, in either low or high relief, using a material such as charcoal powder

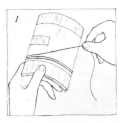
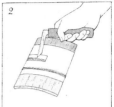
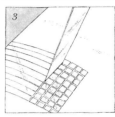
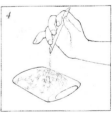

● *GOLD-SPRINKLED LACQUER*
Various stages in the manufacture of gold-sprinkled lacquer: (1) a small sheet of gold leaf, about 2.5 by 1.25 centimetres, was placed on a curved piece of bamboo; this was covered by a sheet of semi-transparent paper which was tied to the bamboo with cord; (2) the gold leaf was cut into thin strips with a blade; (3) after the paper and cord had been removed, the strips were cut in the opposite direction to produce gold powder or squares; (4) the gold powder was then sprinkled on to the wet lacquer surface through a mesh stretched over one end of a bamboo tube.

168

or a compound of grinding-powder and raw lacquer. It was quite common for the combined processes of *hiramaki-e* and *takamaki-e* to be used to decorate a single object.

From the mid-Kamakura period (1185–1392) onwards, gold and silver powders were increasingly used by Japanese lacquer artists in techniques other than *maki-e*. While powder could be sprinkled on to the lacquer, larger pieces were placed individually to produce a mosaic-like effect. Differing effects were achieved by varying the density of the powder and the depth at which it was embedded in the lacquer. The best known gold-sprinkled ground was probably a type known as *nashiji* ('pear ground'), so called because of its resemblance to the granular skin of the Japanese pear. The process involved sprinkling metal powder on to a black lacquer ground and covering it with a yellow-red transparent lacquer.

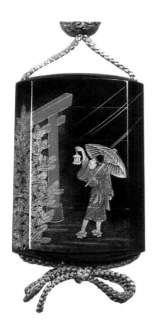

● *Above :* Japanese *inrō*, gold and red *togidashi* on a black lacquer ground, signed Koma Kansai, early nineteenth century. A Shinto priest standing before a *torii* gate in the rain, holding an umbrella and a lantern.
● *Right:* Japanese sample board showing a variety of gold and silver powders sprinkled on to a lacquer ground, late nineteenth century. The finished result differed according to the purity of the metal, the fineness of the powders, and their depth and density in the lacquer base.

Although *maki-e* and other gold-sprinkled techniques were essentially Japanese, Chinese lacquer artists developed alternative gold lacquer techniques, such as gold lacquer painting on a lacquer base. The most important technique, however, was probably that of *qiangjin* ('incised gold'), which first appeared during the early fourteenth century, as well as *tianqi* ('filled-in lacquer'), which was closely associated with it.

With *qiangjin*, a design was etched into a plain black or red lacquer ground. The whole surface was then covered with lacquer, which was wiped off again before it was able to dry, leaving only

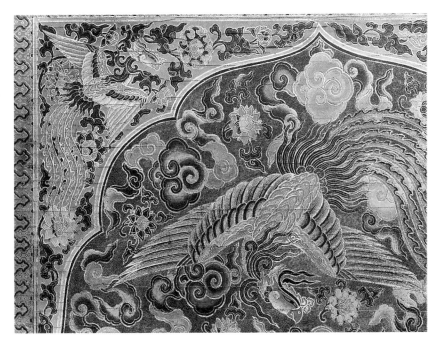

what had collected in the sunken etched lines. This was used as an adhesive for the gold leaf or gold powder which was forced in on top of it. If gold powder rather than gold leaf was used, another layer of lacquer was applied to seal the powder in the etched lines, the remainder again being wiped away.

Although it is recorded that gifts of *qiangjin* lacquer were sent to Japan in 1433 and 1435, the technique did not arouse particular curiosity there, possibly because the *maki-e* techniques were already well established. *Chinkinbori*, the Japanese term for *qiangjin*, did, however, assume a certain degree of popularity during the latter part of the Edo period in response to the demand for lacquer decoration of a novel or unusual kind. The *qiangjin* technique was also introduced to the Ryūkyū Islands, to the south west of Japan, during the fifteenth century, and it was here that some of the finest examples of this type of work were produced.

With the *tianqi* technique incised gold-filled lines associated with *qiangjin* work were used to outline areas of coloured lacquer. This was carried out by two different methods. With the 'wet' method, a lacquer surface was inlaid with lacquer of a contrasting colour while the surface was still wet. Since lacquer dries in thin layers, this method could only accommodate thin inlays.

The 'dry' method, on the other hand, which was the more common of the two, made use of a dried lacquer ground. This meant that a greater depth of lacquer could be cut away for the coloured lacquer inlays in order to secure them firmly. The entire

surface was then polished, and the joins between areas of different-coloured lacquers were incised and filled with gold, as in the technique of *qiangjin*, to cover up any remaining imperfections in the joins and to outline the design. There has been much confusion surrounding the *tianqi* technique since the results often resemble painted lacquer. In Japan the term *Zonsei-nuri* was used imprecisely, referring to both *tianqi* techniques as well as to lacquer painting with few or no gold-filled lines.

INLAID LACQUER

Lacquer readily lent itself to inlaid decoration, the wet lacquer acting as the adhesive holding the materials in place. As early as the Shang period, mother-of-pearl inlays were used on lacquered objects, though it was not until the Tang period (AD 618–907) that this type of decoration came into its own.

The term mother-of-pearl is used to describe the iridescent inner layers of many freshwater and marine shells. The pieces of shell were cut, shaped, polished and set into the lacquer ground, which was usually coloured black or brown to provide a contrast. Incised details could be added once the shell had been firmly embedded in the lacquer. The mother-of-pearl used in early inlaid work was creamy-white in appearance and generally came from the *turbo cornutus*, *turbo marmoratus* or the *nautilus*. The pieces of shell were large and, on account of their thickness, were often raised above the level of the lacquer ground.

Amongst the finest examples of lacquer inlaid with mother-of-pearl are a group of Korean boxes dating from the twelfth and thirteenth centuries. These are either in the form of large *sūtra* boxes or small circular lobed boxes. They have almost identical decoration of tight floral scrolls covering the main surface areas, made up of small and thin pieces of shell, with twisted silver wire forming the stems.

In due course technical advances made possible the production of extremely small, thin slivers of shell. Each tiny piece was shaped and fitted flush with the lacquer surface to form an intricate pattern, a process requiring the utmost skill and precision.

Some of the most notable Chinese inlaid mother-of-pearl is to be seen in the lacquer wares of the fifteenth and sixteenth centuries. The minute pieces of shell were arranged in complex pictorial designs, frequently enclosed within borders of floral and diaper patterns; some of the pieces are so small that it is hard to imagine how they could have been handled and positioned individually in the lacquer. In terms of composition, a number of sixteenth-century examples bear a close resemblance to Chinese painting of

● *Below*: Chinese round box with cover, black lacquer inlaid with mother-of-pearl, sixteenth century. A scholar on a terrace, watching a bird in flight.

171

the Song period (AD 960–1279).

In China and Japan, it became increasingly common to make use of iridescent shell in inlaid lacquerwork, especially the shell of the *haliotis* (Japanese: *awabi*). In general, the thinner the shell was cut, the greater the iridescence. The resulting shades of blue, green, pink and purple were exploited to produce colourful pictorial effects. By the eighteenth century great care was taken to select shell of the appropriate colour for different parts of the design. Additional colour effects were achieved by tinting the pieces of shell or backing them with metal foil.

Lacquer with intricate and iridescent mother-of-pearl inlays was reputed to have been introduced to Japan by Chinese craftsmen. The technique was then learned by the seventeenth-century Japanese lacquerer Chōbei, who subsequently became known as Aogai Chōbei. Whereas in China the term *luo tian* ('shell inlay', Japanese: *raden*) was used to describe all lacquerwork inlaid with mother-of-pearl, the Japanese loosely distinguished between *raden*, for thick inlays, and *aogai* ('blue-green shell'), for thin iridescent inlays.

The latter became popular in Japan in the early eighteenth century, largely on account of the superb craftsmanship of Somada Kiyosuke, whose family carried on the tradition well into the nineteenth century: good-quality lacquerwork inlaid with wafer-thin iridescent shell became synonymous with the name of Somada.

During the eighteenth and nineteenth centuries mother-of-pearl was sprinkled on to lacquer in powder form. It was used in this way for isolated elements of the design and combined decoration.

Mother-of-pearl was not the only material inlaid into lacquer. By the Tang period the practice of inlaying thin metal sheets, usually of gold or silver, was already well established, and it soon spread to Japan. Not until the Qing period, however, was the range of materials increased to include bone, ivory and a wide variety of

● *Above :* Japanese *inrō*, abstract designs in Somada-style lacquer with fragments of tinted shell and gold powder on a lacquer ground, nineteenth century.

● *Left :* Chinese toilet box with lacquer painting and inlaid silver (*ping tuo*), Han period (206 BC–AD 220). The quatrefoil motif on the cover was originally also inlaid with silver.

172

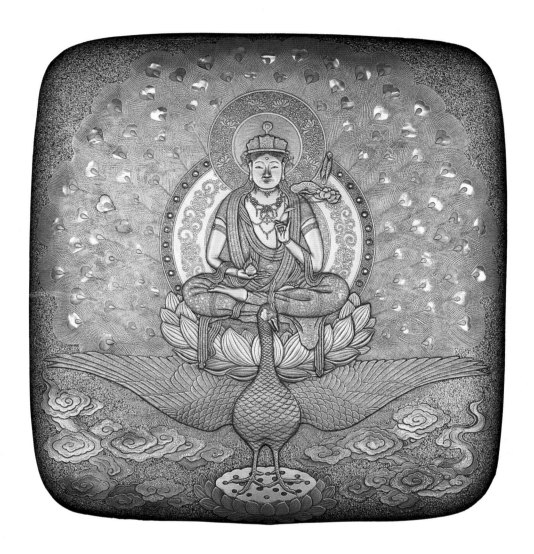

● *Above:* Japanese writing box, with mother-of-pearl inlays on a gold lacquer ground, nineteenth century. The Bodhisattva Kannon is seated on a lotus throne on the back of a peacock which, in turn, stands on a lotus-pod base. The outstretched feathers of the peacock are heightened by the use of small pieces of mother-of-pearl.

hardstones. These were often carved in relief and inlaid in a lacquer base in comparatively large, thick pieces, the decorative effect relying on the contrast of materials, textures and colours. This type of lacquerwork was frequently associated with screens and cabinets intended for export to the Western market.

In Japan, inlaying with metal was taken up by the late sixteenth- and early seventeenth-century lacquer artist Honami Kōetsu, but in a manner hitherto unknown in Japan. He pioneered a style of decoration which combined plain black lacquer and gold *maki-e* with bold, almost impressionistic, inlays of mother-of-pearl, silver and dull base metals such as pewter and lead.

A century later the artist who perhaps more than any other explored the possibilities of inlaid lacquerwork was Ogawa

Haritsu, better known by the name Ritsuō. He not only extended the materials in use to include coral, jade, tortoise-shell and pottery, but also perfected techniques which involved using the lacquer medium to simulate the appearance and texture of other materials such as wood, stone and metal.

The Shibayama school, working under the influence of Ritsuō, was established during the late eighteenth century, and it continued to flourish well into the nineteenth century. The artists used a wide variety of materials, usually inlaying them in a gold lacquer ground. Their work is characterized by the minute size of the pieces of inlay, which were often intricately carved and applied to the base in such a way that they stood out in high relief. The Shibayama, like the Somada, had a preference for decorating small format articles such as the *inrō* (see p. 176), the scale of which was appropriate to the minuteness of their style of decoration.

COROMANDEL LACQUER

Coromandel is a type of lacquer in which carving, lacquering and oil painting are combined in a distinctive manner. It was first made in China for the home market during the seventeenth century and, from the mid century onwards, it was exported to Europe by way of the East India Company. The term Coromandel, as used in the West, derives from the fact that the wares were shipped from the Coromandel Coast of south-east India.

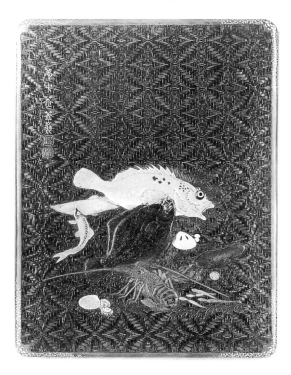

● *Left* : Japanese paper box (*ryōshibako*), lacquered woven bamboo with encrustations of lacquer, painted pottery and horn, by Ogawa Haritsu (1663–1747), also known as Ritsuō, early eighteenth century. Fish, shellfish and crustacea.

The methods used to produce Coromandel involved covering a solid wooden base with a white compound, which contained clay mixed with lacquer, to a thickness of approximately 1 centimetre. The surface was smoothed down before several layers of brown or black lacquer were laid over it. Designs were then carved through the lacquer to the level of the white compound, and the effect was enhanced by filling these areas with pigment combined with oil or lacquer, though not up to the level of the surrounding surface. The technique is seen at its best in large six- or twelve-fold screens.

Lacquer has many different uses. Its resistance to acid has made it useful for laboratory work-surfaces, while its ability to resist the corrosive effects of the sea air have made it a useful material for the interior fittings and decoration of ships. The fact that lacquer can withstand water and high temperatures has also made it a useful covering for many domestic and culinary objects and implements.

Articles connected with the preparation and eating of food, such as *sake* cups and bottles, sweetmeat boxes, picnic sets, bowls and trays, form an important part of lacquer output, particularly in Japan. Lacquer articles for everyday use included clothes chests and clothes stands, low writing tables, cages for birds and insects, palanquins and domestic shrines, as well as toilet articles such as

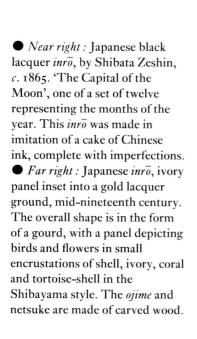

● *Near right :* Japanese black lacquer *inrō*, by Shibata Zeshin, *c.* 1865. 'The Capital of the Moon', one of a set of twelve representing the months of the year. This *inrō* was made in imitation of a cake of Chinese ink, complete with imperfections.
● *Far right :* Japanese *inrō*, ivory panel inset into a gold lacquer ground, mid-nineteenth century. The overall shape is in the form of a gourd, with a panel depicting birds and flowers in small encrustations of shell, ivory, coral and tortoise-shell in the Shibayama style. The *ojime* and netsuke are made of carved wood.

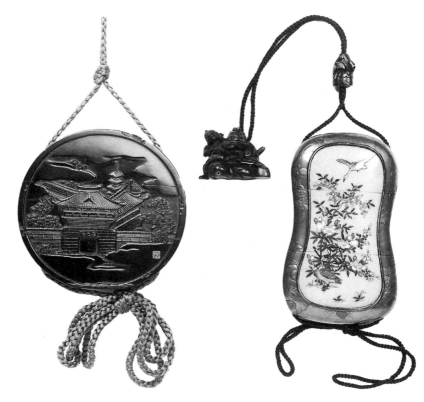

175

combs, brushes, hairpins, mirrors and cosmetic boxes. Lacquer was used in the manufacture of boxes of different sizes and shapes serving a variety of functions. A notable example was the Japanese writing box, which contained the implements for writing.

THE JAPANESE INRŌ

The *inrō* ('seal basket') was developed <u>initially</u> in the lacquer medium. Peculiar to Japan, it was originally designed to hold the owner's carved seal, together with red seal paste, but it gradually became more widely associated with carrying medicines. The *inrō*, almost exclusively worn by men over the hip on the right-hand side, was used by all except those from the lowest strata of society.

In its fully developed form the *inrō* was composed of from one to seven superimposed cases, fitting tightly into one another and closed at the top with a lid. It was, on average, 7 to 10 centimetres high and generally ellipsoid in cross-section. A silk cord was threaded through cord channels at either side of the body and passed through the *ojime* ('sliding bead') above. When not in use, the *ojime* was pushed down as far as possible towards the body, causing the cord to tighten around the interlocking compartments. The cord was secured above the *inrō* and *ojime* by means of a <u>netsuke</u>, the function of which was to provide the means of suspending the *inrō* securely from the belt.

Although the *ojime* and netsuke were necessary if other pouches were to be suspended from the belt, they were regarded as an integral part of the *inrō*. It was customary, therefore, for the *inrō*, the netsuke and, to a lesser extent, the *ojime* to corrrespond in style even though they were <u>generally</u> made by different craftsmen.

In the early stages of its development the *inrō* was primarily a functional object and any surface decoration was of lesser importance. In time, however, it became a fashionable accessory to Japanese dress and its success depended on the decorative treatment of the surface. The role of the *inrō* in Japan has often been <u>compared</u> to that of jewellery in the West.

Although the *inrō* was of a standard form, dictated originally by functional requirements, a degree of modification to the shape was possible. This could be achieved by altering the usual rectangular face to one of circular, hexagonal or octagonal silhouette, or by expanding the elliptical cross-section to form a cylinder. At the same time ways were found of making the best use of the surface area. These included creating designs which extended over both main sides of the body and were often intended to draw the viewer's eye round the body. Some of the <u>finest</u> examples of lacquerwork <u>ever</u> produced were in the *inrō* format.

● *Right :* Part of a Chinese twelve-fold Coromandel lacquer screen, dated 1681. A continuous scene depicting various activities around a lake, with borders decorated with precious objects and calligraphy.

● THE JAPANESE *INRŌ*
(1) netsuke; (2) continuous length of silk cord threaded through cord channels around the *inrō* and (3) arranged in a bow at the bottom, with the two ends secured in the netsuke; (4) *ojime*, or sliding bead, for opening or securing the interlocking compartments; (5) individual compartment; (6) riser, which fits tightly into the base of the compartment above; (7) elliptical cross-section; (8) closed compartments, forming an unbroken surface for decoration.

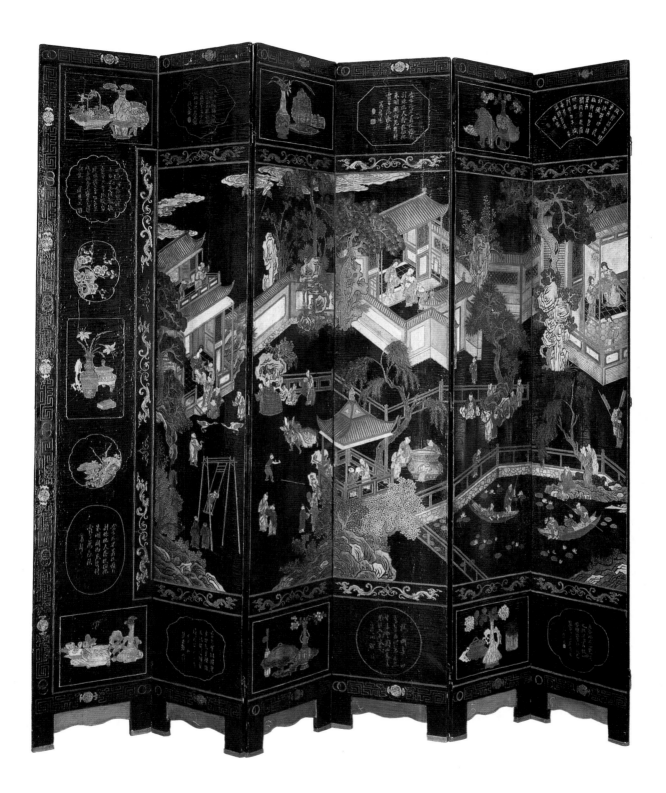

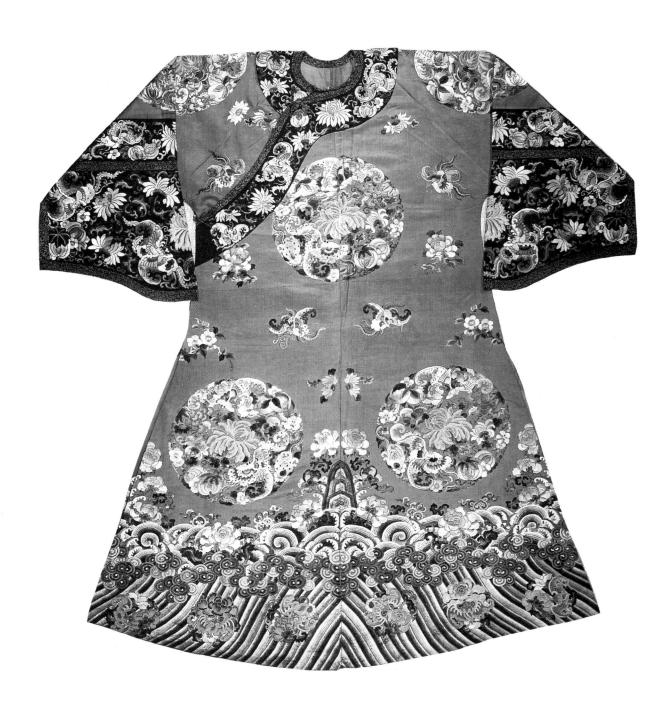

Chapter 7

TEXTILES AND DRESS

THE main function of clothing is to provide some form of protection against the elements, in accordance with prevailing social conventions. From an early date clothing developed as a focus for decorative attention in the Far East, and it has remained one of the most fundamental forms of personal expression, while also reflecting the social hierarchy in China and Japan. The need to supply the upper levels of society and the wealthy with good-quality clothing provided the greatest stimulus to the textile industry.

SILK

Chinese legend ascribes the introduction of silk to the mythological empress Xi Ling Shi, wife of the Yellow Emperor, who, during the third millennium BC, was reputed to have instructed the people in sericulture. The earliest known silkworm cocoon was found at the Neolithic site of Xiyin cun in Shanxi province (*c.* 2200–1700 BC), but it is not certain whether, during this period, the knowledge of how to obtain silk from it had been acquired. By the Shang period (*c.* 1600–1027 BC) silk technology was already comparatively sophisticated, as shown by archaeological finds of patterned weaves. Silk, as well as coarser fabrics, is known to have been used at that time to wrap bronze and jade burial objects, for an imprint of the fabric has remained on the surface of some of the objects.

Amongst the different species of silkworm there was only one which could be reared on picked leaves and which could, therefore, be raised intensively and in a controlled environment, namely the *Bombyx mori*. The diet of the *Bombyx mori* was traditionally the leaves of the mulberry tree, and large plantations were established to satiate its needs.

In the life-cycle of the silkworm the larva, or worm, begins to feed on the leaves soon after emerging from the egg. The feeding period lasts approximately 30 days, during which time it grows enormously, undergoes a series of moults and assumes the appearance of a caterpillar. It might eat as much as 20 times its own bodyweight in leaves during the last few days before it stops feeding and is ready to spin its cocoon. To do this, the worm pushes out filaments from glands on either side of its body which are

● *Above :* Chinese watercolour on paper, nineteenth century. A Chinese official wearing a dragon robe with full accessories, including a collar, beads, belt, and a winter hat with hatspike and a plume of peacock feathers.
● *Left :* Chinese robe, embroidery on turquoise twill weave silk, nineteenth century. A woman's robe decorated with roundels of flowers and bats, with stylized waves and mountains along the bottom. The shape of the sleeves is a vestige of the horsehoof cuffs of earlier Qing robes.

179

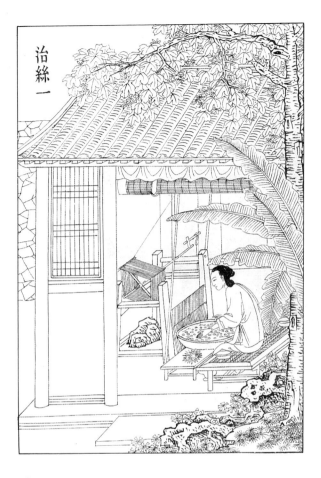

● *Left*: Chinese woodblock print from the book *Tian gong kai wu* by Song Yingxing, first published in 1637. This is one of a series of illustrations of sericulture and silk weaving in the book; it shows a woman unwinding silk thread from the cocoons, which are in a container of hot water, on to a square reel.

combined into a <u>single</u> thread by means of a gummy substance known as <u>sericin</u>. The silk thread is wrapped around the worm to form a cocoon in which the moth develops.

In the normal course of events a moth would emerge from the cocoon some ten days later. Since this would involve breaking through the long and continuous thread of the cocoon, in sericulture it was necessary to wind off the silk before this occurred or (as was the usual method) to kill the moth by steaming it while it was still in the cocoon.

In order to reel the silk the cocoons were placed in hot water, which caused the sericin to dissolve slightly. It was then possible to pick up the various thread ends from different cocoons by agitating a bamboo comb in the water. For the purposes of reeling, a specific number of strands were separated from the rest <u>according to</u> the quality of the thread required: six or seven threads for the finest quality, and around 25 for the coarser grades, the sericin causing the threads <u>to combine</u> in both cases. These were passed through an eye and on to a square reel by means of a foot-operated treadle. By a process known as 'throwing,' it was also possible to twist the

threads together but, although this increased the strength of the thread, it removed some of its lustre.

Each cocoon yields approximately 500 metres of continuous silk thread. During reeling, as each thread neared its end, another was skilfully joined to it. Silk floss of coarse, uneven quality from the ends of the cocoon, together with any broken bits of thread, could be spun together to form spun silk.

Throughout history silk has been an expensive commodity. A vast number of silkworms is required – a recent Chinese publication quoted 6,000 as being the number needed to produce 1.7 square metres of fabric – and specific conditions are demanded for successful rearing, together with careful supervision. The end result, however, is ample reward for the time and effort expended on its manufacture. Soft, supple, fine and highly lustrous, silk has always been regarded as one of the most luxurious natural fibres. It has an important advantage over other natural fibres in that silk is an even thread of enormous strength. The use of silk for the longitudinal warp threads, which normally take the strain in weaving, makes possible the production of fabric of almost infinite length.

● *Below :* Japanese woodblock print, from the book *Sankai meisan zue,* 1799. Men and women can be seen spinning, reeling and hanging out the skeins while the weaver is engrossed in his work at the loom.

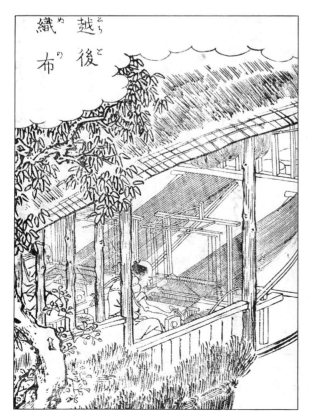
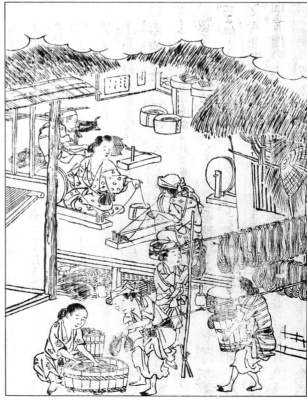

During the Han period (206 BC – AD 220) examples of Chinese silk reached the Middle East, and beyond to the shores of the Mediterranean, including parts of the Roman Empire. Far superior to any existing fabric manufactured at that time outside China, its impact was enormous. The subsequent demand for silk resulted in a flourishing trade along the caravan routes of Central Asia, known collectively as the Silk Route after its most important commodity. Excavations at oasis sites have yielded fragments of numerous different textiles which the dry soil conditions have helped to preserve. The most significant, carried out by Sir Aurel Stein between 1900 and 1916, centred on the site of Loulan.

In an attempt to maintain their monopoly of the silk trade, the Chinese kept the details of sericulture a closely guarded secret. According to the Byzantine historian Procopius, eggs of the *Bombyx mori* silkworm were smuggled into the Byzantine Empire and presented to the Emperor Justinian during the sixth century AD. It was, in any case, at around this time that sericulture and silk technology spread to the West.

Silk has traditionally played an important part in Chinese culture. Not only was it an important ground used in painting, but it was also the material most widely used in the manufacture of clothing, for all but members of the lowest strata of society would have possessed at least one silk garment. For those who could not afford silk, hemp was generally used for clothing and, subsequently, cotton, which was introduced from India during the twelfth century, spreading to Japan in the sixteenth century.

Although China has never been renowned as a major wool-producing area, supplies of wool were imported from Tibet and, especially, from Mongolia, with its lush areas of grassland. In China, wool was not traditionally used in the manufacture of clothing, but the soft and resilient quality of the imported material made it ideally suited to carpet weaving.

CHINESE CARPETS

The majority of Chinese carpets were composed of a foundation of cotton threads, with warps of a single strand. The wefts generally occurred in a sequence of two rows of wefts, a row of knots, followed by another two rows of wefts, a row of knots, and so on. The pile was composed of wool or, more rarely, silk knots. The knot was formed by wrapping the wool around pairs of warp threads in a symmetric Turkish knot, or in an asymmetric Persian knot at either end of each row to provide a firm edge. After each knot had been tied, it was cut to an average height of between 10 and 20 millimetres and, after each row had been completed, the

● *Right :* WEAVES
(1) plain or tabby weave, in which the weft passes over and under alternate warps; the order is reversed in the next row; (2) twill weave, in which the weft passes over two or more warps and then under one or more; each subsequent row starts one warp to the left or right; (3) satin weave, in which the warp passes over at least four wefts before being secured with one weft thread; (4) gauze weave, in which pairs of warp threads are crossed or twisted before passing over or under a weft thread.

● *Below :* KNOTS USED IN CHINESE CARPETS
Both knots involved wrapping the wool round pairs of warp threads: (1) Turkish or symmetric knots; (2) Persian or asymmetric knots.

1

2

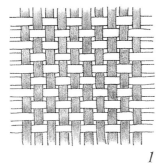

1

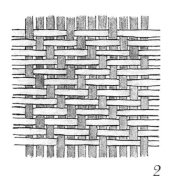

2

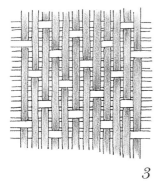

3

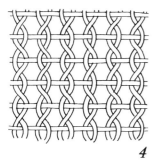

4

knots were secured with a pair of weft threads. The Chinese carpet was made on a vertical loom, working in horizontal rows from the bottom upwards.

Chinese carpet weavers generally worked from designs supplied by professional painters. These were reproduced on thin paper and transferred to the warp threads. In the case of a monochrome carpet, a sculpted effect was achieved by cutting the pile on two levels after the completion of weaving. Alternatively, the outline of a design could be highlighted by cutting the pile at an angle.

The floor carpet was <u>not</u> integral to the traditional Chinese interior since the summer <u>heat</u> and humidity would have rendered it impractical. The Chinese carpet fulfilled a decorative rather than a practical function: it was an article to drape over a table or low bench, a temple hanging, a saddle rug, or, shaped, to provide a seat cover. In the regions of north China, which experience cold winters, rugs were spread over the *kang*, a raised rectangular platform of unbaked bricks on which people slept. Also, long narrow pillar carpets, usually in pairs, were designed to be secured around the wooden pillars of temples, palaces and other important buildings on religious or festive occasions. The design, frequently that of a coiled dragon, was cleverly conceived so that, when the carpet was wrapped completely round a pillar, it would form a <u>continuous</u>, circular motif.

TYPES OF WEAVE

The weave of a fabric is dictated by the order in which the <u>warp</u> (longitudinal) and <u>weft</u> (transverse) threads are interlaced. The basic method, known as plain weave, or tabby, involves passing the weft over and under alternate warps in one row, and reversing the order in the next row, and so on. Twill is formed by passing the weft over two or more warps and then under one or more warps in the same row, in the next and subsequent rows continuing the same sequence but starting one warp space to the right or left. This results in a weave with a <u>diagonal</u> appearance. When a particular sequence involves weft threads which pass over a large number of warps, the resulting long threads exposed on the surface are known as floating threads. Satin, characterized by long floating warp threads, is produced by passing the warp over at least four wefts before anchoring it with one weft thread. The result is a surface consisting predominantly of warp threads. Within a particular weave type it is also possible to <u>vary</u> the basic weave to produce areas of pattern woven into the fabric.

Gauze is another type of fabric used in the Far East. This is made by crossing or twisting pairs of adjacent warp threads each

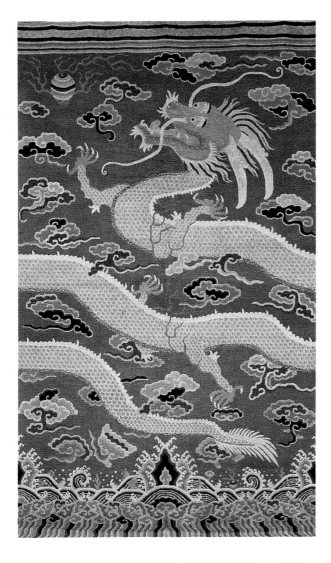

● *Left :* Chinese pillar rug, nineteenth century. A five-clawed dragon chasing a flaming pearl among clouds. The segments of the dragon's body connect up when the rug is wrapped around a pillar.
● *Below :* Pair of Chinese chair covers, coloured cut silk velvet, nineteenth century. The four main decorative panels depict the *shou* 'longevity' character, a dragon, an endless knot and a lion.

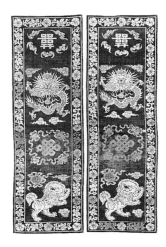

time before passing the weft. As it is generally a lightweight fabric with an open weave, it was much used in China for summer clothes.

The main production of velvet in China began during the late sixteenth century under the direct influence of imported Spanish examples. Silk velvet weaving involves the use of a secondary warp in order to produce a pile above the ground weave. The pile consists of raised loops, formed by inserting small rods into the secondary warp. The rods are then either pulled out, leaving loops of uncut pile, or cut out, to produce tightly packed silk tufts with the characteristic shine and softness associated with velvet. When the pile is cut, the fact that the secondary warp is interwoven with the main ground serves to keep the tufts in place. In examples of *ciselé* velvet the contrast between areas of cut and uncut pile is used to form the pattern. A further distinction exists between solid

● *Above, top:* VELVET
The dark thread represents the secondary warp used to produce a pile of raised loops: (1) uncut pile; (2) cut pile; (3) voided velvet, where the secondary warp is woven into the ground.

● *Above, bottom: KE SI*
Ke si (woven silk tapestry) is built up of blocks of woven colour. If a colour join runs in a warp direction for more than two rows, a vertical slit is formed.

● *Right:* Chinese *ke si* rank badge, sixteenth or seventeenth century. A pair of phoenixes in flight, with peonies, clouds and waves.

velvet – where the pile is distributed over the entire surface ground regardless of whether or not it is cut – and voided velvet. In the latter there are areas where the secondary warp is woven into the ground instead of being raised to form a pile. Chinese, and to a lesser extent Japanese, velvet is also distinguished by the double-woven edges which produce tubular selvages.

A weaving technique particularly associated with China is *ke si* ('cut silk'), which is often referred to as woven silk tapestry. It is made up of different-coloured threads which appear in blocks of colour on a plain-weave ground. Instead of passing backwards and forwards across the full width from selvage to selvage, the coloured threads interlace with the warp threads only where that colour is needed in the design. Where blocks of different colours meet, the weft turns back around the warp it has just crossed and continues interweaving in the opposite direction. If the colour join runs in a warp direction, the colours do not interweave, which results in a vertical slit. In order to minimize any weakness in the fabric that this might cause, the overall design of *ke si* is carefully planned to avoid long vertical slits. Apart from the vertical slits, Chinese *ke si* is distinguished by its use of undyed warp threads, which are covered by the coloured wefts, and by the exclusive use of silk for the ground weave, although the overall effect may be enhanced with gold and silver threads.

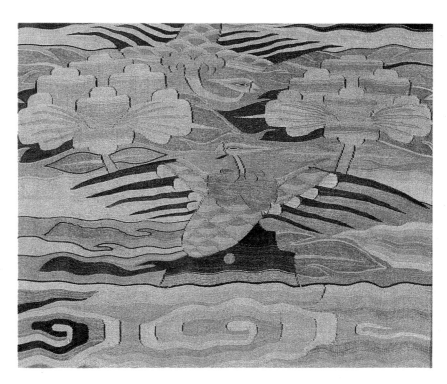

Woven silk tapestry was produced in China at least as early as the Song period (960–1279), though the term *ke si* does not appear to have been used before the twelfth century. The fact that the weft threads were not passed from selvage to selvage allowed for greater freedom of design. It was partly for this reason that *ke si* was used as an effective medium to reproduce the effects of painting. It was also widely used during the Qing period (1644–1911) for the manufacture of clothes, particularly dragon robes (see p. 189) and rank badges (see p. 192), and as a furnishing fabric.

CHINESE DRESS

The fact that articles of dress have not survived in large quantities, especially those of an early date, is largely because the fabrics were of a non-durable nature and were subject to wear and tear through repeated use. They were discarded when no longer serviceable or when fashions changed. Most examples of Chinese dress that do survive date from the latter part of the Qing period.

During the Qing period China was ruled by the Manchu people, who came from beyond its north-eastern borders. On the one hand, the Manchus had a deep respect for Chinese civilization and retained many existing institutions and traditions; on the other hand, they recognized their difficult position as foreign rulers and endeavoured to impose certain aspects of their own cultural identity on the Chinese people. A change in the style of dress was an example of this endeavour. In addition, as a form of humiliation and as proof of submission to the Manchu rulers, male Chinese were obliged to shave the front of their heads and to wear the rest of their hair in a plait.

Since traditional Manchu dress was not suited to the sophistication of Chinese official life, Qing period dress developed as a synthesis of Manchu styles combined with traditional Chinese styles. Some one hundred years after the beginning of the Qing period, the emperor Qian long instigated the codification of official dress and its accessories, which applied to all levels of the civil service up to the emperor himself, in order to regulate and standardize it. This resulted in the illustrated catalogue of ritual paraphernalia, *Huang chao li qi tu shi*, first published in 1759.

Chinese dress traditionally consisted of different layers of clothing worn under a robe, which was the focus of decorative attention. The number of undergarments worn varied according to the time of year. During the colder months, for example, several layers were worn, while the outer robe was sometimes edged or lined with fur. It was also customary to wear robes with a layer of wadding between the lining and the outer surface, which was held

● MEN'S *CHAO FU*
Features of the men's *chao fu* of the Qing period (1644–1911): (1) upper part of the garment, with neck and side fastenings; (2) skirt, in two sections; (3) small square, known as the *ren*, of uncertain function, but possibly a vestige of some earlier method of fastening or of a scabbard slide; (4) horsehoof cuffs; (5) long, close-fitting sleeves, often with a decorative band of horizontal lines.

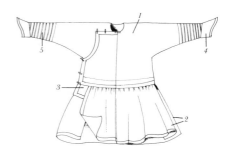

186

in place by vertical lines of quilting. Thin, light fabrics, such as silk, gauze and cotton, were worn during the hotter months. While dark colours, such as mauve, were associated with winter dress, pale blue and other light colours were associated with the summer. The use of some colours, however, was <u>restricted</u> to certain officials: yellow, for example, was reserved for imperial use during the Qing period, though this was <u>not always</u> rigidly adhered to.

During the Qing period the most formal attire was the audience robe, or *chao fu*. It was worn by men at important court ceremonies and annual sacrifices, as well as in the presence of the emperor on

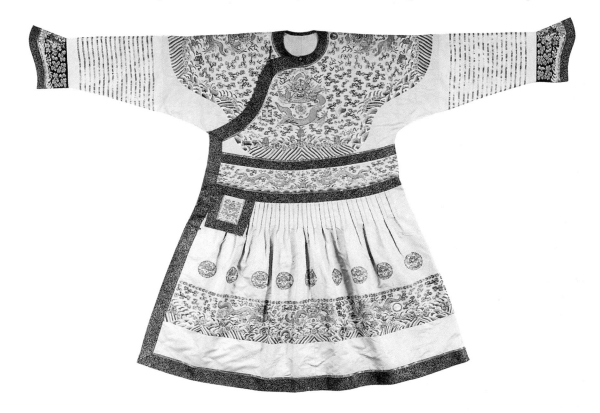

● *Right :* Chinese robe, embroidery on yellow twill weave silk, late nineteenth century. A man's *chao fu* decorated with four dragons around the neck-opening amongst stylized clouds, waves and mountains, together with the Twelve Symbols.

formal occasions. It consisted of a full skirt, which was made up of two sections overlapping at either side of the body. The skirt was gathered on to a band in small pleats and stitched to the upper part of the garment. Examples of a single garment with a pleated skirt have been excavated from two separate tombs of the Ming period (1368−1644), which would suggest that the Manchus adopted an existing, but not widely used, type of Chinese garment. To this, however, were added features derived from clothes traditionally worn by them for horseriding. These features included long, <u>close-fitting</u> sleeves with bow-shaped extensions over the hands, known as horsehoof cuffs, which kept the hands warm and prevented cold

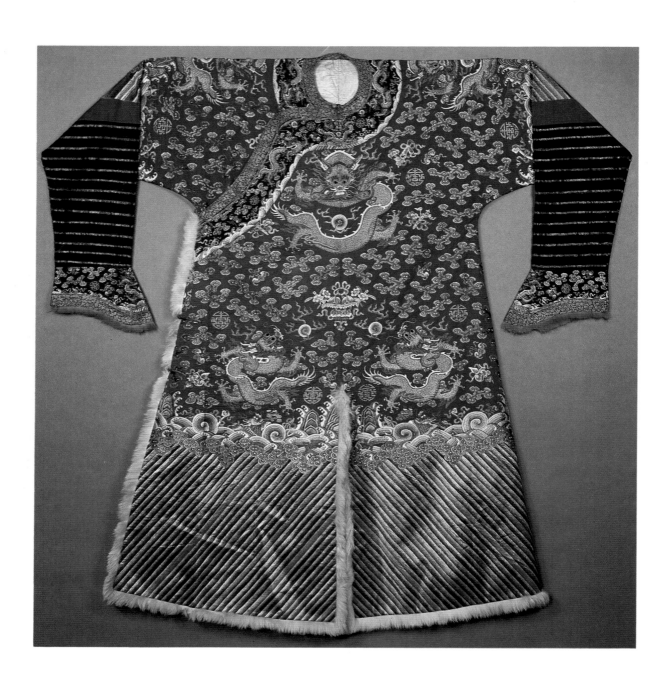

188

● *Left :* Chinese robe, late nineteenth century. A man's dragon robe, embroidered with dragons chasing flaming pearls amongst clouds, with the Eight Daoist Emblems. The fact that the robe is made in colours associated with the cold months of the year and is edged with fur implies that it was made for winter use.

Right : Chinese robe, late nineteenth century. A man's dragon robe in yellow *ke si*, with metallic thread, and with painted and embroidered details.

● MEN'S *LONG PAO* AND *PU FU*

Features of the men's *long pao* ('dragon robe') and *pu fu* of the Qing period:

Long pao (foreground): (1) lower section of the sleeve, including the horsehoof cuff, which was stitched on to one of the main body pieces; (2) decorative edging with neck-opening; (3) additional section of fabric to provide an overlap; (4) side and central vents (the central vents were omitted on the women's equivalent robe).

Pu fu (behind): (5) short wide sleeves; (6) rank badge, which was also worn on the back; (7) central opening.

draughts blowing up the sleeves. When the extensions were not required, they could be turned back and the sleeves pushed up, causing ruching of the fabric along the length of the arm. In Qing dress the ruching was gradually modified to a decorative band of horizontal lines along a section of the arm, either woven, embroidered or in a contrasting fabric.

Of all the garments worn during the Qing period, the best known is the so-called dragon robe, or *long pao*. In its fully developed form this was a full-length robe with tapering sleeves ending in horsehoof cuffs similar to those found on the *chao fu*. It was composed of three main pieces with centre seams at the front and back: left front and back in one piece; right front and back in another; and an additional front piece to provide an overlap. Since the upper part of the sleeve was integral with the two main body pieces, the length of the sleeve was restricted by the width of the material. Lower sleeves were, therefore, attached to them, frequently in a plain, contrasting material, often that of dark blue silk with ribbed lines in gold.

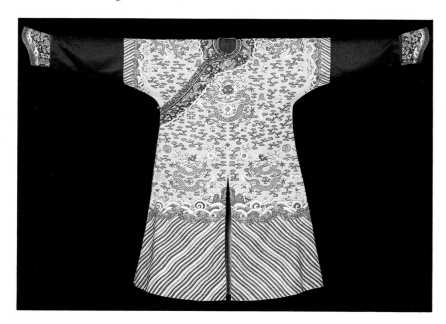

The robe was fastened by means of buttons and loops along the top edge of the overlapping piece in a line from the neck-opening down to under the wearer's right arm and then down the right side. For ease of movement side vents were also left on the lower part of the robe: those at the centre front and back were left over from Manchu clothing, which was adapted for horseriding.

While the *chao fu* was reserved for important state and official occasions, the dragon robe was the standard clothing for men on

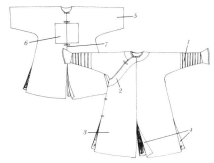

official business. It was worn for everyday life at court and by lesser officials in far-flung government posts of the Chinese Empire.

Women wore a garment similar to the men's dragon robe, the main difference being that it had no centre front and back vents on the lower part of the robe and that it had extra sleevebands. In general, however, the cut and design were less rigidly controlled.

DECORATION OF CHINESE ROBES

The dragon robe derives its name from the ubiquitous dragon motif, which was the main element of the design. In China, from at least as early as the Song period, the dragon was adopted as a a symbol of authority, and subsequently became closely associated with the emperor and the imperial household. Strictly speaking, the use of the dragon depicted with five claws was reserved for the emperor and his immediate family, though this was not always adhered to, particularly during the nineteenth century. Although the dragon was traditionally a Chinese motif, it was readily adopted by the Manchu as a symbol of their authority.

On the Qing dragon robe, in its fully developed form, there was a standard distribution of dragons over the surface: four dragons, depicted full-on, were positioned around the neck, occupying the centre front and back, as well as the two shoulders; a pair of dragons in profile were placed symmetrically about the central seam, both at the front and back, towards the lower part of the garment; another one, normally hidden from view, was depicted on the inner front beneath the shaped flap.

During the Qing period other stylized motifs began to appear and were used in conjunction with the dragon. Water, the natural home of the beast, was portrayed as thin diagonal stripes with waves foaming on the surface. Initially the motif was confined to a narrow band along the bottom of the robe, but gradually it came to occupy anything up to one quarter of the area in height. Rising from the water at the centre and sides were prism shapes representing mountains. The water motif was repeated in a narrow band on the sleeves, at the joins between the main and the lower sleeves.

The dragons on the upper part of the robe were set against a background of clouds; their other natural habitat. Other motifs were often depicted amongst the clouds or on the surface of the water. They included the Eight Daoist Emblems and Eight Precious Objects, in various configurations, not always in complete sets.

The so-called Twelve Symbols (officially) appeared only on the dragon robes and *chao fu* of the emperor and his immediate family, though this was not always the case. They frequently conformed to a standard, though not fixed, disposition over the surface and were

● WOMEN'S *CHAO FU* AND JACKET
Features of the women's *chao fu* and jacket of the Qing period:
Chao fu (foreground): (1) inset sleeves; (2) flaring projections, though sometimes only decorative bands; (3) side vents (no central vent).
Jacket: (4) centre front opening.

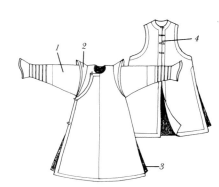

● THE TWELVE SYMBOLS
(1) sun; (2) moon;
(3) constellation; (4) mountains;
(5) dragons; (6) pheasant;
(7) bronze sacrificial cups;
(8) water weed; (9) grain;
(10) fire; (11) axe; (12) *fu*
symbol.

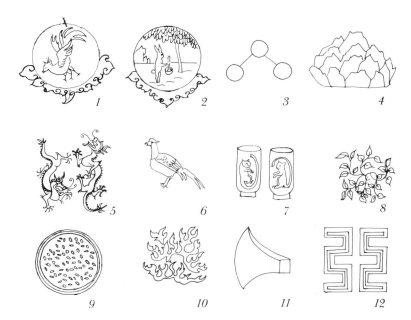

often combined with dragons and other motifs associated with dragon robes. Some of the motifs which make up the Twelve Symbols were used individually from an early date in China, but it was not until the Qing period that their combined use was formalized. Over the years much of the original meaning of the Twelve Symbols has been lost, resulting in a tendency to over-emphasize their symbolic value. It is, perhaps, more appropriate to see them as no more than symbols of the power and authority vested in the emperor.

During the Qing period fewer formal occasions were attended by women. There was, nevertheless, a female version of the *chao fu*. It was similar to the dragon robe with the main difference that the sleeves were inset instead of being integral with the two main body pieces. This feature is thought to reflect the fact that the garment owed its origins to the combination of a robe with a sleeveless full-length coat, the shoulder seams of the inset sleeves representing the outline of the original coat; decorative bands and flaring projections along the seams also derived from the same source. Another difference lay in the use of sleevebands on the lower part of the sleeves. At the height of the Qing period the woman's court robe was worn with a sleeveless, full-length coat, which was similar in material and design.

On formal occasions both the man's and woman's dragon robe was worn with a *pu fu*, or outer coat. The *pu fu* was a plain, dark garment, generally of dark blue silk, with wide sleeves and a centre front opening. Because it was shorter in length than the dragon robe, as also were the sleeves, the wave design on the lower part of the dragon robe and horsehoof cuffs remained visible and

contrasted with the plain, dark surface of the *pu fu*. The decorative feature on the outer coat was a square insignia of rank, sometimes referred to as a mandarin square. The practice of wearing bird and animal motifs to denote rank was already established by the Ming period. In 1652, during the early years of Manchu rule, it was established that a *pu fu* bearing a square rank badge was to be worn over a dragon robe. The insignia to which each official and member of the imperial household was entitled were also regulated. The outer coat of the emperor, for example, had four dragon roundels, two on the shoulders and one each on the front and back; the ranks of civil officials were distinguished by birds and those of military officials by animals, both real and imaginary.

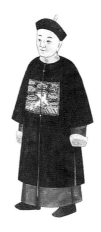

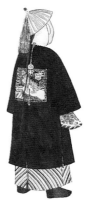

The insignia of rank were frequently embroidered or executed in *ke si* and stitched on to the front and back of the garment, the one for the front being in two halves to accommodate the centre front opening. The bird or animal faced the wearer's right on the front, while this was reversed on the back. Women sometimes wore the insignia of their husband's or father's rank, though there was no formal occasion when this was strictly necessary.

DRESS ACCESSORIES

During the Qing period a number of accessories were used in conjunction with the dragon robe and outer coat, such as the hat, belt, beads and collar. A wide, flaring, triangular-shaped collar, or

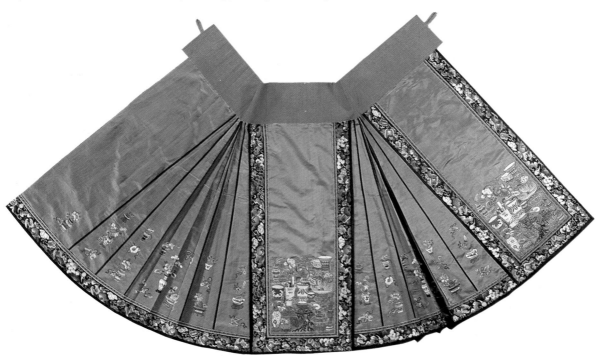

● *Left, top :* Pair of Chinese watercolours on paper, nineteenth century. Officials in formal dress: a ninth-rank civil official (top), and a fourth-rank military official (below). From the album *Court costume of civil and military officials of the Qing dynasty.*

● *Left, bottom :* Chinese skirt, late nineteenth or early twentieth century. A woman's skirt in satin weave silk, with embroidery depicting antique objects and collector's items, fruit and flowers.

● WOMEN'S SKIRT AND SHORT JACKET
Features of one style of skirt-and-jacket combination of the Qing period:
Skirt: (1) embroidered panel of the first section of the skirt that would fit over the less-decorated panel of the second section of the skirt; (2) section of pleated fabric; (3) waistband.
Jacket: (4) side vent.

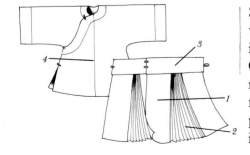

pi ling, which fell over the shoulders, was worn by both men and women with the *chao fu* and also frequently by men with the dragon robe.

One of two different types of hat was worn by officials, according to the season. The winter hat consisted of a close-fitting, dome-shaped crown with an upturned brim in dark satin. For the hotter months a conical hat was worn. This was made of finely split cane or straw and covered with silk gauze. From the apex of both types a tassel of red silk cord or dyed horsehair splayed out over the main body of the hat. On top of this was a spherical hat knob, for everyday use, or a hatspike surmounted by a knob, for formal occasions. To indicate the wearer's rank these knobs were made from precious or semi-precious stones, or from metal, though from 1730 onwards glass substitutes were permitted. As a reward for service plumes, usually of peacock feathers, could also be worn.

A long string of beads, worn over the *pu fu*, was also a part of official dress for all but officials of the lowest rank. It was made up of 108 beads, divided into four sections by marker beads in accordance with the traditions of Buddhist prayer beads. From this main loop hung three short strings, which were worn at the front, while a long string with an ornamental plaque hung down the back. The beads were made from a wide variety of materials, including precious and semi-precious stones, metal, wood, ivory and glass.

The dragons on the man's dragon robe were carefully positioned so as to allow a belt to be passed around the waist without it obscuring any of the main decorative features. The belt, which was made of woven silk, was fitted with four circular or rectangular plaques, one each at the front and back, and one at either side. The various materials of which the plaques were made – jade, gold, silver and horn – served to differentiate between the various groups of officials. Because there were no pockets in traditional Chinese dress, various articles were suspended from the belt. The side plaques of the belt had loops, from which hung such items as fans, chopsticks and spectacles in their cases, and also pouches.

CHINESE WOMEN'S DRESS
Since women were largely excluded from official life, their clothing was not subject to the same strict regulations as those of the men. It is hardly surprising, therefore, that some of the finest examples of Qing dress were worn by women. Apart from the most formal robes, female dress of the period falls largely into two groups: the full-length robe, which was originally associated with the Manchu people, and a shorter robe worn over a skirt, which owes more to indigenous Chinese traditions.

The skirt consisted of two separate sections, each of which was made up of pleats flanked by two straight panels, one decorated and the other almost entirely plain. The decorated panel of one was laid on top of the undecorated panel of the other and attached to the waistband. The skirt was then wrapped around the body over a pair of leggings or trousers, and secured with tape and loops at the waistband so that the remaining undecorated area was covered by the decorated panel. Most of the decoration was on the lower part since only this was visible under the three-quarter length robe which was worn over it. The robe had seams at the centre front and back, as well as wide sleeves cut all in one with the main body pieces. A sleeveless coat could be worn on top of the skirt and robe.

As the Qing period progressed the full-length robe associated with the Manchus was increasingly influenced by traditional Chinese styles. The tapering sleeves with horsehoof cuffs, for example, gradually became shorter and wider. In time the lower part of the sleeve disappeared altogether. Sleevebands and edgings were increasingly used to emphasize the outline and form of the robe, and to complement and contrast with it.

● *Left :* Chinese robe, nineteenth century. A woman's robe in *ke si*, with the *shou* 'longevity' character in metallic thread. Decorative bands have been used along all the edges, including those of the short, wide sleeves.

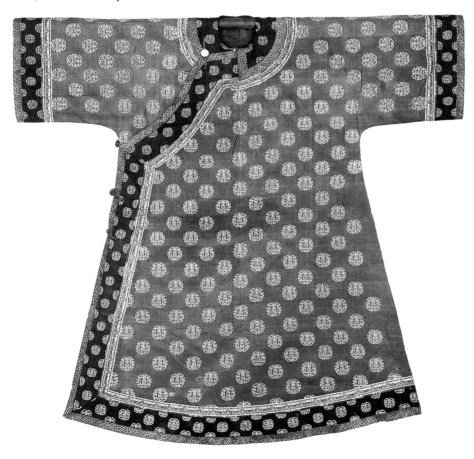

The custom of footbinding, which dates back to the Song period, was at its height during the Qing. The process began when bandages were tightly bound around the infant girl's foot in order to break the arch and turn the toes under. Highly embroidered shoes with heightened soles were made to fit the tiny deformed feet that were so much admired by the male population. The fact that walking any distance was painful served to reinforce the subservient role of women.

EMBROIDERY

The majority of Chinese garments and accessories were decorated by means of embroidery on a plain or patterned silk weave ground. The material to be embroidered was stretched taut by stitching it to a bamboo or wooden frame. If the design was to extend over a seam, the two pieces of material were joined together first. In China, untwisted yarn was the type most widely used for embroidery on account of its lustre.

Embroidery in the Far East is characterized not so much by a profusion of different stitches as by the fine and detailed manner in which the work was executed. This frequently involved blocking in motifs with numerous, tightly packed straight stitches. The stitches often seem to encroach on each other in an uneven fashion, thereby imparting a sense of movement, texture and mass. The overall effect was heightened by the subtle use of coloured threads to produce shading.

● *Above*: Chinese shoes, late nineteenth or early twentieth century. Women's shoes in satin, embroidered with flowers and butterflies, on wooden heels.
● *Right*: Chinese watercolour on paper, nineteenth century. An embroiderer at work, one of a series of paintings depicting trades, occupations and activities. In the Far East, the material to be embroidered was stretched taut on a rectangular wooden frame. Note also the tiny bound feet of the embroiderer.

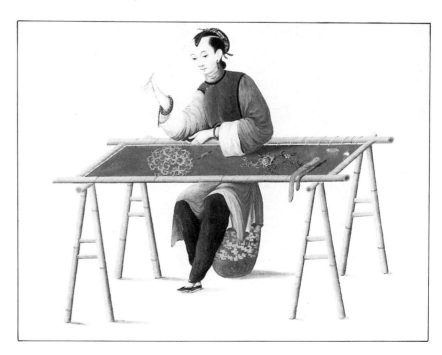

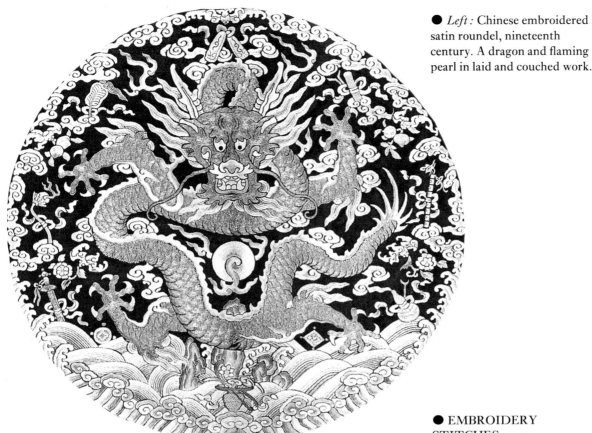

● *Left :* Chinese embroidered
satin roundel, nineteenth
century. A dragon and flaming
pearl in laid and couched work.

● EMBROIDERY
STITCHES
(1) couched stitch ; (2) seed
stitch, shown in three stages, left
to right ; (3) Pekinese stitch.

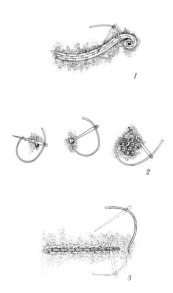

In China, and in Japan from the early Edo period (1615–1868),
laid and couched work was used to cover large areas of a design.
Metal threads were widely used for this technique, though they
were rarely pure. To produce 'gold' thread, for example, iron, lead
and copper were frequently added to a small amount of gold. The
various metals were formed into a sheet, stuck on to paper and then
cut into strips. These were then wound round silk thread. Since it
was not easy to pull the metal thread through the material without
the thread fraying, it was laid on to the surface and secured, or
couched, by means of small stitches at regular intervals.

Seed stitch, or *da zi*, which is similar to the French knot, was
generally confined to small areas of the design and used in
conjunction with other stitches. Another stitch encountered in
Chinese embroidery, known in English as Pekinese stitch,
involved creating small loops and securing them by means of back
stitching. In China the use of two needles enabled the loops and
back stitches to be executed together, while in Europe it was done
in two stages.

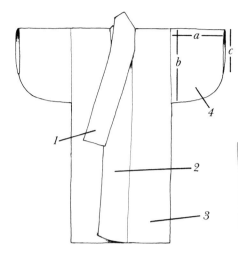

● THE KIMONO

Features of the kimono, one of the standard kimono types from around 1700: (1) neckband; (2) additional strip of fabric to provide an overlap at the front opening; (3) one of the main body pieces, a single length of fabric providing for the wearer's left front and back; (4) sleeve; sleeves were differentiated by their width from the shoulder to the wrist (a), their length from the shoulder down towards the ground (b), and by the length of the sleeve-openings (c).

● *Right*: Japanese kimono, nineteenth century. A *furisode* kimono, with butterflies and flowers against fences embroidered on a figured white silk ground.

JAPANESE DRESS

In China, traditions and styles of dress altered considerably over the years under the influence of foreign rulers such as the Mongols and the Manchu. In Japan, however, from around the tenth century onwards, there evolved a garment, the *kosode*, which was to remain the basic article of dress until the Westernization of Japan during the latter part of the nineteenth century. Whereas in China the standard type of clothing, together with its decoration, was largely dictated by the court and by the requirements of official life, in Japan the most inventive and innovative textile designs and techniques derived from elsewhere.

The *kosode* was originally an undergarment used during the Ashikaga period (1392–1568) by the lower strata of society. Gradually, it was adopted by the upper strata of society as an outer garment, and by the late fifteenth century it had become the standard everyday garment worn by both sexes.

The kimono ('thing worn'), has come to be used as a generic term for the standard Japanese garment. The three main types of kimono are differentiated by the width of the sleeve opening for the wrist, as in the *kosode* ('small sleeve') and the *hirosode* ('wide sleeve'), or by its length, as in the *furisode* ('swinging sleeve').

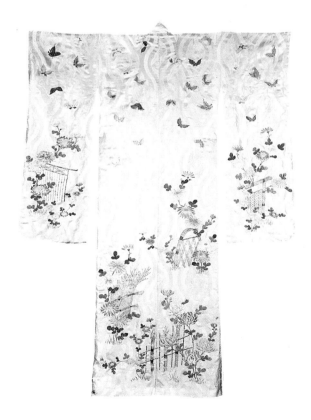

The basic design of the kimono is extremely simple, the principal pieces being cut, with the minimum of wastage, from a single length of cloth some 36 centimetres wide. Altogether it is made up of seven pieces: two body pieces (right side front and back, folded over at the shoulder, and left side), two strips to provide an overlap at the front opening, two sleeves and a neckband. This T-shaped garment has a full-length opening down the centre, and it is worn with the wearer's left side folded over the right, the two firmly held in place by a sash, or *obi*.

The kimono evolved naturally as a garment suited to everyday Japanese life. In the traditional Japanese interior furniture was kept to a minimum, and most activities were conducted kneeling or seated on the floor. At least from the sash down, the kimono could be pulled to either side, leaving the wearer able to move freely.

Although the kimono was worn by men and women, there were certain differences between the two types, such as the sleeve and collar length. Whereas the man's kimono was ankle length, the woman's version frequently swept the ground and was bunched over the sash. Wearing pattens on the feet not only served to raise the woman wearer above mud, water and snow, but also showed her long kimono to its best advantage. A horizontal tuck on the woman's kimono was concealed under the sash and enabled the

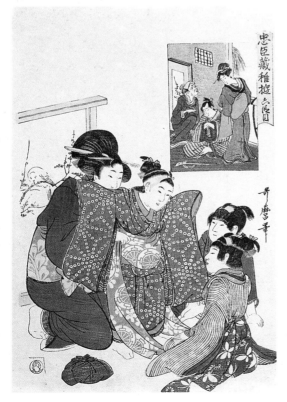

● *Left :* Japanese woodblock colour print by Utamaro (1735– 1806), *c.* 1790. A courtesan is winding the wide sash round the girl before securing it at the back. The girl is wearing a *furisode* kimono decorated in *kanoko*. The contrasting layer of an undergarment is visible at the V-shaped neck-opening.

overall length to be adjusted.

The sash was wound around the body and secured at the back in a knot. From about the late seventeenth century onwards the woman's sash became increasingly elaborate: methods of securing it became more complex and ornate, and, at the same time, it increased considerably in width, often to as much as three times that of a man's. Since the sash obscured a certain amount of the kimono, the overall design was frequently divided into an upper and lower field, with the hidden area under the sash left undecorated. In addition, the kimono had no provision for pockets. To overcome this, various objects were suspended from the sash by means of a netsuke, while the long and short swords, known collectively as the *daishō*, were worn thrust through it.

The kimono, like the Chinese robe, was of a standard shape. It was not tailored to the individual's figure, but was simply wrapped around it and secured with a sash. This arrangement readily lent itself to the addition of several layers of undergarments according to the season of the year. During the winter, for example, articles of clothing could be lined with a thin layer of waste silk covered by cotton wool. In addition, the *yukata*, which was similar to a kimono, was frequently worn by both men and women as an informal summer garment. It was made from thin, roughly bleached cotton, often with simple decoration in blue against a white background.

KIMONO DESIGN

The fact that the kimono was of such a simple shape, resulted in much time and expense being lavished on its decoration. Indeed, the first of many woodblock printed books of kimono designs was published in 1666. These not only served to develop public awareness of textile design, but were also attractive books in their own right. One of the most interesting aspects of kimono design was the disposition of the decoration over the surface area. This included repeating motifs which covered the entire kimono in horizontal rows, diagonal lines or simply as an all-over pattern. Some designs exploited the shape of the kimono, such as plants growing from the hem up the front and back, with their stems extending into the sleeve areas. Perhaps the most interesting were those which displayed an apparent disregard for the outline of the kimono, so that the main elements were placed off-centre and seemed to disappear off the edge of the garment at unexpected angles. In addition, the focal point of the design frequently lay across the shoulders. The motifs found on women's kimonos were extremely varied, ranging from diaper patterns to figural subjects, though flowers and trees predominated.

TECHNIQUES OF KIMONO DECORATION

In China and Korea, embroidery was the main form of textile decoration. In Japan, however, embroidery was often used to emphasize details of the design or else it was combined with other types of decoration.

Surihaku ('rubbed leaf') was a textile technique developed in Japan to manufacture a substitute for the sumptuous woven cloth incorporating gold and silver threads which was originally made in China. The first stage was to apply a rice-flour paste through a stencil on to the fabric. The stencil was then removed and the gold leaf applied, the paste acting as an adhesive. Any superfluous leaf was removed once the paste had dried, so that the area of gold corresponded exactly to the stencil. This technique was used to best advantage against a dark background.

Nuihaku was a variant of this technique in which *surihaku* was combined with embroidery. The ultimate decline of both *nuihaku* and *surihaku* was partly due to the fact that the gold leaf tended to become detached and partly that, during the Edo period, the use of couched gold thread was recognized as a more reliable method of achieving a similar effect.

Colour was basic to many forms of fabric decoration and Japan's greatest contribution to textile manufacture lay in fabric dyeing. Colouring agents were either in the form of dyes or pigments. Dyes are soluble in water and colour the fabric by penetrating its fibres. Most dyes used in the Far East were vegetable in origin, deriving from flowers, leaves, plants and roots. Those that were extracted by boiling generally required the addition of a metallic salt, known as a mordant, to ensure the bonding of dye and fabric. The fact that the chemical composition of the various mordants affected colours in different ways was used to obtain subtle variations of colour.

Pigments were derived from minerals or as by-products of dyes. They are insoluble in water and rest on the surface of the fabric rather than penetrating it. In order to fix the pigments, *gojiru*, a soya-bean liquid, was applied to the fabric. When this was steamed, the *gojiru* coated the pigments, bonding them to the fabric.

There were two methods of dyeing, namely dip-dyeing and brush-dyeing. The former involved preparing a dye bath in which to immerse either a batch of thread or a length of cloth. Repeated immersion was sometimes necessary to obtain the desired shade. Brush-dyeing, as the term suggests, involved applying colour to the fabric with brushes of different sizes.

In general, dip-dyeing was used when an overall colour was required. It was not, however, recommended for resist-paste dyeing since repeated or prolonged immersion in a dye bath caused

● *SHIBORI*
Some examples of the techniques of tie-dyeing and associated methods (top row), and their resulting decorative effects (bottom row); after the fabric had been bound, it was dipped into a dye bath: (1) a circular pattern was obtained by pulling up and tying a quantity of fabric into a vertical projection; this method was used for the distinctive arrangement of tiny circles known as *kanoko*; (2) by this method the whole length of fabric was rolled up and bound as shown to produce a striped effect; (3) strong thread was stitched across the fabric in the desired pattern; when the threads were pulled taut, the fabric bunched up around the thread, which would prevent the dye from penetrating the stitched areas; (4) the fabric was evenly and repeatedly folded to a desired width, like a concertina; when pressure was applied down the centre (usually by binding a pair of boards to the folded fabric), the dye was only able to penetrate along the exposed folds.

the paste to dissolve. Since pigments are insoluble in water, they could only be applied by brush-dyeing. Most dyes, on the other hand, could be applied by either method. When a specific technique of textile decoration demanded brush- rather than dip-dyeing, those dyes which could not be brushed on were made into pigments.

RESIST-DYEING TECHNIQUES

Resist-dyeing involved protecting areas of the pattern from the dye so that they appeared in white against a coloured ground. By protecting, or reserving, the background and exposing the pattern to the dye, the converse effect was achieved.

Shibori, or tie-dyeing, is a particular type of resist-dyeing used to great effect in Japan from the Nara period (AD 710–794) onwards. Binding cloth tightly had the effect of rendering it virtually non-absorbent, and, by binding it in some places but not in others, it was possible to dye particular areas of the cloth; by binding it at different pressures, various shades could also be achieved.

Once the selected parts had been tightly bound, the cloth was immersed in a dye bath. After the cloth had been removed and dried, the bound areas were released, leaving slightly raised and textured patches with blurred outlines. Stitching, folding and clamping were alternative methods of controlling the uptake of the dye and thus of creating a pattern.

Kanoko ('fawn dot') was a striking example of *shibori*, as remarkable for the painstaking work that the process demanded as for the final effect. The fabric was bound in such a way as to produce thousands of tiny circles packed closely together. The dye 'took' in the centre of each circle which had been left unbound. When *kanoko* became subject to sumptuary laws during the Edo period, a substitute was developed using a stencil made up of tiny holes. The results can be distinguished from true *kanoko* by the regularity of the dots and the lack of the slightly raised surface

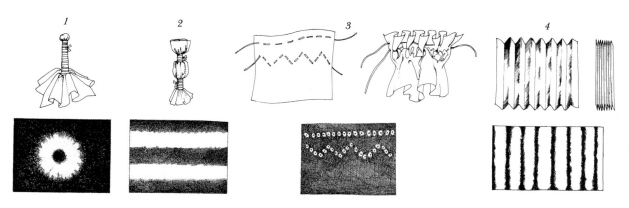

associated with the original technique.

In one method of resist-dyeing a rice-flour paste was used as the resist medium. The design was first painted on to the fabric in a blue liquid which could subsequently be washed out. Paste was then applied freehand to the area to be reserved by squeezing it through a paper cone, and this was followed by a layer of soya-bean liquid to fix the pigments. In order to obtain a variety of colours, as well as different shades of the same colour, resist paste was applied to the relevant areas between each application. Finally, the cloth was rinsed in cold water to remove the paste.

Yūzen dyeing was a type of resist-paste dyeing which developed during the seventeenth century, and in many ways it represents the culmination of the resist-dyeing process during the Edo period. Its name derives from Miyazaka Yūzensai, a fan painter who was active in Kyoto at the end of the seventeenth century, though the nature of his connection with the technique is uncertain. Once the design had been painted on to the fabric, it was outlined with resist paste to leave a narrow line. It is the thin white line separating each part of the design that serves to characterize Yūzen dyeing, and also the use of bright colours and pictorial design.

Another method of resist-paste dyeing, *katazome* ('stencil dyeing'), involved applying paste through the cut areas of a stencil on to the fabric. The stencil was removed and, after the paste had dried, a soya-bean liquid was applied to the surface to act as a fixing agent. After colour was applied by brush-dyeing, the paste was washed away, leaving the pattern in white against a coloured ground.

Kasuri, also known by its Indonesian name, *ikat*, was related to *shibori* in that binding replaced the use of a dye-resist. In the case of *kasuri*, however, lengths of natural yarn were bound and dyed before weaving. This method involved extremely accurate planning and measuring: having designed the pattern of the finished cloth, the experienced weaver had to think in terms of bundles of thread. These were bound at pre-selected intervals along their length so that only when the warp and weft threads were woven together would the design appear, characterized by slightly blurred outlines. A technique essentially associated with folk crafts in Japan, it is distinguished by areas which have been dyed blue and contrast with the natural colour of the thread, which was frequently that of cotton.

THEATRICAL COSTUME

From about the fifteenth century onwards, costumes for the Japanese theatre, such as the Nō drama, became an important part of the work of weavers and textile designers. Rich and colourful,

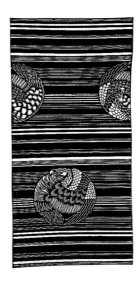

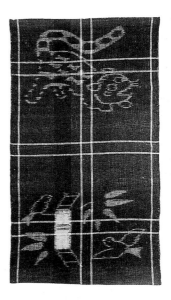

● *Above, top:* Japanese stencil for resist-dyeing, nineteenth century. For added strength, and to prevent tearing, stencils were made in pairs and pasted one on top of the other with a net of human hair between them.
● *Above, bottom:* Japanese cotton cloth decorated by *kasuri* weaving, late nineteenth century. Tiger, birds and bamboo.

202

● *KASURI*
A simple example of the *kasuri* weaving technique: (1) three skeins of thread are tightly bound at pre-selected intervals and then dyed; the dye does not take where the skeins are bound; (2) these are then woven in an exact order to produce a weft pattern.
● *Below, left:* Okinawan kimono, late eighteenth or early nineteenth century. Cranes and pines, executed by a type of stencil resist-dyeing known as *bingata*.
● *Below, right:* Chinese robe, late nineteenth century. The back of a Daoist priest's robe, embroidered with motifs from Daoist iconography.

with bold designs, the costumes were made from stiff, heavy silk: they were designed to create a stunning impression on stage.

Nō costumes were based on the standard forms of Japanese dress which were adapted to the specific needs of the theatre. The sleeves, for example, were often twice as long in the arms as normal and made use of two widths of material. The purpose was undoubtedly to accommodate the expressive sweeps and gestures of the arms characteristic of Nō drama. The costumes were frequently made from patterned silks, often embellished with metal threads. Additional surface decoration was provided by embroidery and by using techniques such as *nuihaku*, which combined embroidery with applied gold leaf.

ECCLESIASTICAL DRESS

Robes worn by Buddhist, Daoist and Shinto priests also represent a variation on the main forms of dress in the Far East. In China, for example, Daoist priests wore a full-length loose robe, which was decorated with symbols from Daoist iconography such as the Eight Daoist Emblems.

In Japan, the focal point of clothing worn by Buddhist priests was the *kesa*, or mantle, which was worn under the right arm and draped over the left shoulder. The *kesa* was made up of rectangular patches of different sizes which were sewn together in vertical panels and enclosed within a continuous border. In addition, six sacred squares made of a different fabric, usually in red or white, were sewn one in each corner, with two larger ones near the middle. The *kesa* was frequently made from rich and colourful figured silks. The fact that such materials were cut up and sewn together as patches was intended to symbolize the rags of poverty associated with Buddhism.

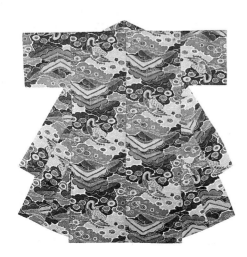

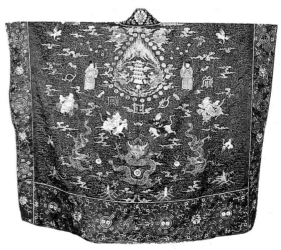

SELECT BIBLIOGRAPHY

General:
Carter, Michael, *Crafts of China*, 1977
Goepper, Roger, and Whitfield, Roderick, *Treasures from Korea* (exh. cat.), 1984
Kim, Chewon, and Kim, Won-yong, *The arts of Korea*, 1966
Lee, Sherman E., *A history of Far Eastern art*, 1964
Medley, Margaret, *A handbook of Chinese art*, 1973
Paine, Robert Treat, and Soper, Alexander, *The art and architecture of Japan*, 1960
Sickman, Laurence, and Soper, Alexander, *The art and architecture of China*, 1971
Tregear, Mary, *Chinese art*, 1980
Watson, William (ed.), *The great Japan Exhibition* (exh. cat.), 1981
Willetts, W., *Foundations of Chinese art*, 1965
Yamada, Chisaburoh F. (ed.), *Decorative arts of Japan*, 1965

Painting:
Akiyama, Terukazu, *Japanese painting*, 1961
Cahill, James, *Chinese painting*, 1960
Kwo, Da-wei, *Chinese brushwork*, 1981
Nakata, Yūjirō (ed.), *Chinese calligraphy*, 1983
Tanaka, Ichimatsu, *Japanese ink painting: Shubun to Sesshu*, 1972
Yonezawa, Yoshiho, and Yoshizawa, Chu, *Japanese painting in the literati style*, 1974

Prints and Printed Books:
Binyon, L., and Sexton, J.J. O'Brien, *Japanese colour prints*, 1960
Carter, Thomas Francis, *The invention of printing in China and its spread westward*, 1955
Chibbett, David, *The history of Japanese printing and book illustration*, 1977
Earle, Joe, *An introduction to Japanese prints*, 1980
Narazaki, M., *The Japanese print: its evolution and essence*, 1966
Wood, Frances, *Chinese illustration*, 1985
Yoshida, T., and Yuki, R., *Japanese print-making*, 1966

Ceramics:
Hamer, F., *The potter's dictionary of materials and techniques*, 1979
Hobson, R.L., *Chinese pottery and porcelain*, 2 vols, 1915
Kerr, R., *Qing ceramics*, 1986
Lion-Goldschmidt, D., *Ming porcelain*, 1978
Medley, M., *The Chinese potter*, 1976
Mikami, Tsugio (trans. Ann Herring), *The art of Japanese ceramics*, 1972
Tregear, Mary, *Song ceramics*, 1982
Wood, N., *Chinese glazes*, 1987

Metalwork:
Barnard, Noel, *Bronze casting and bronze alloys in ancient China*, 1961

Coben, Lawrence A., and Ferster, Dorothy C., *Japanese cloisonné*, 1982
Fong, Wen (ed.), *The great bronze age of China* (exh. cat.), 1980
Garner, Sir Harry, *Chinese and Japanese cloisonné enamels*, 1970
Kanzan Sato, *The Japanese sword*, 1983
Kelly, Clarence W., *Chinese gold and silver*, 1984
Pope, John Alexander, and others, *The Freer Chinese bronzes*, 2 vols, 1967 and 1969
Rawson, Jessica, *Ancient China*, 1980
Robinson, B.W., *The arts of the Japanese sword*, 1970
Watson, William, *Ancient Chinese bronzes*, 1977

Sculpture and Carvings:
Barker, Richard, and Smith, Lawrence, *Netsuke, the miniature sculpture of Japan*, 1976
Davey, Neil K., *Netsuke, a comprehensive study based on the M.T. Hindson Collection*, 1981
Earle, Joe, *An introduction to netsuke*, 1980
Hansford, Howard S., *Chinese carved jades*, 1968
Nishikawa, Kyōtarō, and Sano, Emily J., *The great age of Buddhist sculpture AD 600–1300*, 1982
Rawson, J., and Ayers, J., *Chinese jade throughout the ages* (exh. cat.), 1975 and 1976
Swann, Peter C., *Chinese monumental art*, 1963
Watson, William (ed.), *Chinese ivories from the Shang to the Qing*, 1984
Zwalf, W. (ed.), *Buddhism: art and faith*, 1985

Lacquer:
Bushell, Raymond, *The inrō handbook*, 1979
Garner, Sir Harry, *Chinese lacquer*, 1979
Herberts, K., *Oriental lacquer: art and technique*, 1962
Pekarik, Andrew J., *Japanese lacquer 1600–1900*, 1980
von Ragué, Beatrix, *A history of Japanese lacquerwork*, 1976
Yonemura, Ann, *Japanese lacquer*, 1979

Textiles and Dress:
Burnham, D.K., *Warp and weft: a textile terminology*, 1980
Cammann. Schuyler, *China's dragon robes*, 1952
Lorentz, H.A., *A view of Chinese rugs from the seventeenth to the twentieth century*, 1972
Nakano, Eisha, and Stephan, Barbara, *Japanese stencil dyeing: paste resist techniques*, 1982
Stinchecum, Amanda Meyer, *Kosode: 16th–19th century textiles from the Nomura Collection*, 1984
Tomita, Jun and Noriko, *Japanese ikat weaving, the technique of kasuri*, 1982
Vollmer, John, *In the presence of the dragon throne: Ch'ing dynasty costume (1644–1911)*, 1977
Wada, Yoshiko, Rice, Mary Kellogg, and Barton, Jane, *Shibori: the inventive art of Japanese shaped resist dyeing*, 1983
Wilson, Verity, *Chinese dress*, 1986

ACKNOWLEDGEMENTS

The author would like to acknowledge her debt to Rosemary Scott, Curator of the Percival David Foundation of Chinese Art, for sharing her knowledge of Far Eastern art, as well as for contributing the chapter on Ceramics; also to Margaret Medley for writing the Foreword. The staff of the Far Eastern Department of the Victoria and Albert Museum have been of great assistance, in particular Joe Earle, Rose Kerr, Dr Craig Clunas, Rupert Faulkner, Verity Wilson, Nicholas Pearce, Mandy Proctor, Helen White and Amanda Ward. In the Department of Oriental Manuscripts and Printed Books of the British Library, Yu-ying Brown, Beth McKillop and Dr Frances Wood provided much help, as did Jessica Rawson and Dr Anne Farrer in the Department of Oriental Antiquities at the British Museum. For help with the illustrations the author is especially grateful to Spink & Son Ltd., London, and Roger Keverne and Laura Wood-Homes; also to the University of Oregon Museum of Art. Gill Zeiner is responsible for the artwork and Eric Drewery helped with the design. Finally, thanks are due to Antony Mason, and to Liz Drury, Paddy Seymour and Cathe Carpenter at Roxby Press, for all their help and encouragement.

AAM Asian Art Museum of San Francisco, Avery Brundage Collection; AM Ashmolean Museum, Oxford; BC Burrell Collection, Glasgow; BL British Library, London; BM British Museum, London; CBM City of Bristol Museum and Art Gallery; CMA Cleveland Museum of Art, Ohio; FGA Freer Gallery of Art, Smithsonian Institution, Washington, D.C.; FL Forbes Library, Northampton, Massachusetts; FMC Fitzwilliam Museum, Cambridge; HKM Hong Kong Museum of Art, Urban Council of Hong Kong; MFEA Museum of Far Eastern Antiquities, Stockholm; MG Musée Guimet, Paris; NAM Nelson-Atkins Museum of Art, Kansas City; PDF Percival David Foundation of Chinese Art, London; RBG Royal Botanical Gardens, Kew; RCA Russell Cotes Art Gallery, Bournemouth; SAM Seattle Art Museum, Eugene Fuller Memorial Collection; SP Spink & Son Ltd, London; UOM University of Oregon Museum of Art, Murray Warner Collection and of Oriental Art; VA Victoria Albert Museum, London.

Page 14 VA; p. 15 BM; p. 16 BL; p. 17 SP; p. 18 (above) VA (below) BL; p. 19 FGA; p. 20 (above) SAM (below) SP; p. 21 Private collection; p. 22 (above and below) BL; p. 23 BL; p. 24 SP; p. 25 VA; p. 26 (left) CMA, Norweb Collection (right) CMA, Purchase, John L. Severance Fund; p. 27 CMA, Purchase, John L. Severance Fund; p. 29 (below) SAM; p. 30 BL; p. 31 VA; p. 32 VA; p. 33 (above and below) SP; p. 34 SAM; p. 35 SP; p. 36 BL; p. 37 VA; p. 38 NAM; p. 39 FL; p. 40 SP; p. 41 BL; p. 42 FGA; p. 44 SAM; p. 45 photo. Michael Holford; p. 46 VA; p. 47 VA; p. 48 BL; p. 49 BL; p. 51 photo. John Calmann & King Ltd; p. 52 VA; p. 53 VA; p. 54 (left) VA; p. 56 VA; p. 57 PDF; p. 58 VA; p. 59 VA; p. 60 (left and right) VA; p. 61 (left and right) VA; p. 62 BM; p. 63 VA; p. 64 VA; p. 65 (above and below) VA; p. 66 BL; p. 67 BL; p. 68 BC; p. 69 BC; p. 71 AM; p. 72 VA; p. 73 PDF; p. 74 (above and below) BC; p. 75 MFEA; p. 78 BC; p. 79 PDF; p. 80 (top) VA (left) AAM; p. 81 PDF; p. 82 PDF; p. 83 PDF; p. 84 PDF; p. 85 BC; p. 86 SP, photo. Raymond Fortt Studios; p. 87 (above) BC (left) PDF; p. 88 VA; p. 89 (above) PDF (left) FMC; p. 91 BM; p. 92 PDF; p. 93 AM; p. 94 PDF; p. 95 SP; p. 96 HKM; p. 97 MFEA; p. 98 PDF; p. 99 (above) MFEA; p. 100 (below) VA; p. 102 PDF; p. 103 PDF; p. 104 MG, photo. Documentation Réunion des Musées Nationaux; p. 105 (below) PDF; p. 106 PDF; p. 107 BC; p. 108 VA; p. 109 BM; p. 110 PDF; p. 112 MFEA; p. 113 (above) SP; p. 114 BM; p. 115 (above and below) BM; p. 116 (above) BM (below) FGA; p. 117 (above and below) BM; p. 119 NAM; p. 120 FGA; p. 121 FGA; p. 122 VA; p. 123 Private collection; p. 126 MFEA; p. 127 (above, below left and right) VA; p. 128 (above and below) VA; p. 129 VA; p. 130 (left and right) VA; p. 132 VA; p. 133 (above and below) VA; p. 134 FGA; p. 135 VA; p. 136 (above) FGA; p. 138 (left) SAM (right) CMA, Mrs Severance A. Millikin Collection; p. 139 SP; p. 140 photos. (above left) F. Wood (above right) J. Hutt (centre left) G. Hutt (centre right) G. Hutt (below) F. Wood; p. 141 (above) CMA, Worcester R. Warner Collection (below) NAM; p. 142 (left) FGA (right) MFEA; p. 144 (above) FGA (below) FGA; p. 145 FGA; p. 147 (above) VA (below) SAM; p. 148 PDF; p. 150 (above) BL (below) BM; p. 151 (above) NAM (centre and below) BM; p. 152 VA; p. 153 (above and below) VA; p. 154 SP; p. 155 (above) VA (below) BM; p. 156 (right above, centre and below, and left) VA; p. 157 (left) SAM (right) BL; p. 158 VA; p. 159 BM; p. 161 (above) RBG (below) RCA, photo. Mr Shaun Garner; p. 162 BM; p. 164 (above) SP (below) VA; p. 165 (above) VA (below) VA; p. 166 (above) VA (below) SAM; p. 167 (above) SAM (below) VA; p. 169 (above) VA (below) RBG; p. 170 (above and below) VA; p. 171 VA; p. 172 (above) VA (below) BM; p. 173 SP; p. 174 VA; p. 175 (left and right) VA; p. 177 SP; p. 178 VA; p. 179 SP; p. 180 BL; p. 181 BL; p. 184 (above and below) SP; p. 185 (below) SP; p. 187 VA; p. 188 SP; p. 189 (right) UOM; p. 192 (right) UOM (below) VA; p. 194 SP; p. 195 (above) VA (below) BL; p. 196 (above) VA; p. 197 (below) VA; p. 198 VA; p. 202 (above and below) VA; p. 203 (below left) VA (below right) UOM.

INDEX

Numbers in italics refer to illustrations.

206